Francis Bacon

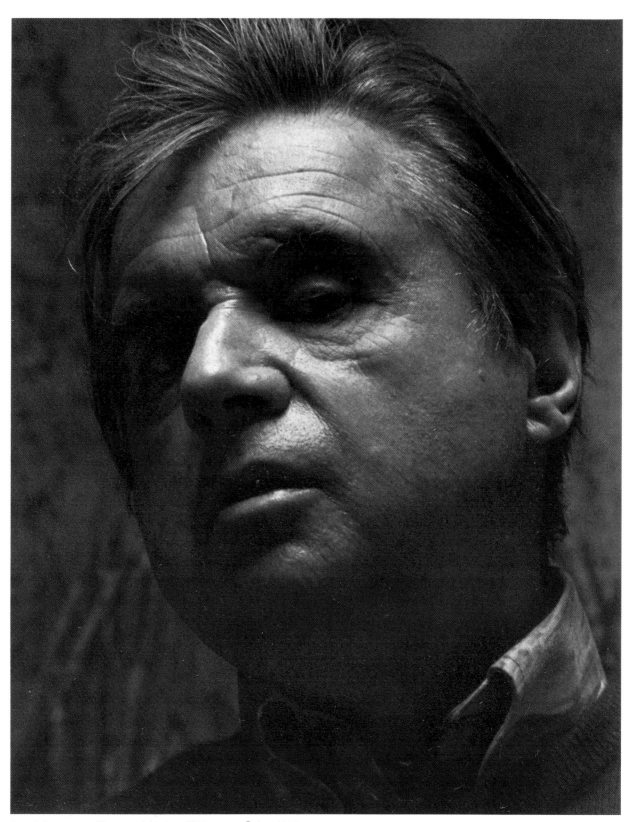

Francis Bacon, 1975. Photograph by Arnold Newman. © Arnold Newman.

Francis Bacon

Lawrence Gowing · Sam Hunter

with a foreword by James T. Demetrion

Thames and Hudson

in association with

Hirshhorn Museum and Sculpture Garden

Smithsonian Institution

Published on the occasion of the exhibition
"Francis Bacon," 1989-1990

EXHIBITION DATES

October 12, 1989–January 7, 1990
Hirshhorn Museum and Sculpture Garden

February 11–April 29, 1990
Los Angeles County Museum of Art

May 24–August 28, 1990
The Museum of Modern Art, New York

Dimensions, as supplied by lenders, are given in
inches (and centimeters), height preceding width.

Figures in brackets [] refer to catalog numbers.

Copublished by Thames and Hudson Ltd,
London, and the Hirshhorn Museum and
Sculpture Garden, Smithsonian Institution,
Washington, D.C.

First published in the United States in 1989 by
Thames and Hudson Inc., 500 Fifth Avenue,
New York, New York 10110

Library of Congress Catalog Card Number
89–50510

Printed and bound in Italy by Amilcare Pizzi SpA,
Milan.

CONTENTS

James T. Demetrion FOREWORD 7

Lawrence Gowing FRANCIS BACON: THE HUMAN PRESENCE 11

Sam Hunter METAPHOR AND MEANING IN FRANCIS BACON 27

CATALOG OF THE EXHIBITION 39

Anna Brooke CHRONOLOGY 182

PUBLIC COLLECTIONS 184

EXHIBITIONS 185

SELECT BIBLIOGRAPHY 186

FOREWORD
James T. Demetrion

I'm just trying to make images as accurately off my nervous system as I can. I don't even know what half of them mean. I'm not saying anything. Whether one's saying anything for other people, I don't know.[1]

<div align="right">Francis Bacon, 1973</div>

A lengthy exhibition history, a continually growing number of prestigious public collections in which he is represented (is any painter of our day as widely collected by museums throughout the world?), and a proliferating and extensive bibliography attest to the fact that Francis Bacon is decidedly saying something of profound significance "for other people."

What exactly that something might be is explored more fully in the insightful essays by Sir Lawrence Gowing and Sam Hunter that follow. Other observers have on occasion criticized the artist for not varying his message. (We will allow ourselves the liberty of referring to the impulses that are received by the viewers as "messages" even though the artist may deny having sent them in the form received.) But Bacon has pronounced himself not an Expressionist but a Realist, and he has even been shown as a Surrealist. If the messages received pertain to the horrors perpetrated on the flesh, the brain, and the psyche—if, indeed, the artist is just making accurate realistic images off his nervous system—it is because that dark side of the human condition, which is Bacon's domain, has not fundamentally changed anywhere in the world over the years.

When I traveled to London earlier this year to see Bacon's recently completed painting *Second Version of Triptych 1944* [59], it was with some skepticism that I entered the galleries in which it was installed. Almost fifty years after painting the masterpiece Bacon himself believes marked the beginning of his career,[2] how could he now compete with himself by painting a second version of what has become one of the icons of twentieth-century art?

Upon seeing the new triptych, however, all skepticism vanished. Despite the obvious differences in the two triptychs—the new work is more than four times larger yet the figurative elements occupy a proportionally smaller amount of canvas; the artist used areas of raw canvas in the center panel and a deep red and red-black background in all panels; the linear elements suggesting interior spaces have been markedly reduced—despite these and other differences, the second version still achieves the power and impact of the first. This results not only from the artist's mastery and refinement of his art, but even more from the fact that the mirror that Bacon holds up to the beast within us all reflects just as accurately and awfully today as it did when the first version of his triptych was originally exhibited in April 1945, just four months before the nuclear age burst forth upon the world in all its fury.

Animal as animal is not Bacon's subject. True, he occasionally paints an image of a baboon, elephant, dog, or other real or imagined creatures. Man as animal, however, stripped to his bestial nature—to his real nature—is Bacon's subject. The *Study for Crouching Nude* [10], the early screaming popes [9,13], the Hirshhorn triptych of 1967 [33], and the repulsive and headless male fugitive from a Boschian nightmare from the left panel of *Diptych 1982-84* [53], are among the more overt examples. Even when Bacon depicts a child, as in *Paralytic Child Walking on All Fours (from Muybridge)* [23], a subject that might elicit sentiments of tenderness and solicitude evokes instead a heightened wariness such as one might feel while being circled by an equally wary animal. Evoking both bestiality and humanity, Bacon's art speaks in universal terms of the isolation and anguish of the late twentieth century.

> *"Fancy thinking the Beast was something you could hunt and kill!" said the head. For a moment or two the forest and all the other dimly appreciated places echoed with the parody of laughter. "You knew, didn't you? I'm part of you? Close, close, close!"*
>
> William Golding, *Lord of the Flies*, 1954

The Hirshhorn Museum and Sculpture Garden is privileged to present the first general survey of Francis Bacon's paintings in the United States since the Guggenheim Museum's exhibition a quarter of a century ago. In fact, along with the Metropolitan Museum of Art's seven-year overview of the artist's work of the late 1960s and early 1970s, this is only the third one-person exhibition of his work to be held in museums in this country. That the Hirshhorn's show coincides with the artist's eightieth birthday is all the more reason for celebration.

The preparation of the exhibition and its accompanying catalog entailed the collaboration and assistance of many persons, and I am grateful to have the opportunity to acknowledge some of them here. To the artist must go our deepest gratitude. His support and cooperation have been of the greatest importance to the realization of this project. In several instances his personal intervention secured loans that might not otherwise have been available.

Valerie Beston of Marlborough Fine Art, London, gave unstintingly of her time and knowledge while Kate Austin helped facilitate loans and gather photographic material. Their assistance, along with that of Gilbert Lloyd and Pierre Levai, proved invaluable. All have our sincere thanks.

John Elderfield and William Rubin of the Museum of Modern Art in New York made valuable suggestions in the formative stages of the exhibition, and the Bacon scholar Hugh Davies of the La Jolla Museum of Contemporary Art could be relied upon for generous assistance whenever called upon. Special help from Dr. Sofia Imber and Fernando Almarza Rísquez of the Museo de Arte Contemporaneo in Caracas should also be acknowledged. Particular mention should be made of Ernst Beyeler of Galerie Beyeler in Basel for providing and

facilitating several key loans. Thanks go to Richard Oldenburg and Earl A. Powell III, directors of the Museum of Modern Art in New York and the Los Angeles County Museum of Art, respectively, for their participation and role in making the exhibition available to a wider public.

The responsibility of mounting a retrospective for one of the world's best-known and extensively collected contemporary artists posed complex problems for the Hirshhorn Museum's staff and, in particular, for its curatorial, registrarial, and technical departments. Special credit must go to Judith Zilczer, Associate Curator of Painting, for diligently coordinating all aspects of the exhibition; to Douglas Robinson, Registrar, and his efficient staff for handling the seemingly infinite number of details in bringing the exhibition together and circulating it; to Ed Schiesser, Chief of Exhibits and Design, and his hard-working staff for designing and skillfully installing the exhibition; to Barbara J. Bradley, Publications Manager, for conscientiously supervising the myriad intricacies pertaining to catalog production; to Anna Brooke, Librarian, and her staff for their thorough work in compiling the chronology and bibliographic material. Our thanks also go to Nikos Stangos at Thames and Hudson in London for his efforts in a wide range of catalog-related details.

This exhibition could not have taken place without the cooperation of numerous lenders in this country and abroad. At a time when loans of major works are becoming increasingly difficult to negotiate, we are truly thankful that, with one exception, all the paintings in the exhibition will be shown at all three venues. Because of its fragility, the sole exception, in the collection of the Museum of Modern Art, has not left that museum since 1970.

Francis Bacon's work is still considered difficult by many, and traditional sources of sponsorship have not generally been available. It is therefore with considerable gratitude that we acknowledge the valued support of the Smithsonian Special Exhibition Fund and of an indemnity from the Federal Council on the Arts and the Humanities.

1. David Sylvester, *The Brutality of Fact: Interviews with Francis Bacon,* 3rd ed. (London and New York: Thames and Hudson, 1987), p. 82.

2. John Rothenstein and Ronald Alley, *Francis Bacon* (London: Thames and Hudson, 1964), p. 11.

FRANCIS BACON:
THE HUMAN PRESENCE

Lawrence Gowing

I would like my pictures to look as if a human being had passed between them, like a snail, leaving a trail of the human presence . . . as the snail leaves its slime.[1]

Francis Bacon, 1955

Genius does not invariably show early signs of direction or decision. Idleness and self-indulgence may be just as characteristic to begin with. So it was to be with the restless son born in 1909 to an English racehorse trainer in Dublin. His habit was wayward; ill health excused him from schooling; to be the descendant and namesake of the great lawyer-philosopher meant nothing to him; his family despaired of him.

We hear little of Francis Bacon's upbringing if only because, as he explained to me this year, he liked his parents too little to talk about them.[2] In 1925, when discipline for the feckless sixteen year old was decided on, he was turned out to make his own way in the world.

So Francis Bacon set out, in the first place for London. In 1927, he stayed for two months in Berlin and then for two years in France. He spent, as he said, "about three months . . . trying to learn French [with a family near] Chantilly."[3] Forty years later, he remembered that he used often to visit the Musée Condé. This is the first we hear of any concern with the art of painting but Bacon received occasional commissions as an interior decorator and his standpoint to painting was already an individual one. The picture at Chantilly that always made a great impression on him was Poussin's *Massacre of the Innocents*, 1630-31 (fig. 1). He has said that "probably the best human cry in painting was made by Poussin,"[4] and the observation as usual is unexpected. How many teenagers go to painting for the "human cry?" Which of them sees one cry as better than another? The *Massacre of the Innocents* was celebrated at the time for its elimination of disturbing violence. To Francis Bacon its example had just the opposite force, and another image, which appeared in 1925, meant even more. He remembered that "almost before I started to paint" he had been deeply impressed by Sergei Eisenstein's film *Battleship Potemkin,* 1925, and in particular it was the face of the screaming nurse on the Odessa steps that he always recalled (fig. 2).

We can gather what occupied him in the years that followed from a double-page spread in an art magazine five years later, announcing that after working "in Paris and Germany for some years," Francis Bacon was established as a designer of interiors with a studio in Kensington.[5] He was still not twenty-one, but the designs that the young man had to show, slightly syncopated adaptations of

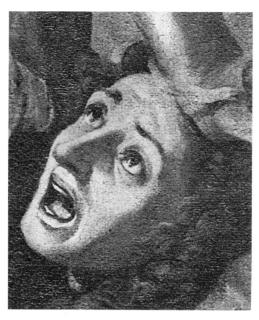
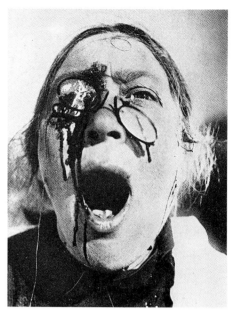

fig. 1. Nicolas Poussin
(French, 1594-1665).
Massacre of the Innocents, 1630-31
(detail), Musée Condé, Chantilly.

fig. 2. Sergei Eisenstein
(Russian, 1898-1948).
Still of the head of the nurse
from *Battleship Potemkin,* 1925.

Breuer and Jeanneret, remain impressive to this day. By 1933 decoration was behind him, and he made his equally surprising appearance as a painter in a prestigious British chronicle of contemporary art, Herbert Read's *Art Now.* He was represented in the book by *Crucifixion,* 1933, with the stick-like limbs of a fantastic insect—a phosphorescent imagining akin to the creatures of André Masson. *Les Presages,* which Masson designed in 1933 for the Monte Carlo Russian Ballet, was dominated by a similarly fateful, bat-like figure. Sir Michael Sadler, the foremost supporter of modern art in England, immediately telegraphed to buy *Crucifixion.* Two variations on the theme followed it into his collection.

Asthma kept Bacon out of the services and it was not until 1945 that the outcome of his sporadic and interrupted work in painting was exhibited. It was a series of three metamorphoses of the figure, which were imagined with passionate resource and realized in a spirit that was ruthless and unsparing—figures modeled with furious coarseness in gray, against an orange-red background for which polite taste had no use—a series called *Three Studies for Figures at the Base of a Crucifixion* (see p. 33).

During the years that followed, the painter in Bacon submerged again. The wanderer in him lived as best he could, sometimes taking jobs in night clubs, gambling a good deal, occasionally with a winning streak (foreshadowing, as he sometimes says, a painter's reckless trust in the chances of paint).

Nevertheless, the painter within him was on his way. Although he seemed at first to lack, if not defiantly to reject, accepted skills and sensibilities, he clearly possessed one exceptional gift. It was the gift of making sense of the most original art of his time, a sense that escaped and still largely escapes conventional taste. Only Bacon, among the painters of his generation in France and England, realized that Picasso's imaginings before 1930—the biomorphic abstractions

crawling with life of their own, which he had seen in an exhibition at the Paul Rosenberg Gallery in 1927—in fact opened a vast realm of unexplored and ominous potentiality in the painting of the human figure. To understand in youth the furthest potential of what is being created at that very moment is perhaps as great a talent as an artist in the twentieth century can possess. (Most find it difficult enough to accept the originality of what was done before they were born.) Looking back at his starting point Bacon said that he "had a desire to do forms. . . . They were influenced by the Picasso things which were done at the end of the 'twenties. And I think there's a whole area there suggested by Picasso, which in a way has been unexplored, of organic form that relates to the human image but is a complete distortion of it."[6]

The three studies for figures at the base of the cross, which hang in the Tate Gallery in London, are too fragile to travel again. Yet this exhibition will not lack the link between this missing foundation of Bacon's development and its present culmination. Bacon has lately painted serenely thoughtful paraphrases of the *Three Studies,* hardly different from the originals in form, yet with a world of reconciliation between them, which will represent his starting point here [59]. We rediscover his basic inspiration not as figures in themselves so much as biomorphic abstractions of the figure, marking still the thought of forty-five years ago yet not merely repetitive nor even retrospective but rather a lively memorandum of a major and continuing growth point in our tradition.

Bacon recognized the possibilities that Picasso opened to him, and unlike most of his contemporaries he realized that they did not favor abstraction. The essential method was free association on the prompting of life. The painter was not limited to fantastication. On the contrary, Bacon's next starting point was a snapshot of his friend and supporter Eric Hall dozing in the sun on a chair in the park, and it was from this beginning that he set out in pursuit of the associations that ended in one of the most significant paintings in his whole work, *Figure in a Landscape,* 1945 [1].

The "form that relates to a human image but is a complete distortion of it," of which he spoke, was evidently not limited to sculptural inventions like *Three Studies for Figures at the Base of a Crucifixion.* It could equally be the shape of sunlight and shadow on a double-breasted suit and its almost invisible wearer, slumped in a dark gulf of unaccountable catastrophe. The subject of the metamorphosis had altered. In place of anatomical archetypes Bacon took a common visual experience, a man sunning himself in the park, as the theme of a transformation that was more disturbing and menacing than ever.

The enigmatic zone of shadow that half swallows *Figure in a Landscape* is explained by the addition of an umbrella in another picture, entitled as if in poker-faced academic masquerade, *Figure Study II,* 1945-46 [2].

The umbrella is no more or less germane than the palm frond that rhymes with it or the herring-bone top coat flung negligently over the massive nakedness of a protagonist unattached to any human role except to suffer. The subject is the agony of this common situation, the extremity of intimacy and portrayal alike,

inarticulate yet strangely explicit in the convulsed and wordless cavern of the mouth. Possibly it is the irretrievable state in which a body gives itself to be realized in paint; later it is more and more evidently identified as such. Picture after picture parallels Bacon's far from humble confession: "I did hope one day to make the best painting of the human cry. I was not able to do it. . . ."[7]

These canvases led to a more famous picture, the noted *Painting,* 1946 [3], which was hardly seen before it was bought for the Museum of Modern Art in New York, the picture by which he is best known all over the world to this day. At just under forty, Bacon had arrived as one of the dominant figures in the art of his day. *Painting* brought the ominous incongruities, the dramatic fall of light around the umbrella and the catastrophic implication all together for the first time. The scene might be a butcher's shop in a luxurious crimson interior behind drawn blinds, where the carnivorous protagonist, no more butcher than priest, waited for his prey or for his doom among the sides of meat displayed around him.

This scene, to which, however well we know it, we are never entirely inured, took on certain qualities that became characteristic of Bacon's imaginative world. The imagined scene, with its implication of menace, has a character that is not merely atmospheric or fantastic. It has a definite formality, the symmetry of a setting for a drama or a rite, and its action is performed within the railings of a little stage, a rostrum that is also an altar and more a device of pictorial architecture than either, a means to concentrate the attention with a sense of occasion. As a result, the scene does not appear fanciful, capricious, or arbitrary; on the contrary, it shows, as the Surrealism that we might take it for never did, a state of existence as imaginably real as anything that shocks us in daily life or nightly dream or as anything that we remember from the cruelty and passion of the most vivid Western painting, with its frequent blend of formality and outrage. We notice with a start that the two modes of visualization, the private trauma and the tradition of narrative painting, are oddly alike. They have a vein of irrational vividness in common.

Bacon had come to figure painting in terms of an elaborate drama. Now the drama was reduced and concentrated. The later 1940s were no time for fantasy. Artists and writers alike felt compelled to dwell on the bitterness of actual existence. Bacon's world was reduced and bitter indeed. It centered on an irreducible human fact—the human head. There was nothing else in the next six pictures but the abject physical reality, the misery of the knob that terminates a human being.

Head I, 1948 [4], is bent back in agony; the chattering teeth, like the teeth of a hunted rodent, break loose in their orifice. The medium of vision, the granular paint, begins to powder down like snow at night. It drifts against the form and loads the canvas; the flesh glitters with a greedy meanness. The paint is now streaming down in a cascade. It makes a curtain of light, which is at once behind the figure and in front of it; the streams of paint only have to thicken a little to constitute the solidity of flesh. The curtain sways—in *Head II,* 1949 [5], it must

be fastened, pinned together with a safety pin as the flesh has been pinned. The flesh is marked, as if impaled by arrows, at once injunctions where to look and points where the ludicrously defenseless creature is struck. The curtains part and the human subject is seen passing between them, unless it is they that are passing through him, making him as much a product of the light as they, yet discovering him at the same time to be all too fleshy and animal. The light splashes down on man and ape alike [15]. They are as solid and as spectral as each other. As bestial and as human.

The first of the "Heads" is surrounded by a little railing like *Painting* and enclosed by the hint of a cubicle in which a tassel hangs, with a certain irony, as if a cell were upholstered in silk. In *Head VI,* 1949 [6], the last of them, all these suggestions come together. The cubicle reveals itself as a veritable cube, of plate glass perhaps. The curtains of light, unless they are shadow, stream down like rain round and through the box, drenching it more than ever. Suspended in it, the ironic tassel now hangs against the nose between invisible unseeing eyes (which shadow and fate have washed away) of a figure who is both a prisoner and a ruler, nothing less than a prince of the church in a violet satin cape, which evokes the biretta on his unseen head. Under the satin with excruciating refinement he wears white lace. The tassel teases or tortures him. With a huge grimace, a pope is screaming.

The shock of the picture, when it was seen with the whole series of heads in Bacon's exhibition at the Hanover Gallery in London at Christmas 1949, was indescribable. It was an outrage, a disloyalty to the existential principle, a mimic capitulation to tradition, a profane pietism like inverted intellectual snobbery, a surrender also to tonal painting, which earnestly progressive painters have never forgiven. It was everything unpardonable. The paradoxical appearance at once of pastiche and of iconoclasm was indeed one of Bacon's most original strokes. The picture remains one of his masterpieces, and one of the least conventional, least foreseeable pictures of the twentieth century. Like really important pictures, it inaugurated a dimension that we could not have imagined and still cannot wholly describe. Such pictures are never without their detractors, and there is a body of opinion that cannot tolerate either the traditionalism in Bacon's painterly style or the invariable element of the irrational in his standpoint. As Bacon has developed, he himself has become more and more aware of this, to the point of doubting whether rational discussion will bring anyone close to his work. "It's also always hopeless talking about painting," he says. "One never does anything but talk around it—because if you could explain your painting you would be explaining your instincts."[8]

Much more in Bacon's method is reasoned and intended than some of his critics understand. The spatial devices that confine his subjects within the picture, for instance, which began with the cubicle occupied by *Head VI,* have none of the significance that has been attached to them. They are meant simply to concentrate the attention, and thus make the figure that they frame more visible, and this they incontestably do. The indications of a box round the first picture of

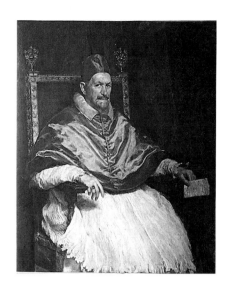

fig. 3. Diego Rodriguez de Silva
Velásquez (Spanish, 1599-1660).
Pope Innocent X, 1650, oil on canvas,
55⅛ × 47¼ in. (140 × 120 cm).
Galleria Doria Pamphili, Rome.

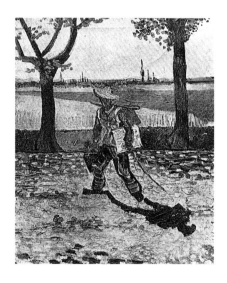

fig. 4. Vincent Van Gogh
(Dutch, 1853-90).
The Painter on the Road to Tarascon, 1888.
Destroyed in World War II. Formerly
in the Kaiser-Friedrich Museum,
Magdeburg.

a pope enthroned quite evidently give a frame of reference without which the pose, as the figure turns to meet our eyes in the immeasurable depth of his chamber, even the paint itself, would look comparatively diffuse and sentimental. In pictures like this Bacon reveals himself to possess a pictorial instinct as well trained, because self-trained, as any painter alive. He originally explained the inspiration of his series of popes as sheer admiration for the color and presence of Velásquez's portrait of Pope Innocent, which obsessed him (fig. 3). When he returned to the discussion fifteen years later, he had come to regret that he ever painted a pope; he had become acutely aware of the impossibility of adding anything to Velásquez's achievement.[9] Yet the links with the past have been precious to him. He has a kind of piety toward them. His sense of how paint works—of how its equations are created and read—has sometimes had an almost devotional attachment. He has celebrated the rite of painting according to the old observance.

Certainly his pictures of popes gain a momentum from history—and not only from the example of Velásquez. The subject of the enthroned pope was inaugurated by Raphael and inherited by Titian and others before Velásquez took it up in the customary form but with his own incomparable painterly resource. Bacon's pictures gain their momentum not only from the authority of the time-honored pattern and the painterly richness of the realization, but from the opportunity to defy and scandalize tradition, and to reverse the expectation of filial obedience by vexing and victimizing the paternal serenity of this—in every sense—father figure of the religious and artistic establishment. A few years later Bacon was able to derive the same momentum and a similarly provocative opportunity from the image of a venerated patron and style-parent of the modern tradition, Van Gogh's famous image of himself setting out to paint on the road to Tarascon (fig. 4). Both with Velásquez and Van Gogh, Bacon was able to borrow the momentum of rich and vivid color, whether Baroque or Postimpressionist. He got a flying start from both, and he pursued each subject through a series of pictures [19], until the defiance had lost its boldness.

Francis Bacon gave a brilliant demonstration of how the modern artist can benefit from tradition without submitting to it for a moment—without traditionalism, in fact, but with his modern freedom unimpaired. One could have called the demonstration unique, but for its single great parallel, Picasso's ability to borrow from Ingres and later from others. But Bacon was alone in conducting his raid into the past with the traditional weaponry of tonal painting, with modeling in light and dark.

A few years later Bacon came to think his impudence had been silly. But to his public it is plain enough that his borrowing and recreation of the traditional papal image is one of the most fertile audacities of modern art. When he tried to repeat the coup with the popes a year or two later, the boldness and the inspiration had gone out of it. But realizing what he had been able to do with tonal painting, he went on to examine the possibilities of that mechanical inheritor of the tonal tradition, the camera, and set to work to borrow as ruthlessly from an old master

of photography, the Anglo-American pioneer of the instantaneous exposure, Eadweard Muybridge.

Again Bacon's effect was not only unexpected; the very dimension in which his shock was delivered was surprising. Bacon was painting now on defiantly raw and unprepared canvas. The paint soiled it or clogged it uncouthly. Then, by another defiant incongruity, heavy frames in burnished gold such as Paul Rosenberg himself awarded to Picasso and Braque, set Bacon's almost insanitary coarseness in the most luxurious context imaginable. Another breach with fashion, as if to protect something refined and precious, these pictures were exhibited under glass. Bacon insisted on it and published the peremptory note pasted on the reverse as if it was a part of the picture. So it was; even the reflections in the glass added a unique completeness. There could be no more categorical defiance of conventional taste, the taste for the specifically visible qualities of visual art. The manifesto embraced the setting in which three pictures were exhibited, the most elegant gallery in the most elegant part of town where the floor was covered from wall to wall with a carpet of an intense violet that infused every impression and outlined the visitors' own reflections as they strived to attend with old-fashioned seriousness to the intrinsic appearance of these disturbing pictures. The regal popes and the defecating dogs were rendered in the same broken paint; the same delusive mirage flitted across the glass. The carelessness and scorn in Bacon's touch had from the beginning a marvelous bleakness, exciting to imaginative life. "I would like the intimacy of the image against a very stark background," he explained later. "I hate a homely atmosphere. . . . I want to . . . take it away from the interior and the home."[10] In the fraught and dubious world of 1950, a touch that was so bare of comfort had an intimidating authority.

Bacon's authority came quite apparently from two distinct sources. It came from his own enormous courage and disdain. He was the dandy of existentialism—so assured that he could accept the most dangerous alliance of all, the cynical, brilliant alliance with history. It called in aid, for example, the commanding visual force of Baroque realism, then quite sardonically and cruelly married it to the realism of the camera. The painterly formula which Velásquez had inherited from Titian and Raphael had a quite papal infallibility, and Bacon joined it to the optical and human data of photography (which is itself a part of history, a creation of the nineteenth century). The combination was irresistible. It was a double key to the desperation under the insupportable tyranny of the real, which we felt in the postwar world and still feel. The imagination that does not recognize its own dilemma in Bacon's images simply does not know the score.

Discussing his sources with David Sylvester, in the *Interviews* which are, I think, among the classics of art-literature, Bacon made an interesting confession. He said that he could no longer separate what he derived from Muybridge from what he owed to Michelangelo. "I've always thought about Michelangelo; he's always been deeply important in my way of thinking about form. . . . Actually,

Michelangelo and Muybridge are mixed up in my mind together, and so I perhaps could learn about positions from Muybridge and learn about the ampleness, the grandeur of form from Michelangelo. . . . But of course, as most of my figures are taken from the male nude, I am sure that I have been influenced by the fact that Michelangelo made the most voluptuous male nudes in the plastic arts."[11]

In 1953, Bacon used again the same dog that he had borrowed from Muybridge the year before [12] (fig. 5). This time the motif was grafted back on to the stem of modern art. A chain joined the dog's collar to its master, leading the dog on its walk. The subject is a double quotation, from Muybridge and also from a Futurist classic, the picture by Giacomo Balla called *Dynamism of a Dog on a Leash,* 1912, which had been exhibited in London the year before. Balla's design was reversed to suit Muybridge's dog and the serial positions of the owner's feet blurred and fused into a monolithic presence. The kinetic force of Futurism was lost and the vividness now was the fact that the dog turned aside on its walk to sniff at a noisome grating in the gutter. Bacon, as often, seems to have satisfied an addiction to squalor as irresistible as the dog's. The sources were transformed yet the value of the impetus from history remained clear. Bacon warned a critic who was enquiring what he might have looked at, "I see everything!"

A graver and deeper resonance from the past was discovered when a composer who had set to music poems by William Blake—the British Romantic visionary, who is a test like litmus for purity of heart—asked Bacon to portray a life mask of Blake for the music cover. The serious passion in Blake excited Bacon, and he eventually painted five variations on the subject [18]. The life mask itself stands in the National Portrait Gallery in London; Bacon went several times to the gallery to study the cast. Yet he preferred to paint his pictures chiefly from a photograph: It is his natural mode of knowledge and I have heard him say that none is so intimate. This was a preference that I then found difficult to understand. As a painter myself I drew my data direct from the actual. Like most people, I wish to convert my friends to my way of thinking. I ordered a cast of Blake's life mask and took it to Francis Bacon, supposing that if he could be persuaded to paint from the actual form, instead of the photograph, he would feel some benefit. It was not a good idea; Bacon thanked me with his invariable courtesy, but I doubt if the parcel was ever unpacked. Perhaps the opalescent mirage in the polyethylene wrapping was satisfying enough in itself. The solid actuality would have been irrelevant, even a hindrance. The methods by which a subject is evoked, Bacon has said, are so artifical that to have the actual subject before him would inhibit him. He often paints his friends and rarely anyone else (he has an uncommon talent for friendship). But he has explained that their presence would not help: "They inhibit me because if I like them I don't want to practise before them the injury that I do them in my·work. I would rather practise the injury by which I can record them in private."

Nevertheless, Bacon had arrived at a conviction that for him the subject of painting was to be human, particular, and actual. "I want," he said in 1962, "to

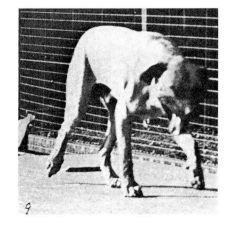

fig. 5. Eadweard Muybridge (American, b. England, 1830-1904). Photograph of a dog from *Animals in Motion,* 1887.

do very specific things like portraits, and they will be portraits of . . . people, but, when you come to analyze them, you just won't know—or it would be very hard to see—how the image is made up at all."[12]

They were to be portraits, in fact, like no others ever painted. He remained and remains undisturbed in his conviction that art is an obsession with life "and after all, as we are human beings, our greatest obsession is with ourselves. Then possibly with animals, and then with landscapes." So he would alter the traditional hierarchy of subjects. Portraits, which used to be subordinate, "now that things are so difficult," must come first. Landscapes hardly occupy him at all. Animals, however, are seen as a living commentary on our own species. A dog hobbles along with the abject, afflicted look that we can see in humanity as well. "I . . . look at animal photographs all the time," he said, "because animal movement and human movement are continually linked in my imagery of human movement."[13] David Sylvester was perplexed that when he was sitting for Bacon in the 1950s, before he abandoned models, Bacon looked so much at an animal photograph. One should know Mr. Sylvester's heavyweight sagacity and uneven temper (or the clogged gray paint of Bacon's pictures) to appreciate the fact that he was looking at a rhinoceros.[14] But the nucleus of human concern must be with another human being. The center of painting, on which we concentrate whatever powers we have left, is for him the art of portraiture.

Bacon's sense of the climate of thought made it quite difficult to envisage painting at all, let alone to realize the humanism of this program. The idea that an image might be "factual and at the same time deeply suggestive . . . unlocking areas of sensation" beyond what was intended, was in itself contradictory and irrational. It had to be pursued in areas beyond reason. The whole frame of mind of the time was against it. Purpose was beset by instinct; knowledge was undermined by doubt; hope was no match for common despair. Bacon understood the creative dilemma better than anyone. Listen to him talking to David Sylvester. Purpose? Man can only hope for "the will to make oneself completely free. Will is the wrong word, because in the end you could call it despair. Because it really comes out of an absolute feeling of it's impossible to do these things, so I might as well just do anything. And out of this anything one sees what happens." Knowledge? Bacon confessed, "I don't in fact know very often what the paint will do, and it does many things which are very much better than I could make it do. Is that an accident?" And again, "If anything ever does work in my case, it works from that moment when consciously I don't know what I'm doing." What can he trust in? "One's basic nature is totally without hope, and yet one's nervous system is made out of optimistic stuff. It doesn't make any difference to my awareness of the shortness of the moment of existence between birth and death." "Perhaps . . . despair is more helpful, because out of despair you may find yourself making the image in a more radical way by taking greater risks." David Sylvester's interviews with Francis Bacon are classics of a specifically modern self-awareness. His painting, Bacon says, is "concerned with my kind of psyche, it's concerned with my kind of . . . exhilarated despair."[15]

The curtains of darkness fall straight and remorseless round the man of mid-century in Bacon's portraits. The verticals invade the image, interrupt it, and are themselves interrupted. The head in the series "Man in Blue" is eventually modeled in vertical strokes [14]. The series remains the nearest Bacon has come to stable realism, painted prose. But from 1960 on everything conspired to replace realism with Bacon's own irrational poetics. *Sleeping Figure,* 1959 [21], is one of a series in which reclining naked figures are poured out in fat, natural curves. The paint was spilled out, much as the body was sprawled out on the mattress—dropped in amorphous, random pools. In one picture at least the spillage was actually out of control. In another version the body area of a reclining woman had to be cut out of the original canvas and glued to one that still possessed its clarity. The fact reveals an awareness of a quality in paint that is uncontrollable. In a year or two it was to become his dearest ally.

In 1963, on one of Bacon's visits to Tangier, the country near Malabata suggested an elliptical bowl full of curling brush strokes for dry grasses, blown this way and that under a hot, dark sky. The bowl of landscape near Malabata, however, bred a creature of its own, a mushroom shaped bush that possessed a sparkling, beady eye and reared itself to gaze at the scene. In the Hirshhorn variation of Van Gogh [19] the lumpy road seems to be composed of diminutive, writhing, naked figures. Paint and nature, as well as the human subject, seem each to have developed an autonomous life. It is neither explicitly nor rationally accountable, but it is quite definite and ominous, even frightening.

We are watching the emergence of a self-generating quality of painting, which after Bacon's exhibitions in 1962 and 1963 changed the character of his art. The sign of it was *Three Studies for a Crucifixion,* 1962 [24], the masterly evocation of bodily fate that explored unshrinkingly the theme that had been latent in his earlier work. Until 1962, the date of Bacon's first exhibition at the Tate Gallery, most of his pictures had been devoted essentially to single embodiments. Sometimes more than one figure come together in a single canvas and, in some, couples of figures, suggested by photographs of wrestlers by Muybridge, join in an inseparable relationship. One of these, in which the couple is half hidden in long grass, is included here [17]. Another picture in which two figures are locked in a single action, usually known as *Fragment for a Crucifixion,* 1950 [8], is more in the nature of a Descent from the Cross. It pointed the way to the triptych *Three Studies for a Crucifixion,* which appeared in the Tate Exhibition in 1962 and in the following year at the Solomon R. Guggenheim Museum in New York where it remained. Although there is little sign of accepted iconography, the four figures in these three canvases are jointly concerned in a single episode which at least relates to the theme of crucifixion in exemplifying the violence that men do to each other. A body lying head downward against an upright plane has indeed a suggestion of a crucifixion by Cimabue, which Bacon has said that he thinks of as "a worm crawling . . . just moving, undulating down the cross" (fig. 6).[16] From this point on in Bacon's work figures are more often concerned together in a single episode or in an identifiable setting, a landscape or a townscape or a

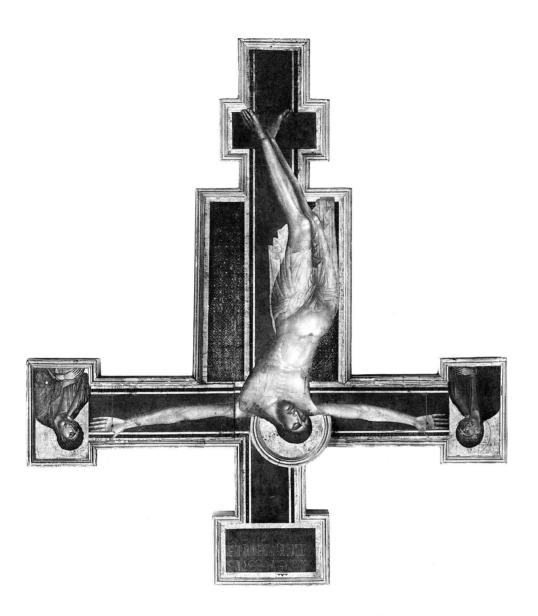

fig. 6. Giovanni Cimabue
(Italian, c. 1240-1302?).
Crucifixion, 1272-74 (inverted),
oil on wooden panel,
176⅜ × 153½ in. (448 × 389.9 cm).
Chiesa di Santa Croce, Florence.

habitable interior. The subjects are more often actions, whose purpose we may or may not be allowed to construe.

Pictures like this extended Bacon's art and his reading of human drama into a region of instinct and unknowing, nervous awareness, a region seemingly unknown and unknowable, which was quite new to modern figurative art.

The principle had been rooted in his work from the beginning. There is a well-known account of how he conceived *Painting,* 1946 [3], as a picture of a bird alighting in a field when "suddenly the lines that I'd drawn suggested something totally different, and out of this suggestion arose this picture," with its likeness to a ritual butcher's shop. Did the flapping bird suggest the umbrella? No, it was rather that the shape suggested "an opening-up into another area of feeling altogether"[17] (in the way, one imagines, that wings unfold, and likewise umbrellas). It opened up, in the way free association opens up, into continually enlarging perspectives. The subject was a metaphor for the unfolding procedure, a metaphor figuratively powerful enough to change the figurative intention.

That, it seems, is how painting has always unfolded its compelling possibilities to Bacon. Nothing is more informative than his description of how he painted a portrait in 1962: "I don't know how the form can be made. For instance, the other day I painted a head of somebody, and what made the sockets of the eyes, the nose, the mouth were, when you analyzed them, just forms which had nothing to do with eyes, nose or mouth; but the paint moving from one contour into another made a likeness of this person I was trying to paint. . . . The next day I tried to take it further . . . and I lost the image completely. Because this image is a kind of tightrope walk between what is called figurative painting and abstraction."[18]

"In despair . . . I used a very big brush and a great deal of paint and I put it on very, very freely, and I simply didn't know in the end what I was doing, and suddenly this thing clicked, and became exactly like this image I was trying to record. But not out of any conscious will. . . . This . . . way of painting is more poignant than illustration" (as Bacon calls naturalistic description). "I suppose because it has a life completely of its own. . . . Like the image one's trying to trap. . . . So that the artist may be able to . . . unlock the valves of feeling and . . . return the onlooker to life more violently."[19]

In the 1960s Bacon's new triptych format opened the gates to the irrational with a rush, and a new vein of portraiture led him to images that were at once specifically observed and wide-ranging in fantastically free associations. At the time of the Rawsthorne portraits and the extraordinary *Portrait of George Dyer Riding a Bicycle,* 1966 [28], Bacon said: "What I want . . . is to distort the thing far beyond the appearance, but in the distortion to bring it back to a recording of the appearance."[20] Another time Bacon was discussing a self-portrait in Aix-en-Provence which may or may not be the work of Rembrandt: "If you analyze it, you will see that there are hardly any sockets to the eyes, that it is almost completely anti-illustrational. I think that the mystery of fact is conveyed by an image being made out of non-rational marks. And you can't will this non-rationality of a mark. That is the reason that accident always has to enter into this activity, because the moment you know what to do, you're making just another form of illustration."[21] Then in 1971: "What so-called chance gives you is quite different from what willed application of paint gives you. It has an inevitability very often which the willed putting-on of paint doesn't give you."[22]

The portraits of the 1960s were basically controlled and purposeful, as the popes and the Blakes, for example, had been. The robust form-making touch, which produced powerful and predictable limbs, was only displaced, repeated, and superimposed where the emotional focus requires fantastic reinforcement. In the masterpiece of these pictures—a particular favorite of the painter—*Portrait of Isabel Rawsthorne Standing in a Street in Soho,* 1967 [31], the streams of white attack, it seems, her wallet and her shopping bag, while more white paint is spread by her feet, as if the homely occupations on which Mrs. Rawsthorne was setting out had to be interrupted. The splendid femme fatale in her lustrous black dress was thus immobilized in the Soho street.

The white paint seems always to be flung from the right in an impulsive forehand sweep. Bacon has told Sylvester how it is done. "I do . . . work very much more by chance now than I did when I was young. For instance, I throw an awful lot of paint onto things, and I don't know what's going to happen to it." "Do you throw it with a brush?" "No, I throw it with my hand. I just squeeze it into my hand and throw it on." "When you throw paint, the image has reached a certain state and you want to push it further?" "Yes, and I can't by my will push it further. I can only hope that the throwing of paint onto the already-made . . . or half-made image will either re-form the image or that I will be able to manipulate this paint further into—anyway, for me—a greater intensity."[23]

What this portrays with indisputable vividness is the arbitrariness of the impulse. When we know that it is a handful of paint straight from the tube flung at the canvas, we may admire the confidence of the performance, its scorn for the illusion that it jettisons. So it communicates defiant disregard, and in place of the figurative logic we must attend to the painter's instinct. Not all the pictures get paint flung at them. The small portraits that Bacon paints on canvases thirty-five by thirty centimeters never do, and we do not miss it. The little heads show a more tender regard for the consistency of life. But everything is on probation. If any picture shows signs of becoming trivially illustrative, the paint will fly.

Although the flinging of paint interrupts the servile illusion, it sets up an illusory zone of its own. On top of the paint, self-criticism leaves its shining track like an imperious snail. What the flung stream of white portrays is an irresistible nostalgia and more, an imperative demand for the instinctive state. "The will has been subdued by the instinct." And so we come to recognize that the pristine white of this impulse is an integral part of the real image, inseparable from the emotional unity. The images come over inevitably. "They come over without the brain interfering. . . . It seems to come straight out of what we choose to call the unconscious with the foam of the unconscious locked around it—which is its freshness."[24] The poetry of Bacon's faith in the emotional life and liveliness of painting is one of the truest things in modern art.

The imaginative life of the later work has a continually deepening recourse to poetry and myth. Yet the presentations that are assembled in these canvases often owe their vividness not only to the implication of narrative but even more to the quality of the realization of a single figure.

Bacon's themes are sometimes deceptive and it may be impossible to know how much importance to attach to his titles. He could not himself decide, for instance, what to call the Sweeney triptych [33], and the title was chosen by his dealer. He had lately been reading T. S. Eliot's verse dramas and the famous three-part summary of the human situation

That's all the facts when you come to brass tacks:
Birth, and copulation, and death.[25]

is possibly evoked, respectively by the left, right, and center panels of the triptych. Bacon was reminded of Sweeney Agonistes in preceding years if only

fig. 7. Jean-Auguste-Dominique Ingres
(French, 1780-1867).
Drawing, 1862, for the right-hand figure in
The Turkish Bath, 1859-63, oil on paper,
9⅝ × 10 in. (24.5 × 25.5 cm).
Musée Ingres, Montauban.

because he was, if I remember rightly, sometimes present at parties in Sussex Terrace, Regent's Park, at which Mr. Eliot was persuaded to take part in memorable readings of the plays. The center panel, with its sense of lonely fatality, was left deliberately unpeopled while that on the right, one of the images derived from Muybridge's wrestlers, offered Bacon's customary formulation for sexual passion.

The *Triptych Inspired by the Oresteia of Aeschylus,* 1981 [49], concerns a poet who has been of continuous importance to Bacon. Passages in the plays have suggested mysterious symbolic inventions to him and these panels are taken from three of them. On the left the pursuit of Orestes reaches its climax: Bacon prefers the translation by Stanford which is evoked in the dreadful trail across the space, "The reek of human blood smiles out at me."[26]

Bacon remains engrossed in the human concern with which his work as a painter began. As large a part as ever of his meaning arises from the character that representation takes on in his hands. Portrayal has been found to be enriched not only by the incongruity and randomness that minister to it. For a time chance was cultivated in the use of paint, in the expectation that the accidents of how the paint fell would separate the picture from deliberation and will. Only very recently a noble calm has supervened, so that handfuls of paint have ceased to be flung at a venture. Classic lucidity has enabled the painter to fantasize metamorphoses of the female nudes in *The Turkish Bath,* 1859–63 (fig. 7), of Ingres so that a whole world of linear harmony and smoothly modeled roundness suddenly opens to him [53]. It was in this context that he was able to return to the metamorphic fantasy of the *Studies for Figures at the Base of a Crucifixion* and close the open circle of his work. No one could have foreseen that he would make his way back to the reassured lucidity attained by the portrait triptychs of later years, which some of us find among the most convincing things in his work.

The presentation of Bacon's world becomes in the later pictures simple and self-evident. If we can free ourselves from the notion that his work is always in some way sensational we shall see that the sensation in these pictures is only the invariable force with which the presence of life is felt and communicated in original painting. The animal presence of a woman in a Soho street [31] is certainly felt and realized with a kind of violence; to those who never feel life thus the presentation may remain mysterious, but some may recognize in Bacon's picture only what is savagely compelling in the nervous reaction to the human being. The realization in paint, and its momentum, are for me irrefutable and irresistible. One notices how precisely the pictorial stage is set, with the formality of an altarpiece, concentrating both the presence of the woman and the impression of a place, a corner where the blinds of Soho flap against the dazzling sunlight and people in the street disclose their sensual voracity.

The little portraits of recent years, shown singly or two or three together, are the most legible and controlled of Bacon's pictures [46, 52]. It is not entirely a joke when he complains that his output of self-portraits must increase because his friends persist in dying and leaving him with no model but himself. These

pictures reveal the way in which his model, whether the link with him or her is a photograph, a memory, or an affection, must be imaginatively present, a part of the painter's life, unless he is to feel bereft, solitary, and impoverished. Getting to know his pictures and their models, one becomes aware that the talent for friendship is very close to the talent that nourishes his sense of the weaving and plaiting of living shape, which makes the solidity of a head or a figure in these pictures.

Bacon's fantasy of portraiture as a kind of private injury done to its subject—a fantasy that many painters must have known—is balanced by the drive that is exactly the reverse, the intimate and equally private reconstruction of whatever rhythmic principle it is that gives the unity of life to living shape. In the deepest sense, Francis Bacon's paintings are about his knowledge that the inhabitants of his world are alive. For him the deepest senses of pictorial unity are perhaps the senses of sociability and love; to know them you must know the private damage as well. When we are able to put Bacon's whole achievement together, it will mean much to discover which of his portraits were affectionate or sociable or amorous—and which distant, reminiscent, posthumous, bereaved. Both kinds of pictures are richly represented in this exhibition. We must learn to construe their language. It is a privilege to introduce an experience of humankind that must be profoundly strange—and yet will, one cannot doubt, be deeply recognizable and enhancing to the sense by which we live. Only a part of a great and complex painter can be shown in any single exhibition. What is well shown here is the variety of Bacon's imagining. It is part and parcel of the poetic awareness of our time.

Bacon's inventiveness is never entirely within his own understanding. But he is not short of pictures. He describes how they continually drop into his mind like slides into a viewer. He explains, "I don't really think my pictures out, you know; I think of the disposition . . . and then I watch the forms form themselves."[27] He described to David Sylvester how one of his triptychs was painted while the process was still continuing. "I think that, when images drop in . . . the images themselves are suggestive of the way I can hope that chance and accident will work for me. I always think of myself not so much as a painter but as a medium for accident and chance."[28]

Bacon's modesty accompanies a realistic understanding of the nature of creativeness. "Perhaps I am unique in that way; and perhaps it's a vanity to say such a thing. But I don't think I'm gifted. I just think I'm receptive."[29]

1. Francis Bacon, statement in *The New Decade: 22 European Painters and Sculptors* (New York: Museum of Modern Art, 1955), p. 63.

2. Bacon, conversation with the author, February 28, 1989. Information not otherwise cited is drawn from such conversations since 1962.

3. Bacon's dicta, with abundant biographical information, are recorded by David Sylvester, *The Brutality of Fact: Interviews with Francis Bacon*, 3rd ed. (London and New York: Thames and Hudson, 1987); here, p. 35.

4. Ibid., p. 34.

5. "The 1930 Look in British Decoration," *Studio* 100 (London, August 1930): 140-41. See also John Rothenstein and Ronald Alley, *Francis Bacon* (London: Thames and Hudson, 1964), pp. 9, 22.

6. Sylvester, *The Brutality of Fact,* p. 8.

7. Ibid., p. 34.

8. Ibid., p. 100.

9. Ibid., pp. 24-29. Compare Richard Francis, *Francis Bacon: A Booklet* (London: Tate Gallery, 1985), p. 9.

10. Sylvester, *The Brutality of Fact,* both quotations p. 120.

11. Ibid., p. 114.

12. Ibid., p. 11.

13. Ibid., p. 116.

14. Ibid., p. 32.

15. Ibid., pp. 13, 16-17, 53-54, 80, 121, 83.

16. Ibid., p. 14.

17. Ibid., p. 11.

18. Ibid., p. 12.

19. Ibid., p. 17.

20. Ibid., p. 40.

21. Ibid., p. 58.

22. Ibid., p. 99.

23. Ibid., p. 90.

24. Ibid., both quotations p. 120.

25. T. S. Eliot, "Sweeney Agonistes," in *Collected Poems 1909-1935* (London: Faber and Faber, 1936; New York: Harcourt, Brace and Company, 1936), p. 147.

26. Francis, *Francis Bacon,* p. 28.

27. Sylvester, *The Brutality of Fact,* p. 136.

28. Ibid., p. 140.

29. Ibid., p. 141.

METAPHOR AND MEANING
IN FRANCIS BACON
Sam Hunter

The paintings of Francis Bacon have been the object of a good deal of critical confusion and loose, romantic appreciation over the years. They have rarely encouraged a consensus of informed opinion or a systematic objective analysis, with the notable exception of the recent monograph by Hugh Davies and Sally Yard and a controversial study of Bacon's iconography by the art historian of Surrealism Dawn Ades (whose conclusions, however, the artist disavowed).[1] Bacon cannot be readily categorized as an artist who fits neatly the traditional stylistic distinctions or matches the identities that have so often been reserved for him, among them, a hallucinatory realism and specialized aspects of Surrealism and Expressionism. He has been perceived, at least by the casual public, as a sensational trafficker in obscenely horrific imagery of the mutilated human form, which in turn generates an association with some of the more distressing historical episodes of the twentieth century and with the plight of the individual today who has, at least in contemporary literature, experienced life as basically "absurd."

To the further dismay of his less-knowing viewers, his visual assaults on taboo subject matter and conventional taste have, if anything, been made even less palatable by his wild, baroque extravagance of style and the transparent emulation of the Old Masters in their painterly technique and even their formal presentation. Ironically, his insistent glazing and use of resplendent traditional picture frames helped intensify some of his most horrifying subject matter and chimerical effects. Bacon feels that by segregating his sinister and inciting imagery behind a glass barrier, the effect of surface unity can be enhanced without compelling him to reduce either the visual candor of his representation or the abruptness of its oppositions.

What has become increasingly clear with the test of time, as Bacon enters his eighties, is the clarity, durability, and powerful authority of his visual discourse. The issues at the center of his highly individualistic art necessarily involve an amalgam of widely diverse topics, contemporary and historical, drawing on a variety of formal explorations and visual sources—from photography and popular culture to the didactic uses of the past, from a deliberate iconography of tragic implication to a furtively impressionistic, ahistorical pictorial method based on impulse and chance. All his strategies are enriched by the conscious play of psychological and philosophical metaphors touching on some of the most fertile paradoxes of modern thought.

The early interpreters of Francis Bacon's work emphasized its potent, original imagery and violent content at a time when a new humanist figuration, with

distinct overtones of existential angst, had begun to appear in postwar art.[2] Other notable instances of a palpable shift in the zeitgeist were the poignant, phantasmal sculptures of Alberto Giacometti, the masterfully structured but erotically charged figure compositions of Balthus, and the powerful *art brut* images of Jean Dubuffet. As European artists assimilated the wartime experience, they conceived a new interest in the human image, reflecting an awareness, as never before, of man's condition of loneliness and his will to endure. Thus, they mediated the dominant Expressionist abstraction of an earlier period with a challenging new kind of tortured humanistic imagery.

Bacon dealt with an articulate existential dread and a profound sense of exasperation in the temper of the times by pushing his personal vision even further than the macabre clowning of Dubuffet and psychic distress of Giacometti. His preoccupation with terror was both instinctively theatrical and deeply disturbing in its psychological impact. Often it seemed siphoned directly from the most memorable and catastrophic media events, as he incorporated in his art grim reminders of the Holocaust and its death camps, whose visual evidence surfaced only after World War II. With his sense of Surrealist menace and images blurred as if in motion, Bacon stated the case for postwar European despair with a vehemence and an originality that earned him a special place among contemporary Cassandras.

Photographs from the late forties show Bacon's first Kensington studio cluttered with an accumulation of photographic reproductions (fig. 1) that had caught his eye and that weighted his allusive art with a special quality of social gravity.[3] His sources were the daily newspapers, magazines, and such crime sheets as *News of the Week* in London and *Crapouillot* in Paris, all of which readily provided for his practiced eye a fertile image bank of the most notorious happenings and unsavory personalities of the period. The operative principle governing his reinvention of a compelling visual drama, drawing on this inventory of shameful events, was its mysterious topical concurrence with unseen psychological forces within himself. Violence, and its affront to personal stability or even sanity, was the common denominator of photographs showing war atrocities, Joseph Goebbels waggling a finger on a public platform, the bloody streets of Moscow during the October Revolution, the human carnage of a highway accident, fantastic scientific contraptions culled from the pages of *Popular Mechanics,* or a rhinoceros crashing through a jungle swamp.

The artistic issue of this raw photographic data proved unpredictable and without a direct precedent in past art despite Bacon's admitted affinities with the Surrealists. Once a new pictorial composite was creatively synthesized on the picture plane, its real-life reference almost disappeared, but not entirely. Emotive antecedents continued to resonate in the paint as the unlaid ghosts of visual fact, no matter how distanced the final pictorial formulation might be. Somewhere between the simple cold mechanics of the camera and the most charged and tragic moments of recent European history, Bacon created a moving and

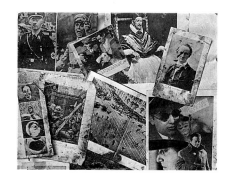

fig. 1. Newspaper and magazine clippings from Bacon's first Kensington studio.

crepuscular world of the imagination, reviving and transcending associations of violence and terror to arrive at his own unique kind of catharsis.

Bacon's introduction to an American public came shortly after the war, in 1948, when Alfred Barr acquired *Painting, 1946* [3], for the Museum of Modern Art. It is a faceless and brutal image of a dictator-like figure, part man, part ape, standing between two suspended carcasses of beef that suggest a slaughterhouse and perhaps, too, the influence of the shockingly cruel Surrealist film, *Un Chien Andalou,* 1928, by Salvador Dali and Luis Buñuel. The monstrous humanoid creature at center stage in the painting is shielded by an emblematic umbrella, strangely reminiscent of Neville Chamberlain, the deluded British prime minister who tried futilely to conciliate Adolf Hitler on the eve of World War II. His visage dissolves into a lewd, simian grimace and gaping wound while the platform fuses into some sort of barred contraption, suggesting both a cage and medieval rack, that seems to have a machine gun mounted on it. A conventional heroic representation of a public figure disintegrates before our eyes, first in an unwholesome, poisonous, "real" atmosphere and then internally in psychological space.

Bacon disdains the kind of methodical literary or conceptual interpretation that places reductive limits on his meaning. When the art critic Sir John Rothenstein speculated that the imagery of *Painting* could be read as a dualism of spirit and carnality, Bacon was quick to turn aside the suggestion. Surprisingly, he focused on the painting's far-fetched and unrelated beginnings, noting that he originally had in mind the representation of a bird of prey alighting on a plowed field. The carcasses were inspired by his childhood fascination with butcher shops. The distance he traveled from his original intention, Rothenstein noted, was the result of a deliberately controlled reverie and process of automatism, which invited free association and an unusual psychological entry into subject matter. He became, in Rothenstein's apt formulation, "a sort of figurative action-painter working under the spell of the subconscious."[4]

Conditioned by both the horrors of World War II and vivid memories of a violent and troubled childhood in revolution-torn Ireland, Bacon presents a complex web of intriguing contradictions as a man and artist. A late starter, he claims he had "no upbringing at all . . . I used simply to work at my father's racing stable near Dublin."[5] His father bred and trained horses, and the family frequently moved, making Bacon's schooling erratic. He has said, "I read almost nothing as a child—as for pictures, I was hardly aware that they existed."[6] He left home at an early age to try his luck in London and then traveled on the Continent, testing the sensual freedom of Berlin but finally preferring the artistic liberation of Paris. Without formal art training, he began painting on his own in the 1920s after seeing a Picasso exhibition but did not attract much notice or support. Then he turned to a related discipline in the applied arts, working in a mixture of Constructivist and Art Deco styles and briefly eliciting interest as a furniture designer and interior decorator. His tubular Bauhaus furniture has persisted in his painting, in a transformed state, as the geometric space-frames in

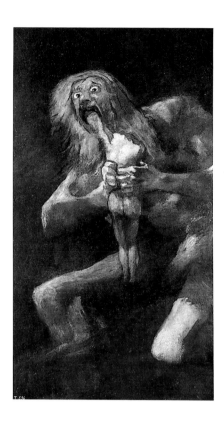

fig. 2. Francisco José de Goya y Lucientes (Spanish, 1746–1828).
Saturn Devouring His Children, 1820–22, fresco (transferred to canvas),
57⅞ x 32⅝ in. (147 x 83 cm).
Museo del Prado, Madrid.

the background. They are part of a complex system of formal mechanics, bridging abstraction and representation, that distill and fix his powerful imagery permanently in memory.

Although he resumed painting in a desultory fashion in the late thirties and early forties, Bacon achieved public recognition only in the late forties and early fifties with his obsessive grimacing and screaming popes [9, 13] and related work of a similar visionary force. One does not soon forget these sensational images of hysteria and nightmare in paint, which spoke so eloquently to our postwar distress. The celebrated series shockingly paraphrased and reversed Velásquez's sumptuous and magisterial seventeenth-century portrait of Pope Innocent X in the Doria Palace in Rome (see p. 16). Bacon's vivid invention transformed the crafty and smug prince of the church into a threatening, even depraved, modern image. Influenced by early film classics as well as tabloid journalism, in his "Pope" series Bacon incorporated photographic images of gunmen, Eadweard Muybridge's motion studies of the late 1880s, and the dying nurse—mouth agape and pince-nez shattered—from Sergei Eisenstein's film *Battleship Potemkin,* 1925 (see p. 12). There were also the fragmentary intimations of classic news photographs of Hitler and his barbarian lieutenants, all conspiring to create a half-real, half-fantastic world of powerful psychological immediacy, a public chamber of horrors and private nightmare.

These and other idiosyncratic images of the forties and fifties bear witness to the trauma of World War II and the cold war aftermath, but they also signify more broadly man's innate capacity for violence. They can also be understood as the modern Freudian equivalent of Goya's savage visual commentaries of man's infinite capacity for irrational cruelty in *The Disasters of War,* 1810–14. For Bacon, however, pain and suffering are neither exceptional and intermittent nor limited to the ravages of war. Pain is continuous and irremediable, inseparable from individual consciousness. The only joy for the artist, he once observed, comes in the manipulation of paint, through the act of painting. Bacon's first sympathetic English critic, Robert Melville, complimented the artist on his power and freedom of execution but noted that Bacon's bravura pictorial effects occurred in the atmosphere of a concentration camp. His howling prelates and intertwined sadomasochistic couples, set within veiled dream spaces and defined by transparent perspective boxes or a proscenium space, seemed to have anticipated the obscene image of Adolf Eichmann, who was protected from the rage of his victims by a bulletproof glass box during his trial for war crimes.

Bacon continued to paint individual figures after his "Pope" series in *Study for a Portrait,* 1953 [14], and the "Man in Blue" series, 1954. The ceremonial setting and appurtenances have been modified to accommodate a more anonymous, modern-day theme of life in hotel bedrooms. These are rare instances of work painted directly from real-life models, rather than from photographs or memory. They contain the ambiguity found in so much of Bacon's painting by presenting the human figure as both victim and ruthless interrogator. It was a period when Senator Joseph McCarthy was running amock in America, humi-

liating his victims in Congressional hearings and the press. Bacon reverses the conventions of modern realism in his figure studies, however. Instead of pretending his stage is a specific and identifiable public or private place, he takes a familiar space (art critic John Russell aptly dubbed it the "universal room") and converts it into a metaphysical platform by giving actual individuals and the sensational events of their lives new form and meaning. In doing so, Bacon brings to the surface fresh levels of awareness, both mythic and psychological, that range far beyond the scope or intention of any contemporary realism. At the same time, he recalls an oppressive and claustrophobic postwar period by creating an image of hell in the form of anonymous and sordid hotel bedrooms that are reminiscent of the paralyzing, affectless settings of Jean-Paul Sartre's *No Exit,* 1942, and Samuel Beckett's *Endgame,* 1957.

Paradoxically, even at his most gruesome and disquieting, Bacon also manages to inject a sense of exuberance and catharsis into his work. In his introduction to the catalog for Bacon's retrospective exhibition in Moscow, Grey Gowrie captured exactly, it seemed, the artist's "gaiety" and grace under pressure, noting that he conveyed "the same feeling of a civilization undergoing nervous breakdown that we find in Eliot's poem *The Waste Land* ('These fragments I have shored against my ruin') although the prevailing mood is of relish rather than disgust."[7] Bacon has admitted, however, that one of his goals is to meet the challenge of a violent age by reviving in a meaningful modern form the primal human cry and to restore to the community a sense of purgation and emotional release associated with the tragic ritual drama of Aeschylus and Shakespeare.[8] Bacon has the faculty of a particular genre of visionary artistic genius, also evident in Bosch, Goya, Picasso (figs. 2, 3), and other masters of the macabre, of clothing his most shattering and repugnant images, taken directly from the id as it often seems, in shimmering veils of seductive colored pigment. Despite the demonism of his imagery, his brushwork is closer to the French Impressionists than Northern European Expressionists.

In conversation, however, Bacon usually disavows any disposition favoring a particular subject matter or symbolism. He discusses content and form matter-of-factly, primarily in terms of sensation and technical problems. When critics wrote that his early shows exemplified the postwar mood of despair, under the influence of Surrealism and Existentialism, *Time* magazine quoted him as follows: "Horrible or not, said Bacon, his pictures were not supposed to mean a thing. '. . . Painting is the pattern of one's own nervous system being projected on canvas.'"[9] Regarding his early obsession with the human mouth and primal scream, he denies any intention of trying to terrorize or shock his viewers:

People say that these [open mouths] have all sorts of sexual implications, and I was always very obsessed by the actual appearance of the mouth and teeth, and perhaps I have lost that obsession now, but it was a very strong thing at one time. . . . I've always hoped in a sense to be able to paint the mouth like Monet painted a sunset.[10]

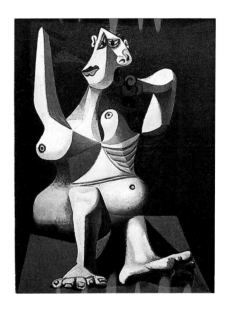

fig. 3. Pablo Picasso (Spanish, 1881–1973). *Woman Dressing Her Hair,* 1940, oil on canvas, 51¼ x 38¼ in. (130 x 97 cm). Mrs. Bertram Smith, New York.

Although Bacon steadfastly insists that he does not set out to paint scary or even enigmatic pictures, he does not deny holding a fatalistic view of existence. He considers his philosophy a demonstrable or, perhaps more accurately, an obligatory form of modern realism for the honest observer willing to examine the ways of the world. He acknowledges that his paintings are difficult and that they place serious demands on their audience because they strip away our more optimistic illusions and compel us to shed our habits of belief in the shallow euphemisms of a glittering consumer culture.

His abiding concern for the irrational is evident in his imagery of the abnormal and the impaired, underscoring a darker view of a humanity only partially evolved from an ignoble, animal condition. Thus, his studies after Muybridge, notably the *Study for Crouching Nude,* 1952 [10], and the more explicit and fully realized *Paralytic Child Walking on All Fours (from Muybridge),* 1961 [23], are examples of the artist's talent for reducing man to an ignominious animal state suggesting an evolutionary regression. Dawn Ades and the critic Gilles Deleuze have described these transformations as a form of truth-telling about the human condition and even suggested that they show a special sensitivity to animal life by elevating the beast rather than "lowering" man to the level of the beast.[11] A perhaps more persuasive and reasonable interpretation is suggested by the psychologist Bruno Bettelheim in a fascinating discussion of partially animalized children. He describes the malformed or half-animal, half-human creatures of folk myth as fantasy projections of parental rage or discord, a condition that is usually corrected in the benevolent, stereotypical fairy tale resolution with the restoration of positive feeling for the child on the part of the parents. "In fairy tales and dreams," he writes, "physical malformation often stands for psychological misdevelopment."[12]

Bacon's pessimistic philosophy also makes connection with the gallows humor, the *humour noir,* of so much modern literature bred in the emotional climate of World War II, among which he particularly admires the prose of Samuel Beckett and Harold Pinter. Like these severe but tonic writers, Bacon feels his art represents the simple unalloyed truth of existence as he perceives it, no matter how hard to bear that reality may be. For him, the philosophical Existentialists and their literary followers set the tone with their perception that the basic problems of existence were loneliness, the impenetrable mystery of the universe, and death. Basically, Bacon believes in a form of the philosopher Friedrich Nietzsche's nihilism and certainly, too, in the aspect of the Greek ideal that Nietzsche so enthusiastically endorsed, the Dionysian conquest of pessimism through art.

In the sixties Bacon named one of his most harrowing triptychs [33], a three-panel excursion into a phantasmagoria of bloody murder and mayhem that was based on an actual crime of sensational character, after Eliot's poem "Sweeney Agonistes," 1932. The poem contains the daunting refrain: "that's all the facts when you come to brass tacks:/Birth, and copulation, and death."[13] The Eliot reference recalls a similar sentiment of disenchantment regarding the futility of

existence expressed by Nietzsche in a dialogue in *The Birth of Tragedy*, 1872. When Midas asked Silenus what fate is best for man, Silenus answered: "Pitiful race of a day, children of accidents and sorrow, why do you force me to say what were better left unheard? The best of all is unobtainable—not to be born, to be nothing. The second best is to die early."[14]

Another leitmotif in Bacon's painting besides the vanity of existence was stated as early as 1944 in *Three Studies for Figures at the Base of a Crucifixion* (fig. 4), and it has been reaffirmed in some of his masterful triptychs of the eighties: the Greek theme of nemesis. More explicitly, his imagery involves the myth of the pursuit of Oedipus and Orestes by the Furies for their different heinous crimes of patricide, incest, and matricide. To frame the two myths in updated Freudian terms, Bacon evokes the anguish of primal guilt. His private artistic demons are the self-conscious modern version of the Greek Fates and Furies. "We are always hounding ourselves," he has said. "We've been made aware of this side of ourselves by Freud, whether or not his ideas worked therapeutically."[15] He believes that for the authentic and incorruptible artist, impervious to social hypocrisy, the only available transcendence from man's poignant and vulnerable condition is achieved through the experience of art. As Nietzsche put it with a finality that would have pleased Bacon, "It is only as an esthetic phenomenon that existence and the world appear justified."[16]

In a masterpiece of the eighties Bacon dealt with the dark events of the Oresteia myth. *Triptych Inspired by the Oresteia of Aeschylus*, 1981 [49], is one of his most condensed and austere inventions, representing the Baconian equivalent of the tragic agon in three panels of powerfully condensed, hypnotic imagery. At left, the haunting and obscene symbol of the Erinyes, the Furies that relentlessly pursued a hallucinating Orestes for the murder of his mother, Clytemnestra, dangles like an obscene bat-like creature in a cage structure. Although the action isn't specifically bound to a particular scene in the Aeschylus trilogy, the central panel suggests the contorted figure of the foully murdered Agamemnon, focusing on his spinal structure and jaw in the frontal plane, as if seen in x-ray vision. The ceremonial dais and a schematic throne can be read as the high position of the

 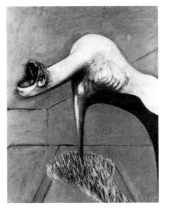

fig. 4. *Three Studies for Figures at the Base of a Crucifixion*, 1944. Oil and pastel on hardboard, three panels, each 38¼ x 29⅛ in. (97 x 74 cm). Tate Gallery, London.

king who met his death at the hands of the queen mother, out of vengeance for his own sacrificial murder of their daughter Iphigenia.

The third panel evokes both victim and oppressor and may stand for the tragic hero Orestes as well as the undefined shapes and darkness of unformed life (the élan vital or libido), lifting the chilling painting to an even higher level of allegorical meaning. This inspired paraphrase of the action and possible modern applications of Greek tragedy translates into the recognizable Surrealist forms of metamorphosis and interiorized imagery. The half-playful inventions of Surrealist fantasy achieve a deeper and more serious content, however, by tapping into ancient sources in myth, ritual, and a theatrical form that reveals its meanings more mysteriously, both in the paint action and through a dramatic theatrical setting. Bacon has told Hugh Davies, "If you talk about futility you have to be grand like Shakespeare's *Macbeth*. . . ."[17] Davies concluded that Bacon attained significant grandeur and something more in a searing but high formal art that "reinvent[s] . . . what we know of our existence . . . tearing away the veils."[18]

Despite Bacon's painfully testing imagery, his extraordinary figures and pictorial drama revive singular qualities in the art of our time, recreating modern man in the image of the formal grandeur and with the beauty of texture of the greatest Old Masters from Titian, Rembrandt, and Velásquez to Goya. Closer to our own time, works by Degas and Cézanne have also keenly engaged his interest. *Cézanne: The Early Years 1859–1872,* an exhibition of that artist's curiously obsessive early paintings on view at the Royal Academy in London in the summer of 1988, riveted Bacon. He visited the show more than once, relishing the strangely unfinished, touching images of Cézanne's family and intimate circle of friends and his violently erotic inventions, with their fresh, contemporary spirit and vital handling. The combination of evident gaucherie and expressive power within a once-derided system of figuration that is now recognized as clearly original particularly moved Bacon. Some observers discovered unexpected affinities between the two artists, finding a bridge to Bacon in Cézanne's youthful compulsions, his rawness and aggression in paint handling, and "a lurid visual imagination which can shock even in the era of new expressionism," as the art historian John House described the revelatory show.[19]

Bacon respects art historical precedent, but risk and chance remain constants in his work, much as they figured in his biography, reflected particularly in his early compulsive gambling bouts, wanderlust, and unconventional life style. His dominant artistic concern has been to capture the instant of movement and life's ephemera before they lose their immediacy. At the same time, he feels that he is engaged in a constant battle, more often lost than won, between the potential expressiveness of the raw material of oil paint on its support and his own refined intention to achieve the visual equivalent of Flaubert's exacting "le mot juste."

Nonetheless, Bacon also paints with abandon, freely using rags and his hands as well as the brush. He is not beyond combining paint with random mixtures of

the dust and crushed pastel that have accumulated on his rarely swept and untidy studio floor. He has always painted directly on canvas in a spontaneous and inspirational process of whipping and dragging pigment over the surface with brush or rags, or even flinging it onto the surface from a distance, often in a kind of ecstatic frenzy. His fierce emotional investment in his work, and the desperate all-or-nothing premium he places on expressive realization, however, give way to a secondary refining process and synthesis of formal structuring. Actually, it is inseparable in his mind from the original inspiration and helps him further clarify, focus, and build his repertory of images in their fascinating encounters and mutations.

In the late sixties especially Bacon contrived some of his most brilliant exercises in portraiture in repeated images of himself and some of his closest friends at that time [26–31, 34, 36]. They are masterful evocations of a familiar cast of characters for those who know his oeuvre, not unlike Picasso's rapidly changing guard of favored mistresses who were recognizable models for his figure compositions and portraits of the late thirties and forties. For Bacon, these identifiable and named individuals represent an important break in his art, beginning with a small painting of Lucian Freud in 1951 and proceeding through his more complex portraits of George Dyer, John Edwards, Lucian Freud, Isabel Rawsthorne, and others from his intimate circle over the next three decades.

On the one hand, this development allowed Bacon to shed what he perceived as an exhausted anonymity both in his isolated figures and allegorized representations of the antiheroic, contemporary Everyman, depicted as victim, persecutor, or mere witness to an age of violence. Instead, he created a more subtle and verifiable pictorial illusion of specific individuals from his own entourage. They seemed to afford him fresh access to equally compelling dramatic and expressive forms that could be appreciated less equivocally as a genre of modern realism. At the same time, he transcended the obvious limits of realism by endowing his still-mysterious portrait figures with something of the same ceremonial dignity and tragic resonance found in his triptychs and narrative art.

In both genres an external force, translated into alternately wounding and obliterating paint marks, seems to erode the physical substance and, by inference, the very being of his dramatis personae. The self-conscious stripping away of the social mask has been a major strategy of Bacon's truth-telling art, although sitting for one of his uncanny portraits is such an intense and unnerving experience that he no longer works directly from his models. He prefers not to alienate his old friends or concern himself with their aghast responses, lest he inhibit the violence and freedom required for realizing his pictorial vision.

"'My ideal,' Bacon told David Sylvester [collaborator in the major collection of his interviews], 'would really be just to pick up a handful of paint and throw it at the canvas and hope that the portrait was there.'"[20] His gallery of portraits also recalls some of the great visceral images of Oskar Kokoschka and Egon Schiele, those Viennese antecedents in visionary Expressionist portraiture that was also calculated to unmask and bare the soul of the artist's uneasy sitter.

Because working from the model made him uneasy but also from a fascination with the challenge of his own phenomenological persona, as it exists objectively in the world, Bacon has also focused strongly and repeatedly on the self-portrait. He has painted himself almost as often as he has his best friends. There was a certain practicality in turning to a cooperative model and also undoubted philosophical and formal rewards in keeping a visual record of the changing meanings of flesh depicted over time, with the inescapable test of resolute will and spirit implicit in that confrontation. *Study for Self-Portrait—Triptych,* 1985–86 [54], is his most ambitious recent study of this kind. The figure's hunched pose—legs crossed and arms hugging his knees—and precarious stance on a stool recall the coiled and tortured posture of his 1973 self-portrait [40] and some of the body torsions of related portraits in the sixties and seventies of Dyer, Freud, and Rawsthorne. All these awkward, gratuitously demeaning poses echo a more distant crouching, animalized nude figure of 1952—the harrowing image of an apparently headless figure perched ape-like on a curving rail [10]. The image was taken, and modified, from Muybridge's photograph, *Man Performing Standing Broad Jump.*

The extent of Bacon's irrational, but personally meaningful, translation of Muybridge's banal image has been described by Davies and Yard in a passage of rare candor. Their convincing interpretation once again underscores the deeper meanings of Bacon's metaphors and reconstructions of contemporary and historical visual sources. The "compact pose," they write, "ambiguously suggests the fetal position, the stance for defecation, and—as seen more clearly some twenty years later, in *Triptych May–June,* 1973 [41]—the position assumed in death."[21] That triptych presented with painful accuracy the physical circumstances of the suicide of Bacon's close friend George Dyer. The writers continue to explore the drama of Bacon's symbolism, providing the reader with an important bridge from the atrocious particulars of his imagery to its transcendent implications of familiar visual and moral lessons of the age:

> *Calling to mind naked men locked away in anonymous, windowless cells, this figure conveys the introspection, regression, and withdrawal associated with prison or asylum inmates, the quintessential posture of man divested of civilization.*[22]

Dignity rather than degradation is the keystone of Bacon's more recent self-portraiture. The old smears and distortions of paint still exist in the 1985–86 triptych but with less vehemence or pressure on the human image. The action takes place in a more austere but benign environment against a simplified background, in this instance, the curved areas, painted white, that contrast with the expanse of unsized canvas. Few of the distracting tics or agitation of his freakish humanoid imagery of the past persist. Bacon's new figural paradigm is drawn from Egyptian sculpture of the Ptolemaic period.[23]

In a recent and rare nonfigurative work, *Jet of Water,* 1988 [57], however, Bacon continued his dogged tracking of the ephemeral and marvelous by literally emptying a bucket of grayed white paint on the upright canvas to simulate the

violent spurt and flood of a powerful stream of murky water. Only through such play with chance, with its intense momentary truth, whether in the frozen human grimace or in a powerful water jet, can Bacon "unlock the valves of feeling and therefore return the onlooker to life more violently."[24] Spurning the illustrational side of realism, he says that the successful artist must connive to bait reality and "set a trap by which you hope to trap this living fact alive."[25]

Another recent painting, *Study for Portrait of John Edwards*, 1988 [58], is one of a continuing series with his companion John Edwards as model. It dramatically illustrates Bacon's major pictorial premises, combining allusions to the heroic male nudes of the Italian Renaissance or, in a source closer to hand, the Elgin marbles in the British Museum, with the sense of human flesh as the mortal envelope we all bear and ultimately must slip. His depicted flesh is both ghoulish and strangely beautiful, touching a nerve as it declines into ectoplasmic nullity, swallowed by a vaguely sinister panel of black. Bacon has always concentrated on the flesh—in this instance, a roseate face, powerfully muscled torso, and limbs that extend themselves mysteriously into a puddle of nondescript shadow-cum-paint.

Over the years Bacon has proved himself a voluptuary of the flesh, like Rubens, Watteau, or Soutine (fig. 5) in their distinctly different ways, and in his later years, he seems most like the aging Rembrandt. Flesh is for him the essential material of being and of things, life's basic substance. Paint becomes flesh in its color, texture, material density, and fluidity—a vehicle that serves desire and rekindles art historical and personal memory, allowing him to discover the physical and spiritual particularity of a specific person. Perhaps in this limited sense he is a realist at heart, as some of his English colleagues have averred when they recently sought to link him with a self-conscious London school that includes such devotees of figuration as Frank Auerbach, Lucian Freud, and R. B. Kitaj.[26] In *Study for Portrait of John Edwards* Bacon compresses his figure of Edwards into a kind of iridescent pigment skin where paint and depicted body gloriously fuse, pushing his warped figuration to a point near dissolution, not unlike the gorgeous sunsets of Monet that he tried to emulate in his disturbing early paintings of the papal scream.

Ever the wily magician in his manipulation of paint, Bacon has lost none of his touch or invention with the years. In his recent work he continues to bait the "trap" for capturing the distilled essence of reality, salvaging the mysterious living image of man from the ruins of time, as the great paintings of the past have done for the instruction and delectation of the privileged viewer.

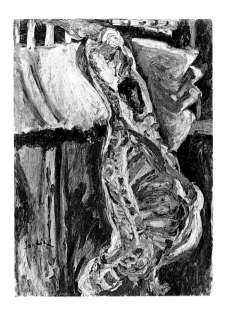

fig. 5. Chaim Soutine (French, b. Lithuania, 1894–1943).
Side of Beef, 1920, oil on canvas, 27½ x 20½ in. (70 x 52 cm).
Colin Collection, New York.

1. Hugh Davies and Sally Yard, *Francis Bacon* (New York: Abbeville, 1986); Dawn Ades, "Web of Images," in *Francis Bacon*, exhibition catalog (London: Tate Gallery and Thames and Hudson, 1985; New York: Abrams, 1985).

2. Sam Hunter, "Francis Bacon: The Anatomy of Horror," *Magazine of Art* 45 (January 1952): 11–15; Robert Melville, "Francis Bacon," *Horizon* 20 (December 1949–January 1950): 419–23; James Thrall Soby, "Mr. Francis Bacon," *Saturday Review* 36 (November 1953): 48–49.

3. Hunter, "Francis Bacon," p. 12.

4. John Rothenstein, *Francis Bacon,* exhibition catalog (London: Tate Gallery, 1962), unpaginated.

5. Davies and Yard, *Francis Bacon,* p. 11.

6. Ibid.

7. Grey Gowrie, in *Fréncis Békon zhivopis',* exhibition catalog (London: British Council and Marlborough Fine Art, 1988), p. 20.

8. Francis Bacon, interview by the author, June 22, 1988.

9. Quoted in Davies and Yard, *Francis Bacon,* p. 21.

10. David Sylvester, *The Brutality of Fact: Interviews with Francis Bacon,* 3rd ed. (London and New York: Thames and Hudson, 1987), pp. 48–50.

11. See Ades, "Web of Images," and Gilles Deleuze, *Francis Bacon: Logique de la sensation* (Paris: Editions de la Différence, 1981).

12. Bruno Bettelheim, *The Uses of Enchantment, The Meanings and Importance of Fairy Tales* (New York: Knopf, 1976; London: Thames and Hudson, 1979), p. 70.

13. T. S. Eliot, "Sweeney Agonistes," in *Collected Poems 1909–1935* (London: Faber and Faber, 1936; New York: Harcourt, Brace and Company, 1936), p. 147.

14. Friedrich Nietzsche, "The Birth of Tragedy out of the Spirit of Music," in Will Durant, *The Story of Philosophy* (New York: Simon and Schuster, 1953), p. 306.

15. Bacon, interview by Davies, September 7, 1983, in Davies and Yard, *Francis Bacon,* p. 102.

16. Nietzsche, *Birth of Tragedy,* in Durant, p. 306.

17. Bacon, interview by Davies, April 3, 1983, in Davies and Yard, *Francis Bacon,* p. 102.

18. Bacon, interview by Davies, June 26, 1973, in Davies and Yard, *Francis Bacon,* p. 102.

19. John House, "The Work of Cézanne before He Became Cézanne," *New York Times,* June 5, 1988, sec. H, pp. 37, 39.

20. Andrew Forge, "About Bacon," in *Francis Bacon,* exhibition catalog (London: Tate Gallery and Thames and Hudson, 1985; New York: Abrams, 1985), p. 30.

21. Davies and Yard, *Francis Bacon,* p. 29.

22. Ibid.

23. Bacon, interview by the author, June 22, 1988.

24. Sylvester, *The Brutality of Fact,* p. 17.

25. Ibid., p. 57.

26. Michael Peppiatt, "Could There Be a School of London?" and "Francis Bacon: Reality Conveyed by a Lie," *Art International* (Paris) 1 (Autumn 1987): 7–21 and 30–33.

CATALOG OF

THE EXHIBITION

1 FIGURE IN A LANDSCAPE, 1945
Oil on canvas; 57 x 50½ (144.8 x 128.3)
The Trustees of the Tate Gallery, London

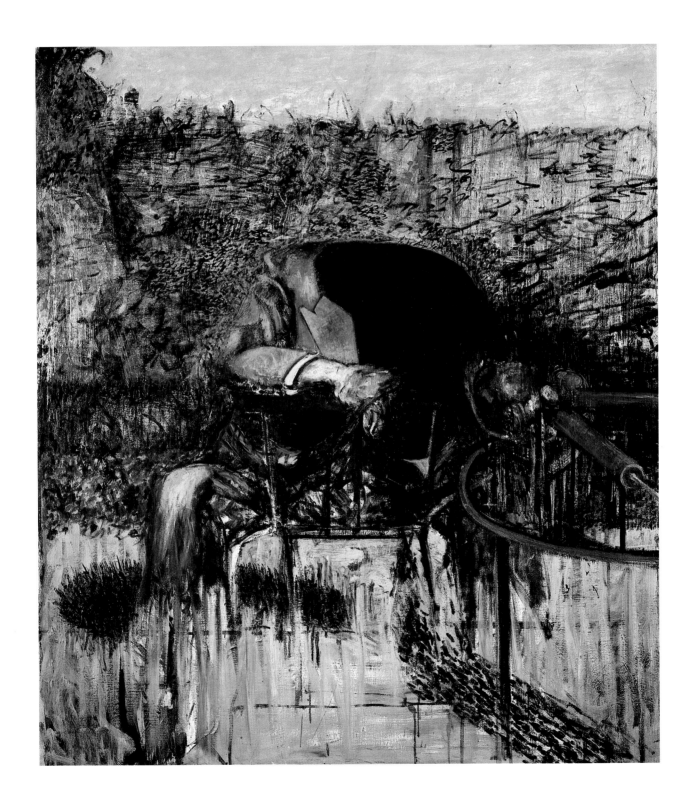

2 FIGURE STUDY II, 1945-46
Oil on canvas; 57¼ x 50¾ (145.4 x 128.9)
Kirklees Metropolitan Council, Huddersfield Art Gallery, Yorkshire, England

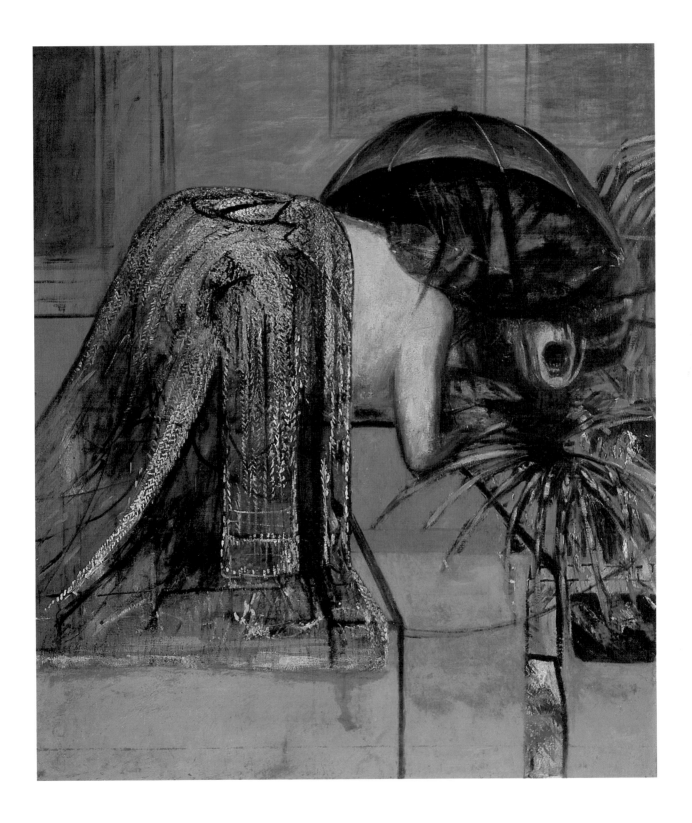

3 PAINTING, 1946
Oil on canvas; 78 x 52 (198.1 x 132.1)
The Museum of Modern Art, New York, purchase
(*shown at the Museum of Modern Art only*)

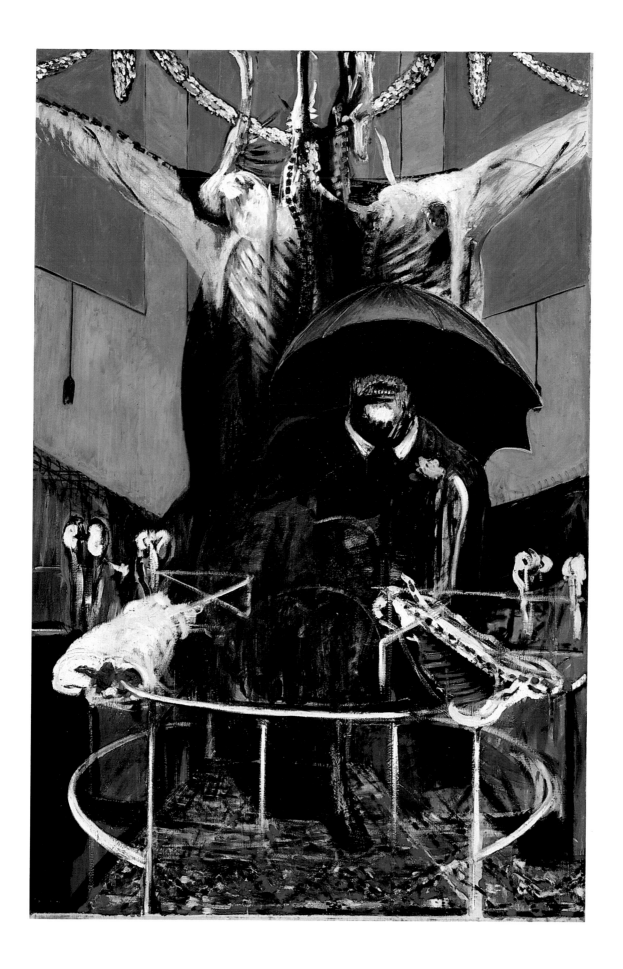

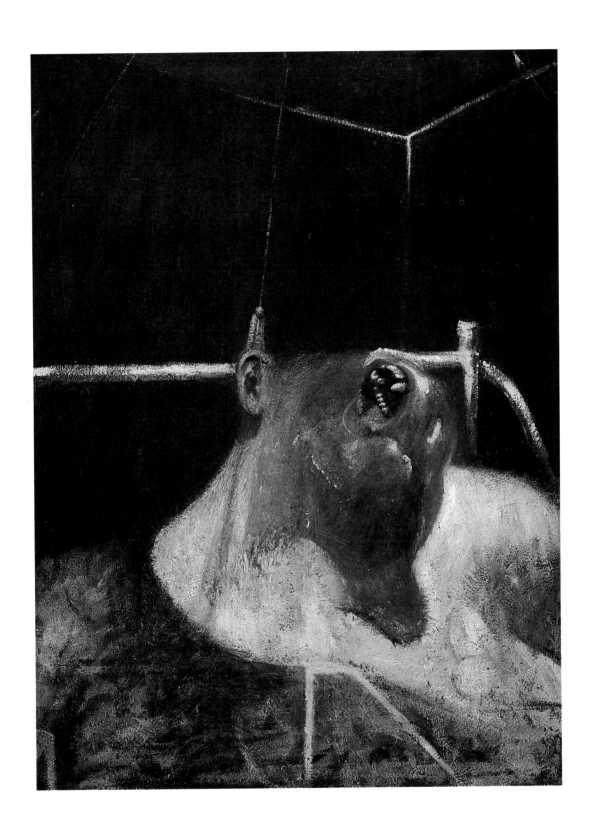

5 HEAD II, 1949
Oil on canvas; 31¾ x 25⅝ (80.6 x 65.1)
Ulster Museum, Belfast

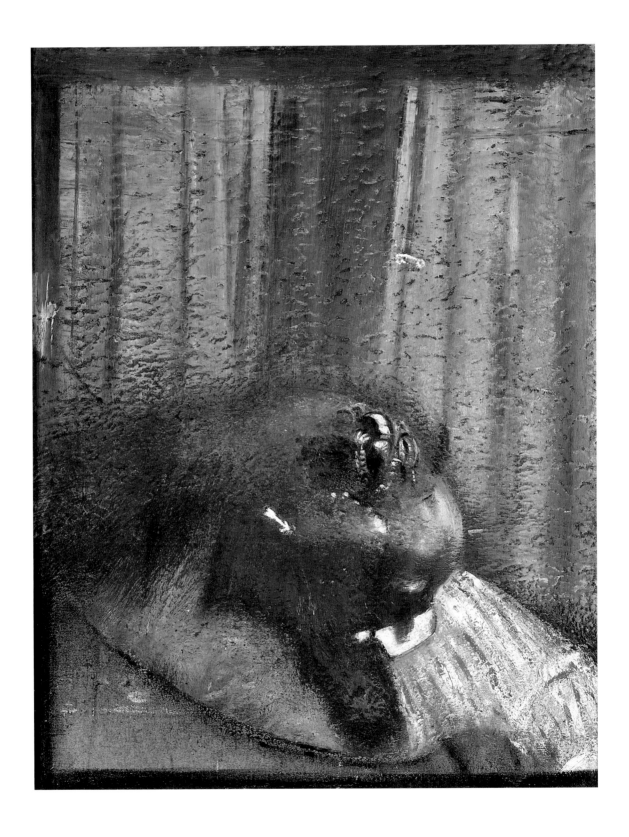

6 HEAD VI, 1949
Oil on canvas; 36⅝ x 30⅛ (93.2 x 76.5)
Arts Council of Great Britain, London

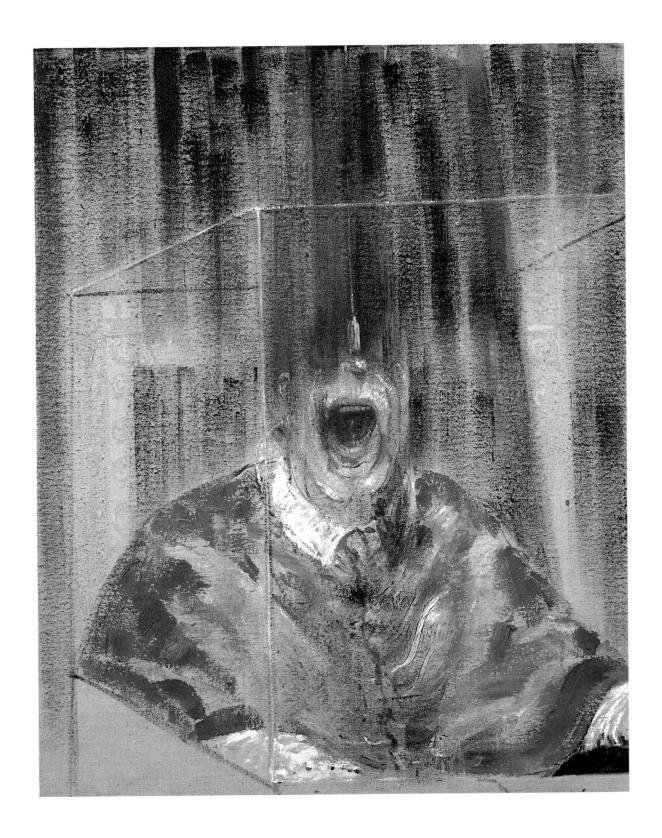

7 STUDY FOR PORTRAIT (MAN IN A BLUE BOX), 1949
Oil on canvas; 58 x 51½ (147.3 x 130.8)
Museum of Contemporary Art, Chicago, gift of Joseph and Jory Shapiro

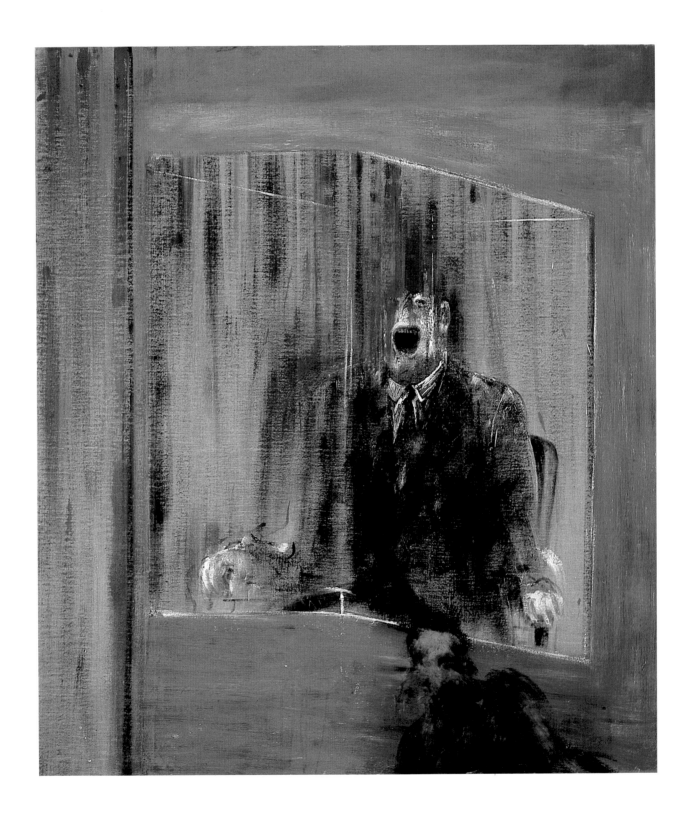

8 FRAGMENT FOR A CRUCIFIXION, 1950
Oil and cotton wool on canvas; 55 x 42¾ (139.7 x 108.6)
Stedelijk van Abbemuseum, Eindhoven, The Netherlands

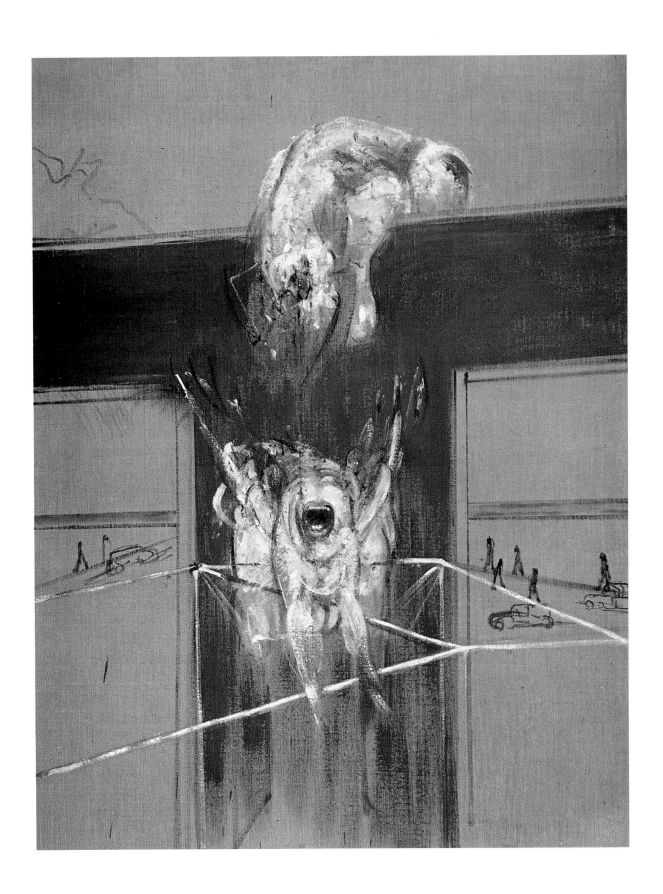

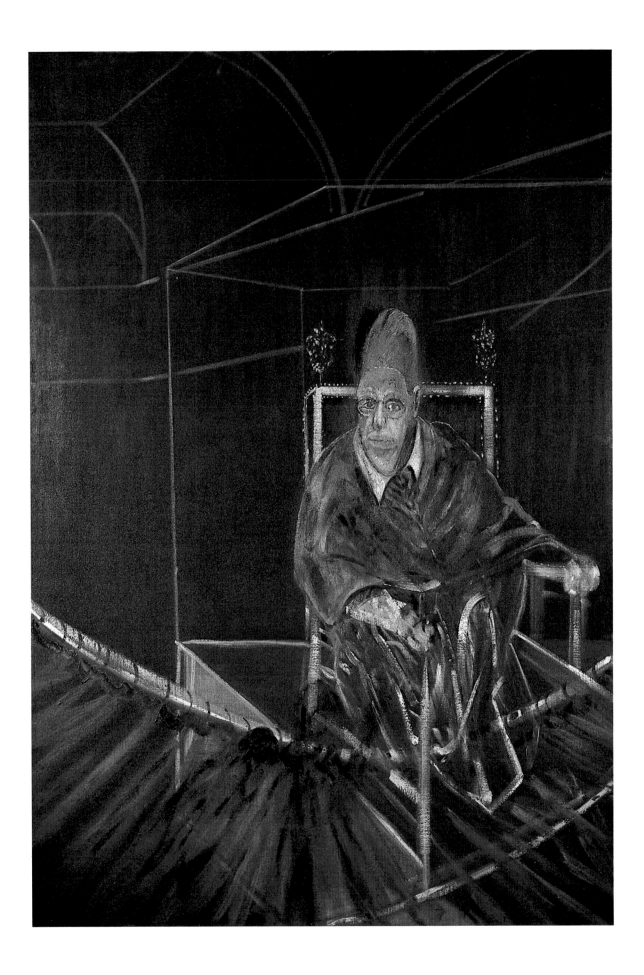

10 STUDY FOR CROUCHING NUDE, 1952
Oil and sand on canvas; 78 x 54 (198.1 x 137.2)
The Detroit Institute of Arts, gift of Dr. Wilhelm R. Valentiner

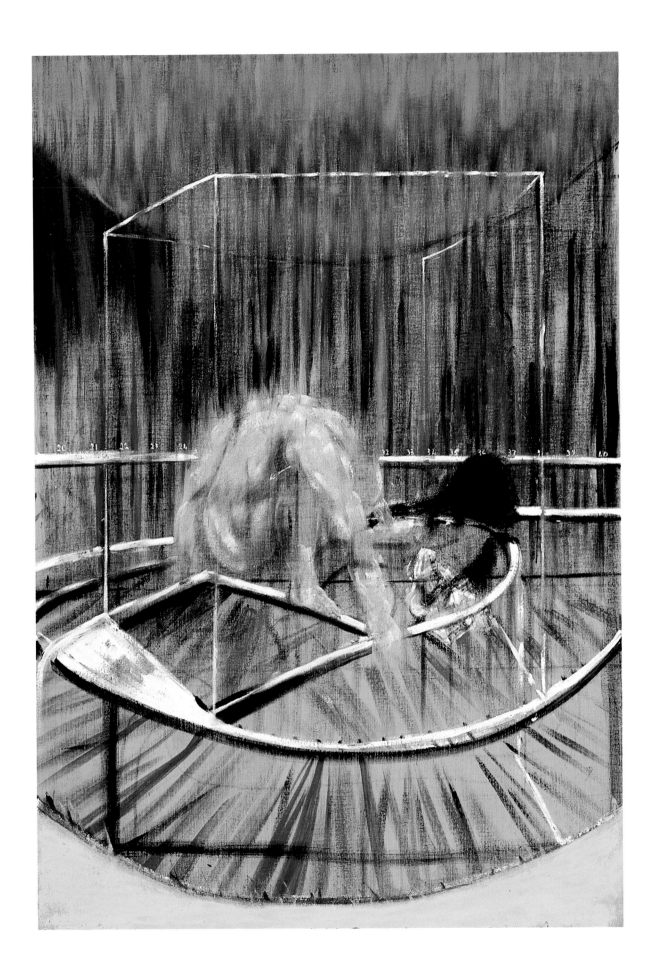

11 STUDY OF FIGURE IN A LANDSCAPE, 1952
Oil on canvas; 78 x 54¼ (198.1 x 137.8)
The Phillips Collection, Washington, D.C.

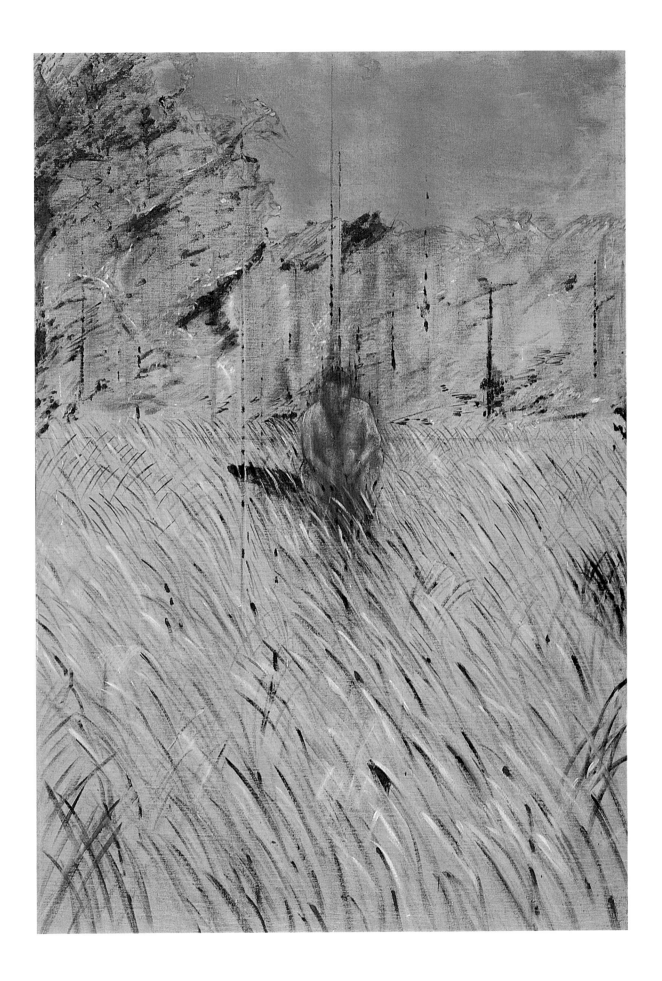

12 MAN WITH DOG, 1953
Oil on canvas; 59⅞ x 46 (152.1 x 116.8)
Albright-Knox Art Gallery, Buffalo, gift of Seymour H. Knox

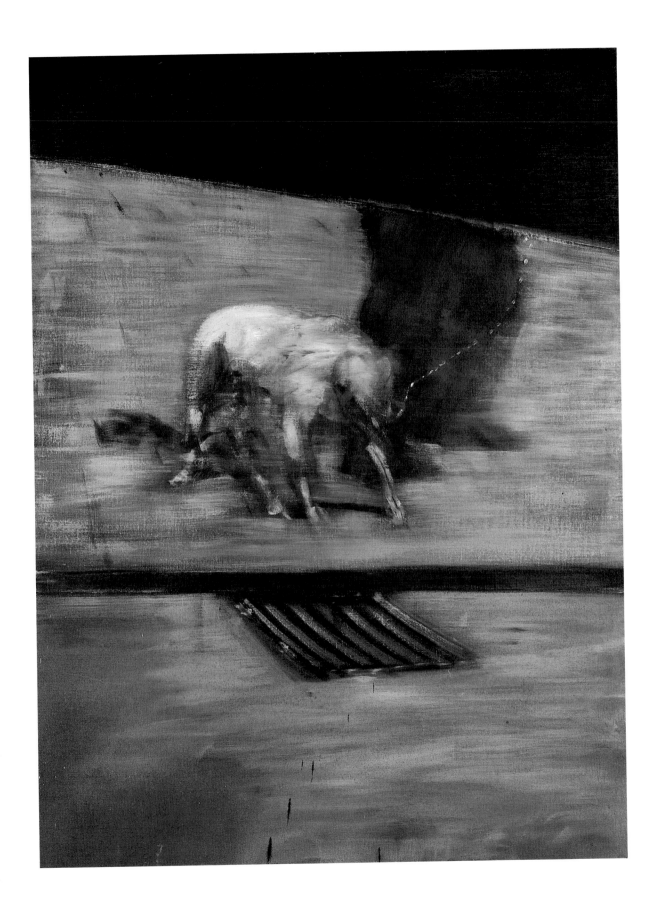

13 STUDY AFTER VELASQUEZ'S PORTRAIT OF POPE INNOCENT X, 1953
Oil on canvas; 60¼ x 46½ (153.0 x 118.1)
Des Moines Art Center, Coffin Fine Arts Trust Fund

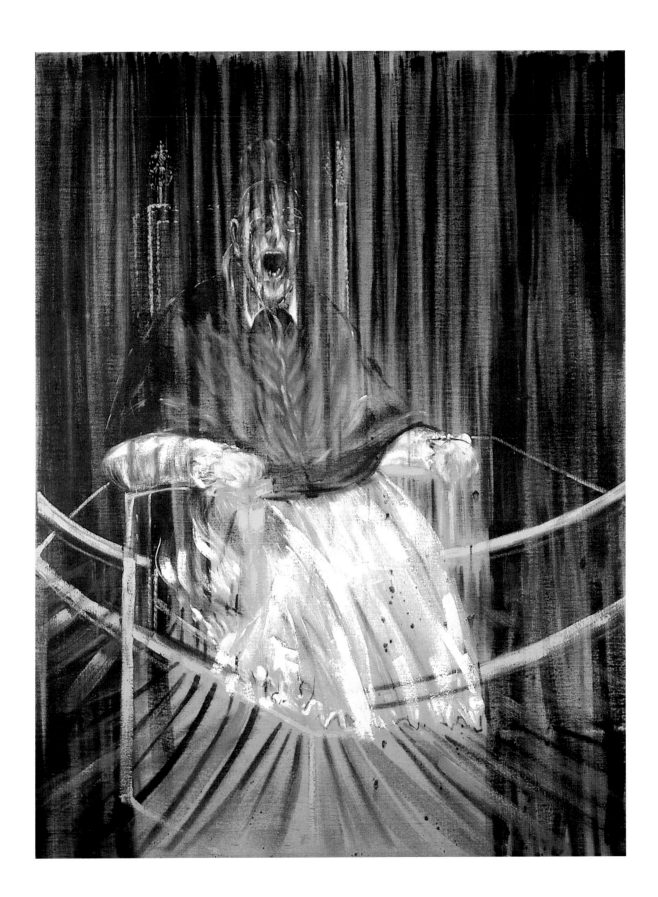

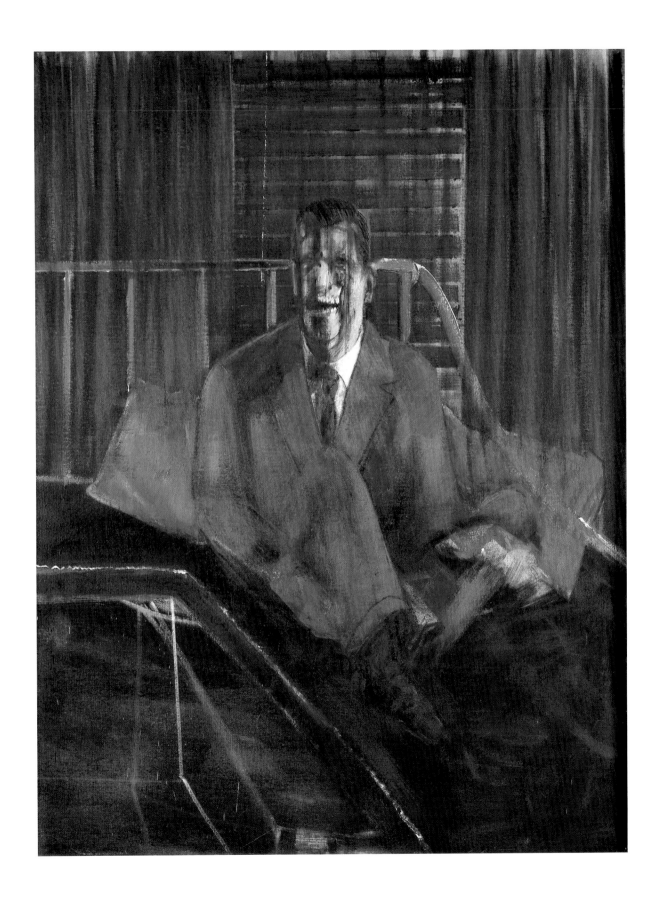

15 STUDY OF A BABOON, 1953
Oil on canvas; 78⅛ x 54⅛ (198.4 x 137.5)
The Museum of Modern Art, New York, James Thrall Soby Bequest

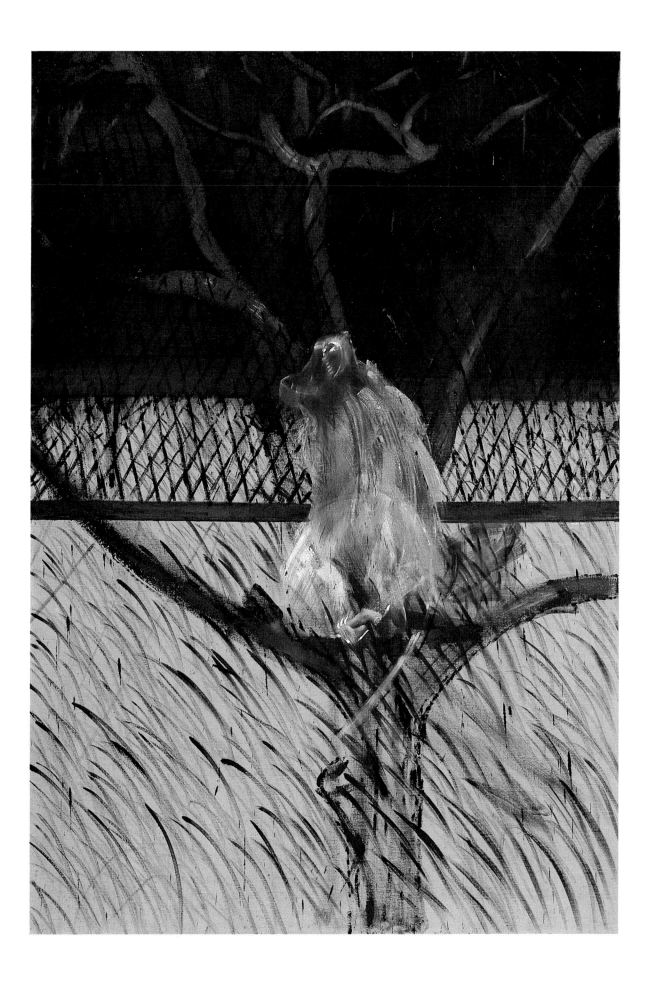

16 SPHINX II, 1953
Oil and pastel on canvas; 78¼ x 58¼ (198.8 x 147.9)
Yale University Art Gallery, New Haven,
gift of Stephen Carlton Clark, B.A. 1903, courtesy Yale Center for British Art

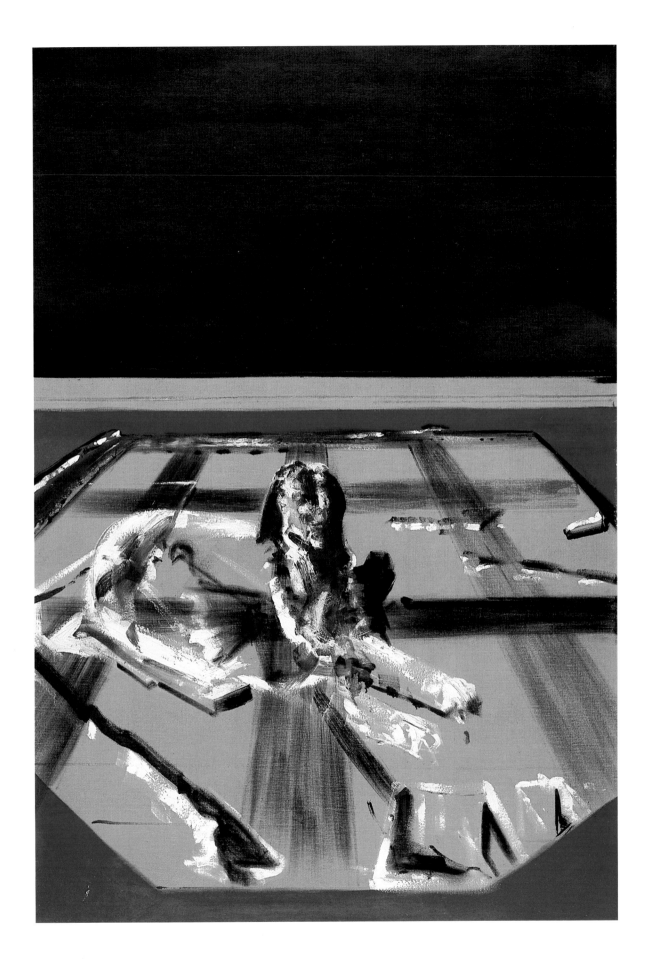

17 TWO FIGURES IN THE GRASS, 1954
Oil on canvas; 59¾ x 46⅛ (151.8 x 117.2)
Private collection

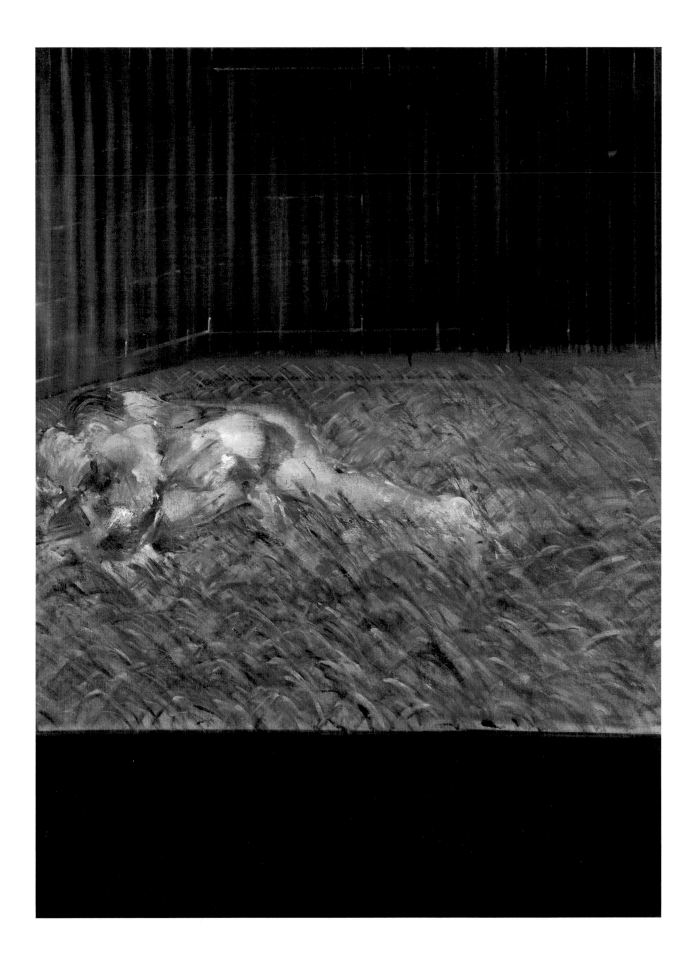

18 STUDY FOR PORTRAIT II (AFTER THE LIFE MASK OF WILLIAM BLAKE), 1955
Oil on canvas; 24 x 20 (61.0 x 50.1)
The Trustees of the Tate Gallery, London

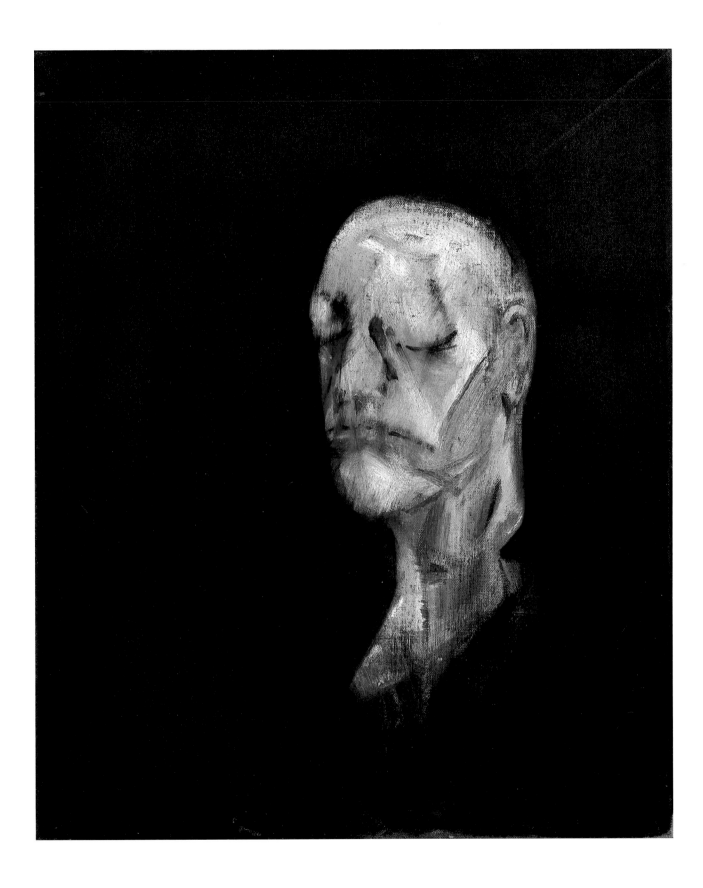

19 STUDY FOR PORTRAIT OF VAN GOGH III, 1957
Oil and sand on canvas; 78⅛ x 54⅛ (198.4 x 137.5)
Hirshhorn Museum and Sculpture Garden, Smithsonian Institution,
Washington, D.C., gift of the Joseph H. Hirshhorn Foundation

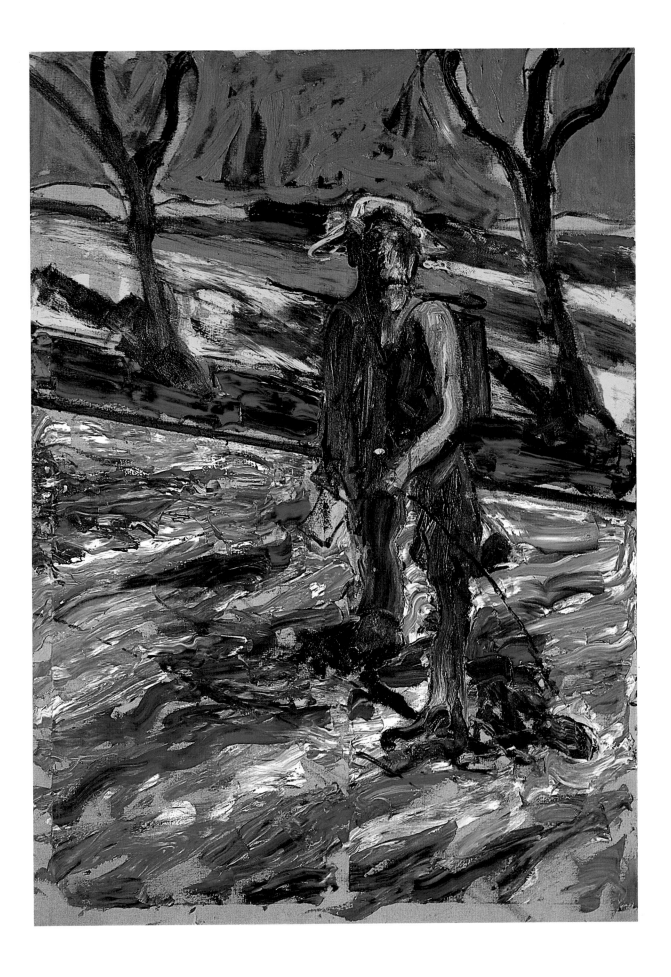

20 SELF-PORTRAIT, 1958
Oil on canvas; 59⅞ x 47 (152.1 x 119.4)
Hirshhorn Museum and Sculpture Garden, Smithsonian Institution,
Washington, D.C., gift of the Joseph H. Hirshhorn Foundation

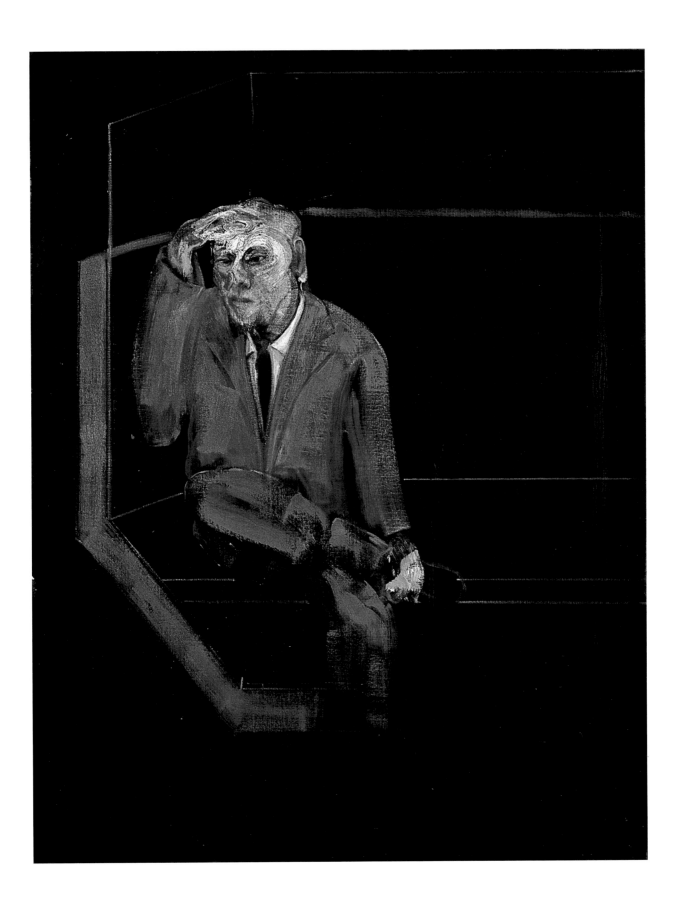

21 SLEEPING FIGURE, 1959
Oil on canvas; 47 x 60 (119.4 x 152.4)
Private collection, England

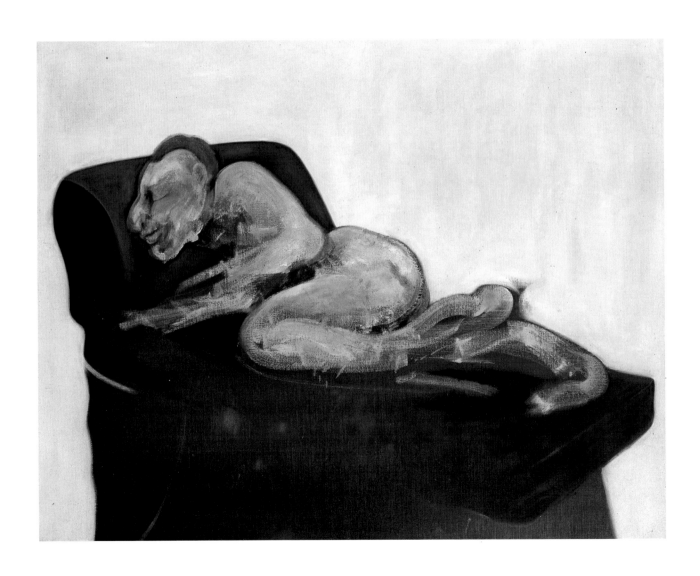

22 HEAD OF A WOMAN, 1960
Oil on canvas; 35 x 26⅞ (88.9 x 68.3)
Mrs. Lewis H. Lapham

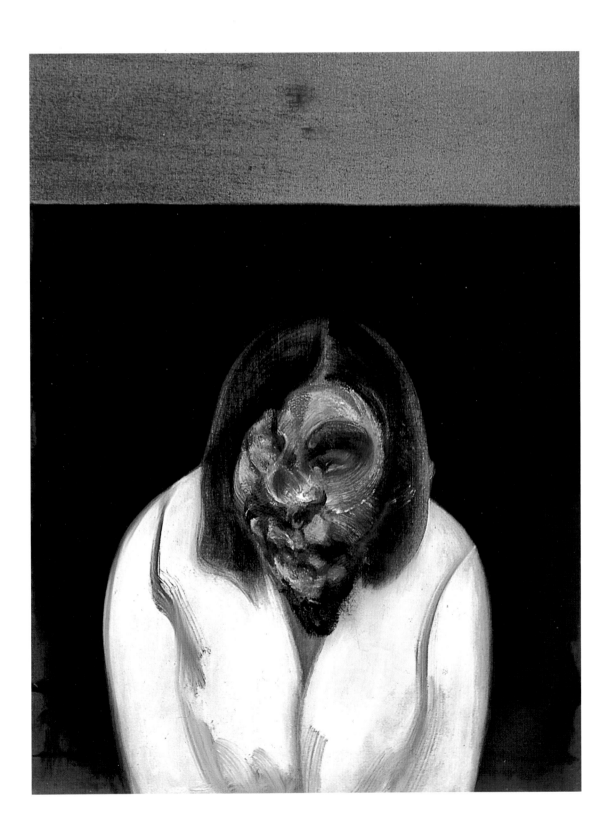

23 PARALYTIC CHILD WALKING ON ALL FOURS (FROM MUYBRIDGE), 1961
Oil on canvas; 77¾ x 55½ (197.5 x 140.9)
Haags Gemeentemuseum, The Hague

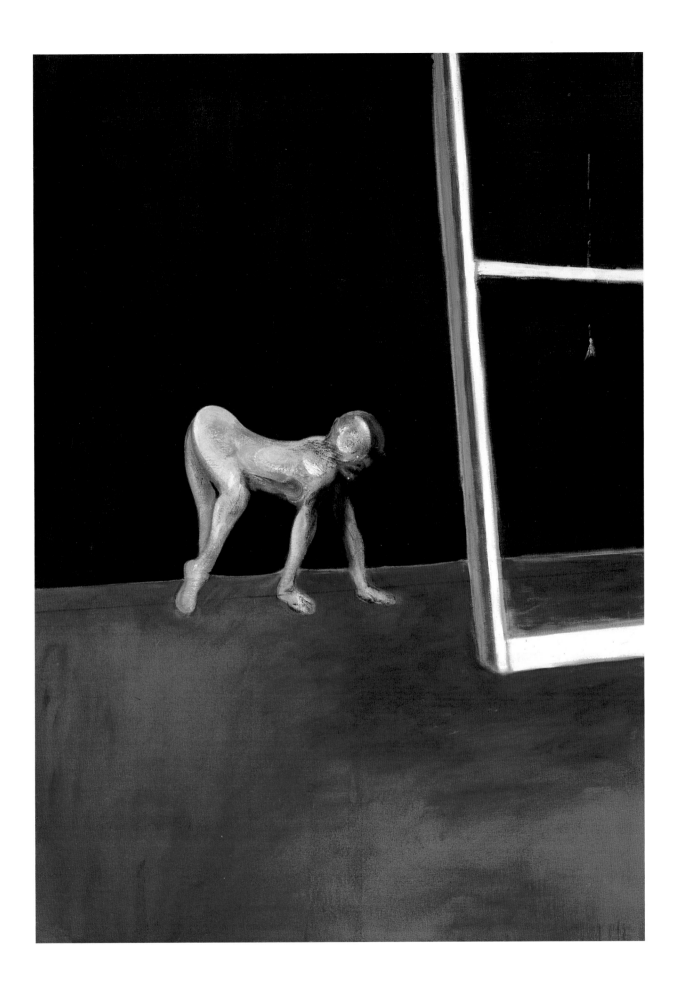

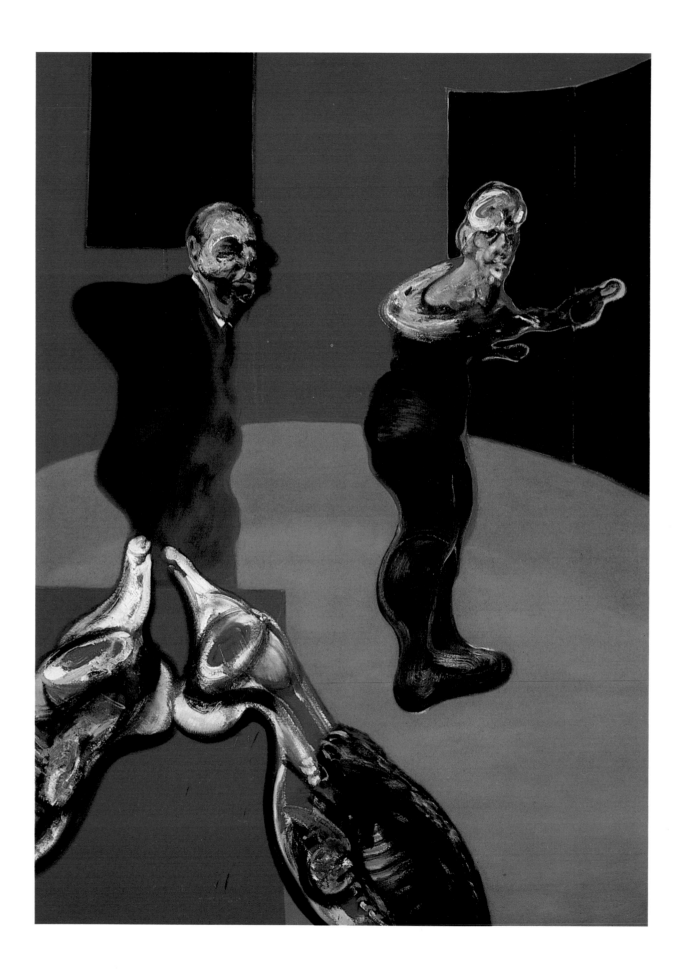

25 LANDSCAPE NEAR MALABATA, TANGIER, 1963
Oil on canvas; 78 x 57 (198.1 x 144.8)
Ivor Braka Limited, London

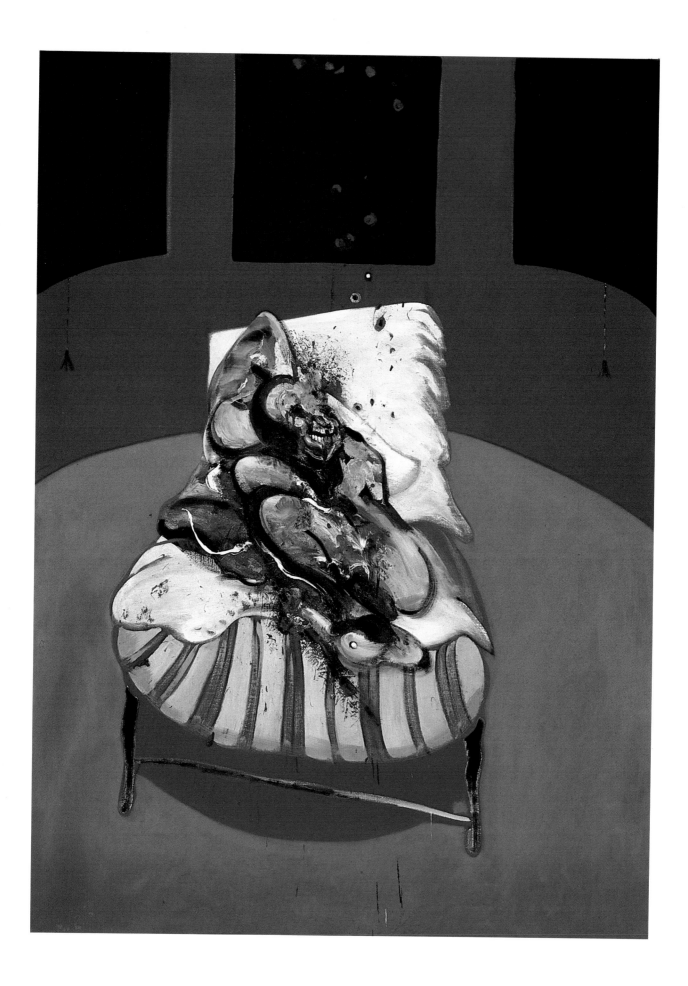

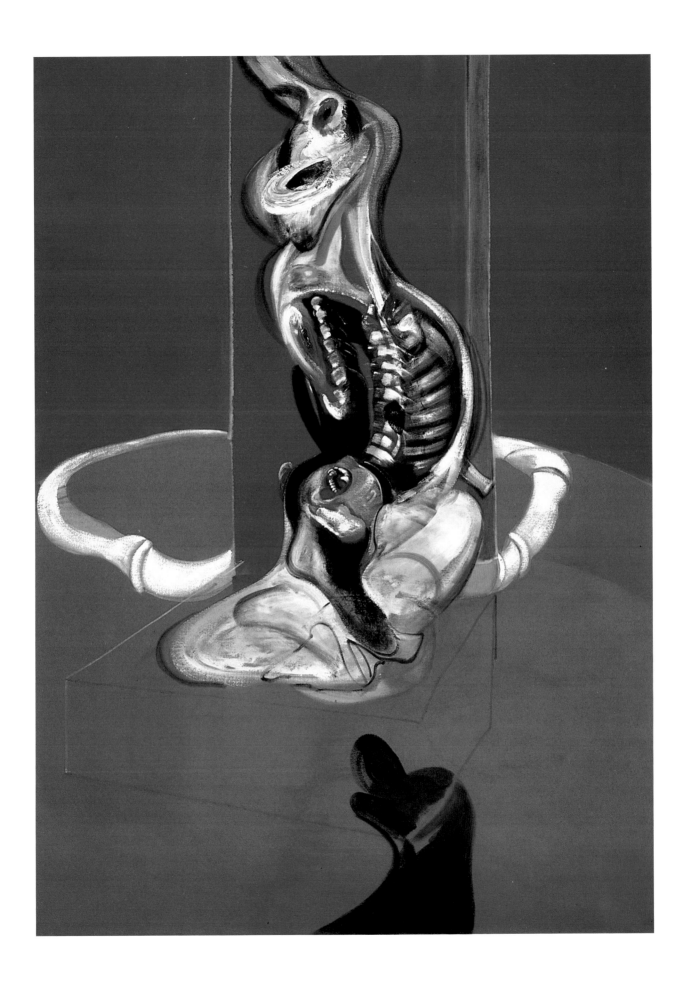

24 THREE STUDIES FOR A CRUCIFIXION, 1962
Oil and sand on canvas; three panels, each 78 x 57 (198.1 x 144.8)
Solomon R. Guggenheim Museum, New York

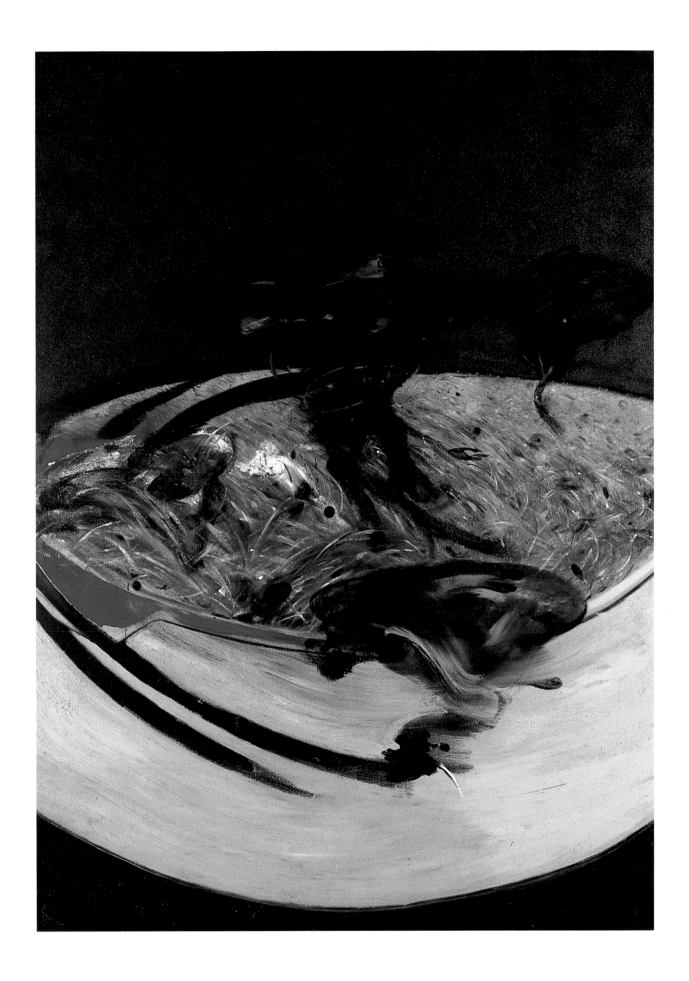

26 DOUBLE PORTRAIT OF LUCIAN FREUD AND FRANK AUERBACH, 1964
Oil on canvas; two panels, each 66 x 57 (167.7 x 144.8)
Moderna Museet, Stockholm

27 PORTRAIT OF GEORGE DYER CROUCHING, 1966
Oil on canvas; 78 x 58 (198.1 x 147.3)
Private collection, Caracas

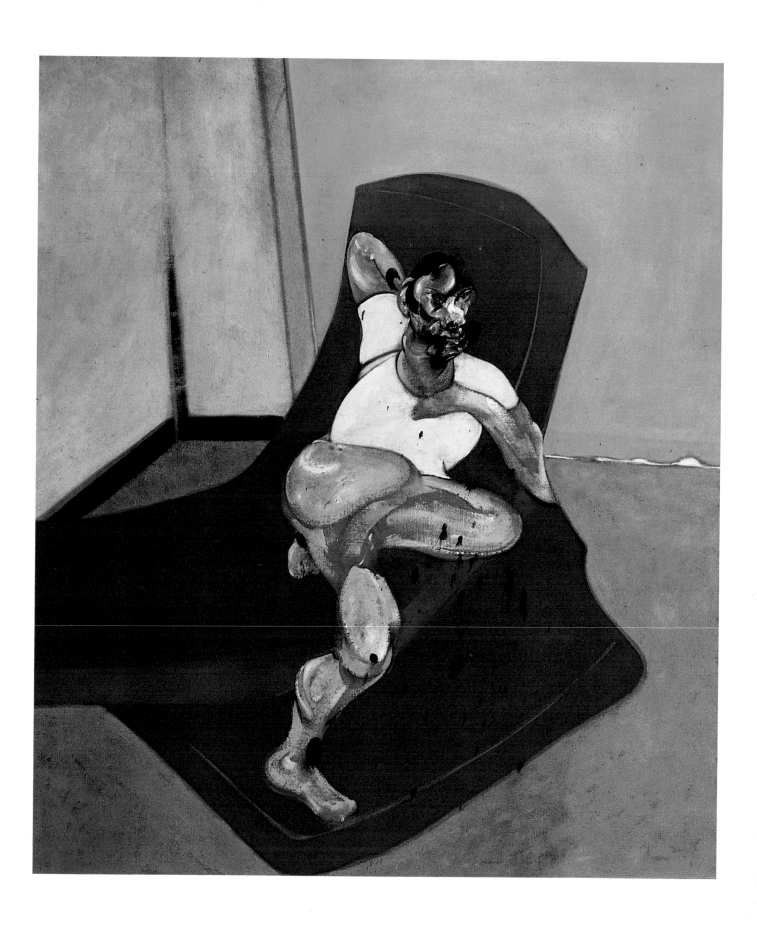

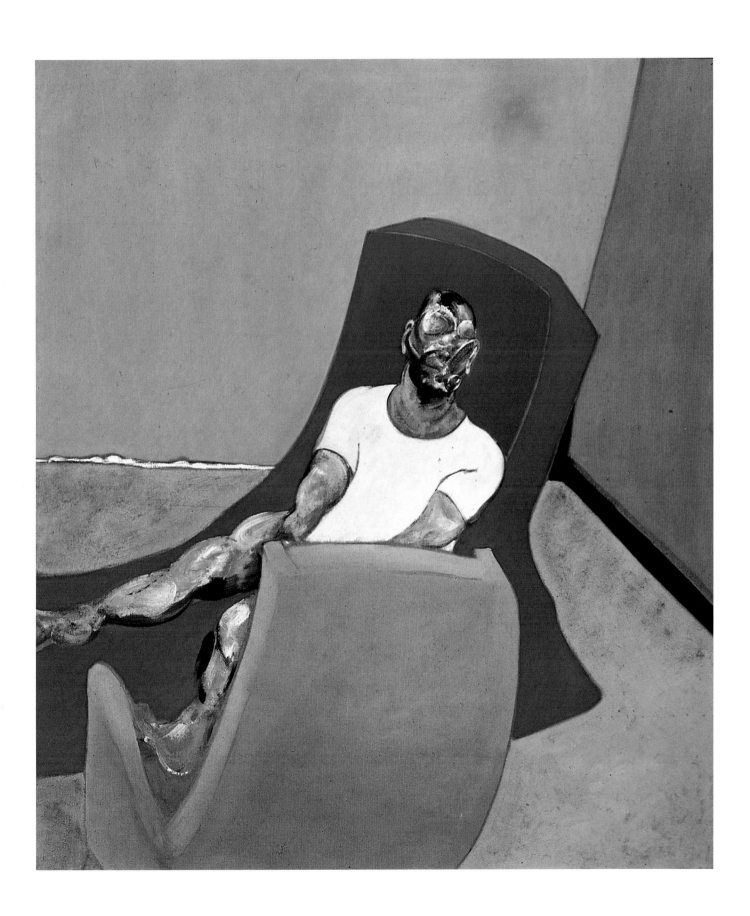

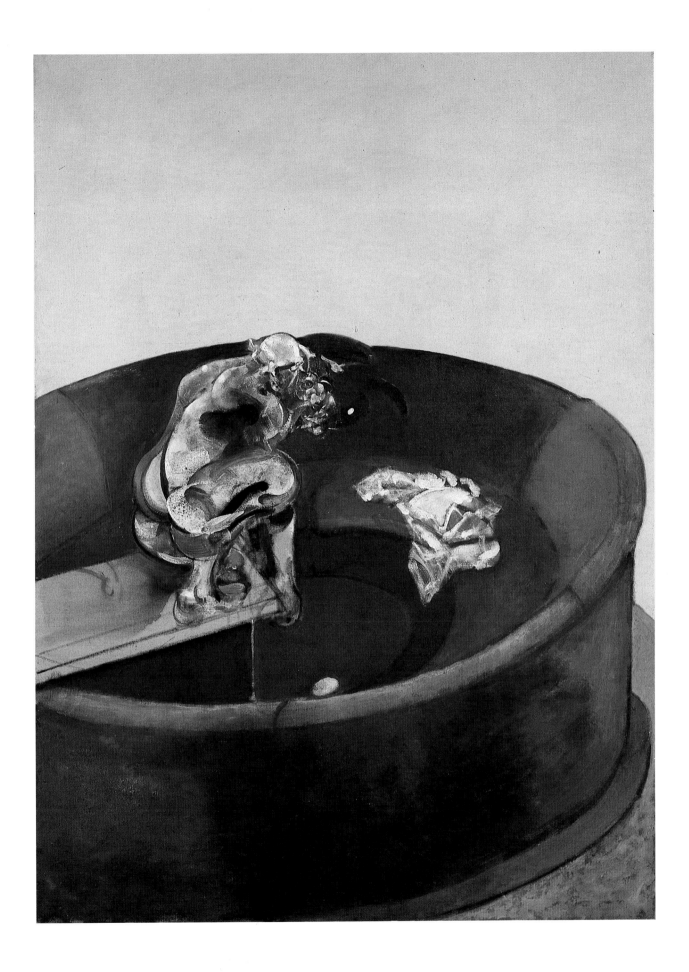

28 PORTRAIT OF GEORGE DYER RIDING A BICYCLE, 1966
Oil on canvas; 78 x 58 (198.1 x 147.3)
Ernst Beyeler, Basel

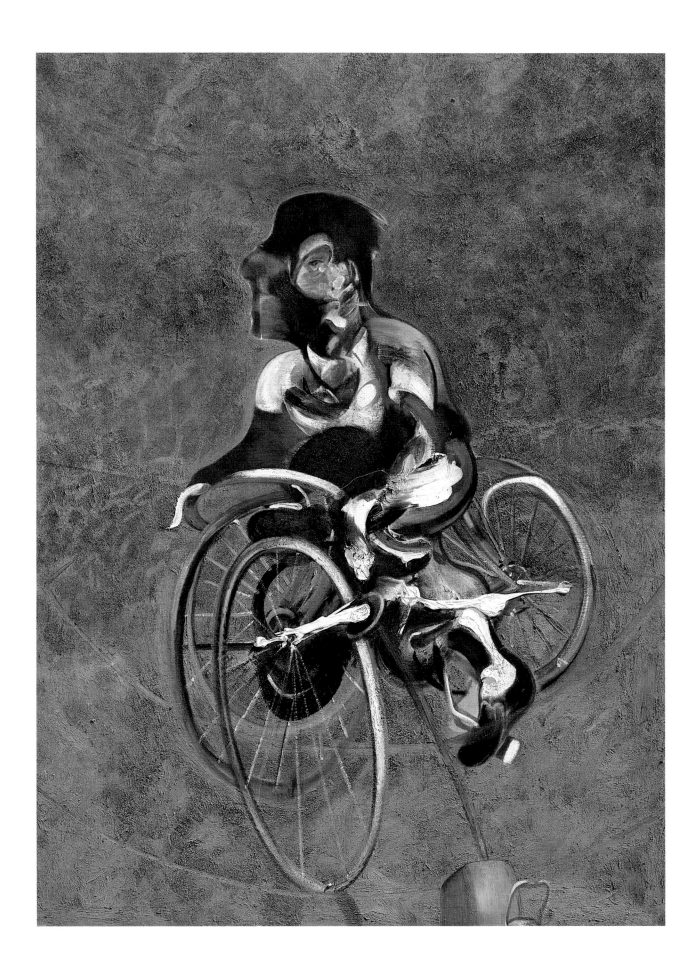

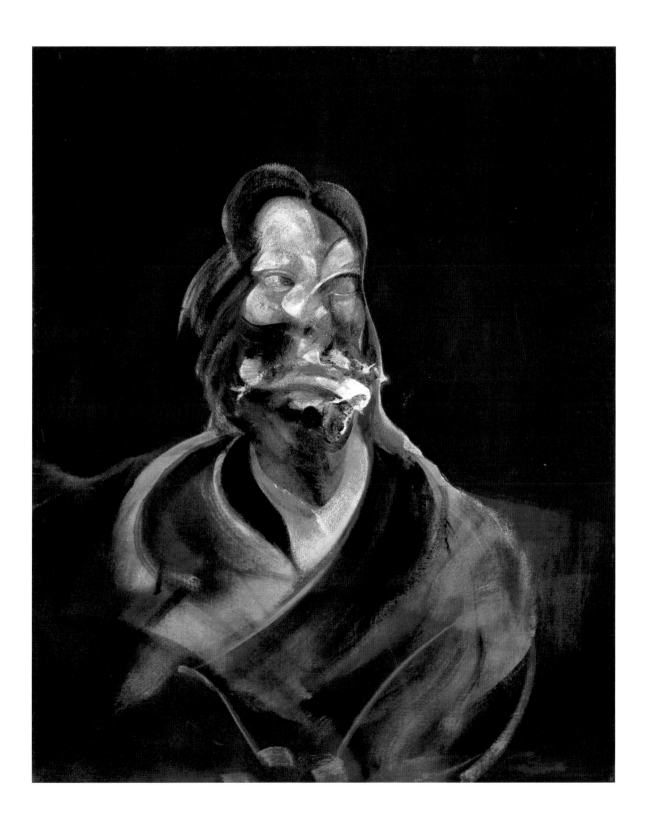

30 THREE STUDIES FOR PORTRAITS: ISABEL RAWSTHORNE, LUCIAN FREUD, AND J.H., 1966
Oil on canvas; three panels, each 14 x 12 (35.5 x 30.5)
Private collection

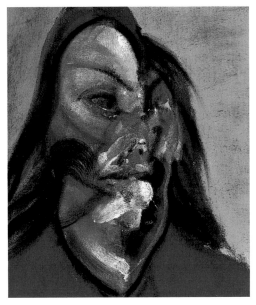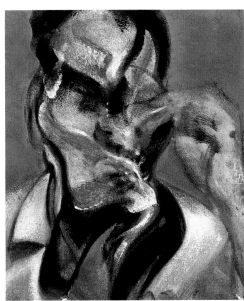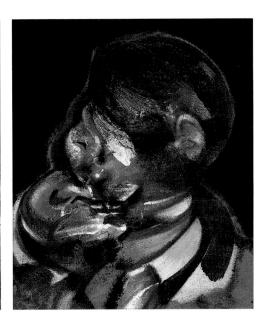

31 PORTRAIT OF ISABEL RAWSTHORNE STANDING IN A STREET IN SOHO, 1967
Oil on canvas; 78 x 58 (198.1 x 147.3)
Staatliche Museen Preussischer Kulturbesitz, Nationalgalerie, Berlin

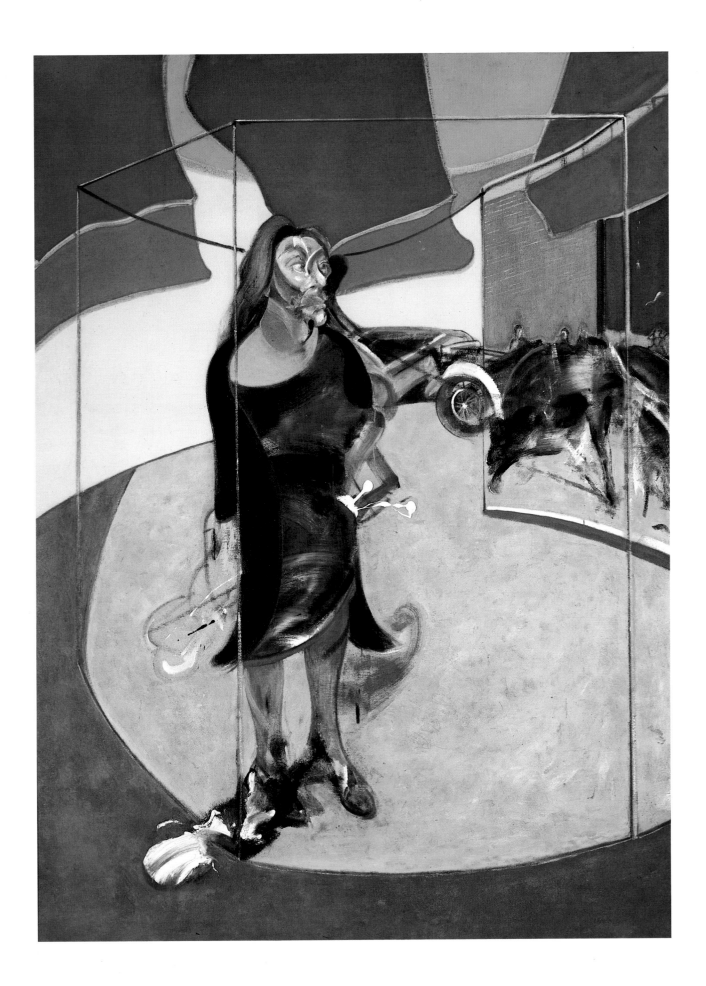

32 STUDY FOR A PORTRAIT, 1967
Oil on canvas; 61 x 55 (154.9 x 139.7)
Richard E. Lang and Jane M. Davis Collection, Medina, Washington

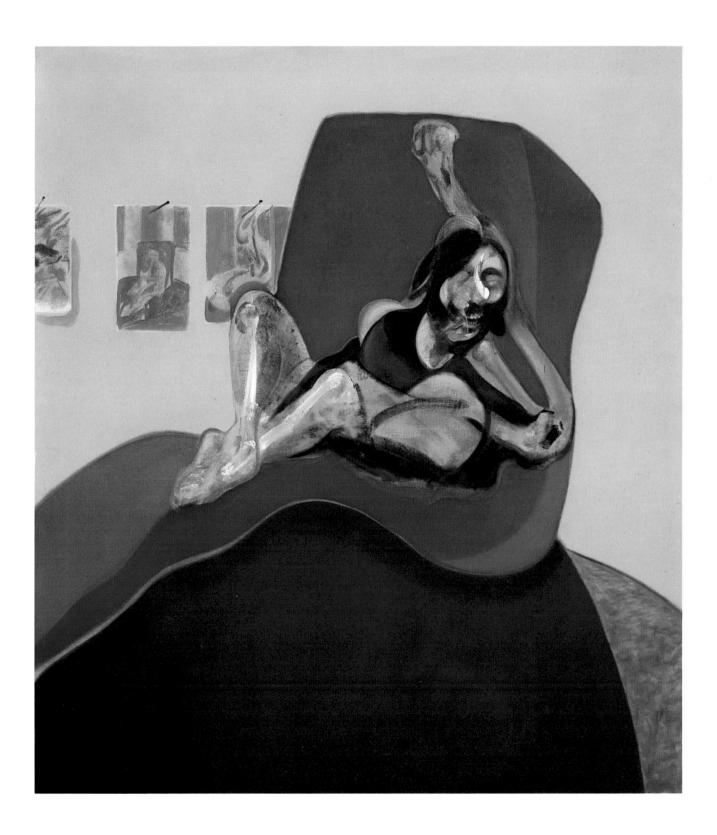

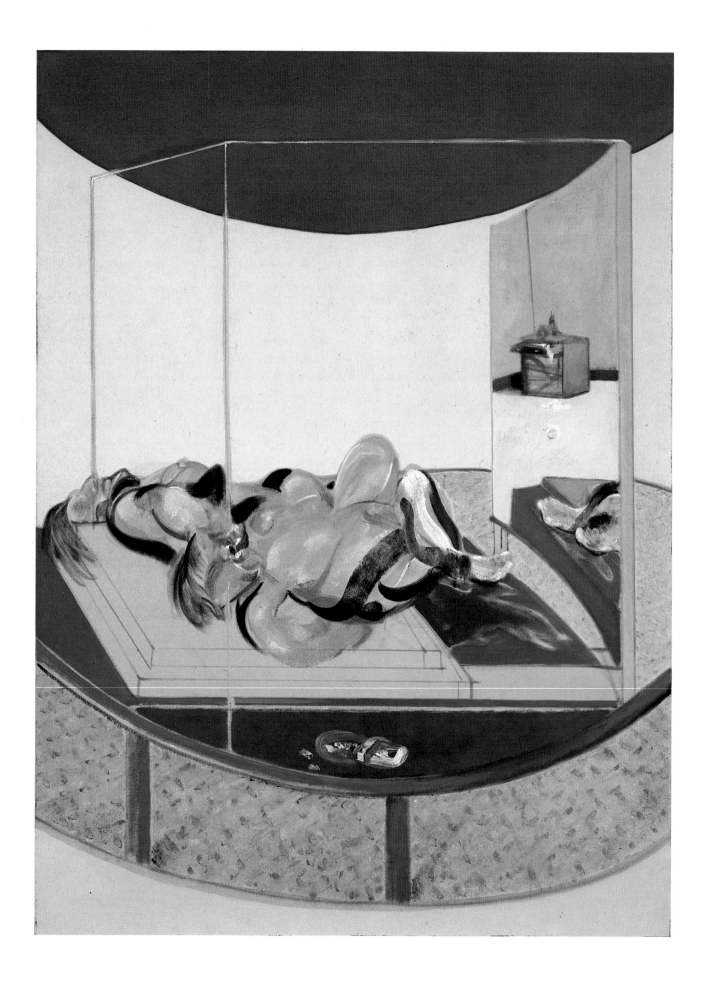

33 TRIPTYCH INSPIRED BY T. S. ELIOT'S POEM SWEENEY AGONISTES, 1967
Oil on canvas; three panels,
left: 78¼ x 58⅜ (198.8 x 148.3); center: 78¼ x 58¼ (198.8 x 147.9); right: 78⅛ x 58¼ (198.4 x 147.9)
Hirshhorn Museum and Sculpture Garden, Smithsonian Institution,
Washington, D.C., gift of the Joseph H. Hirshhorn Foundation

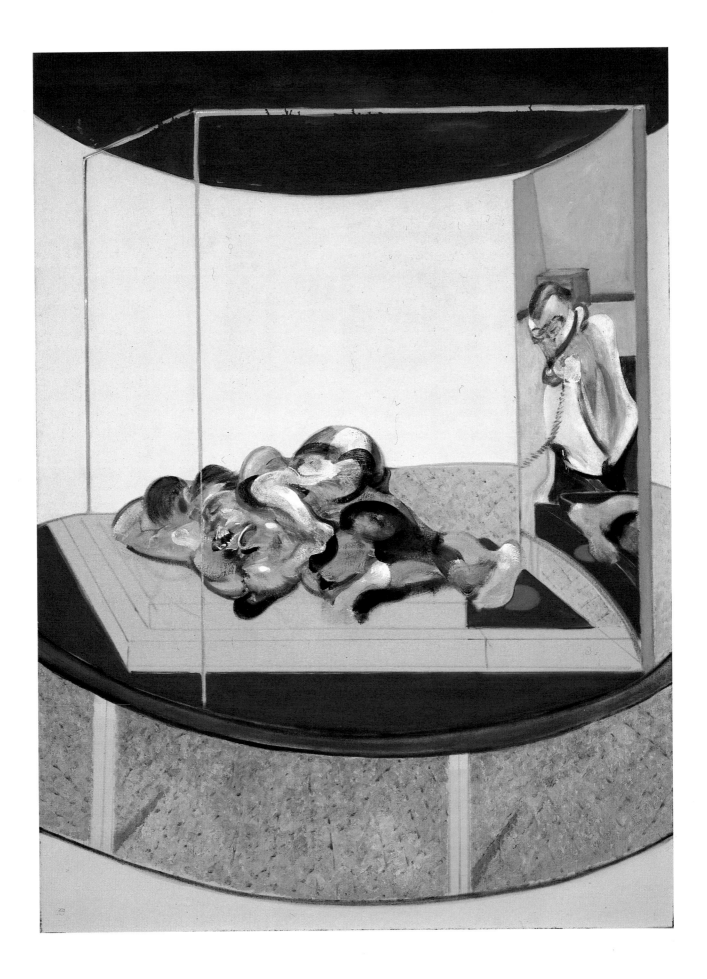

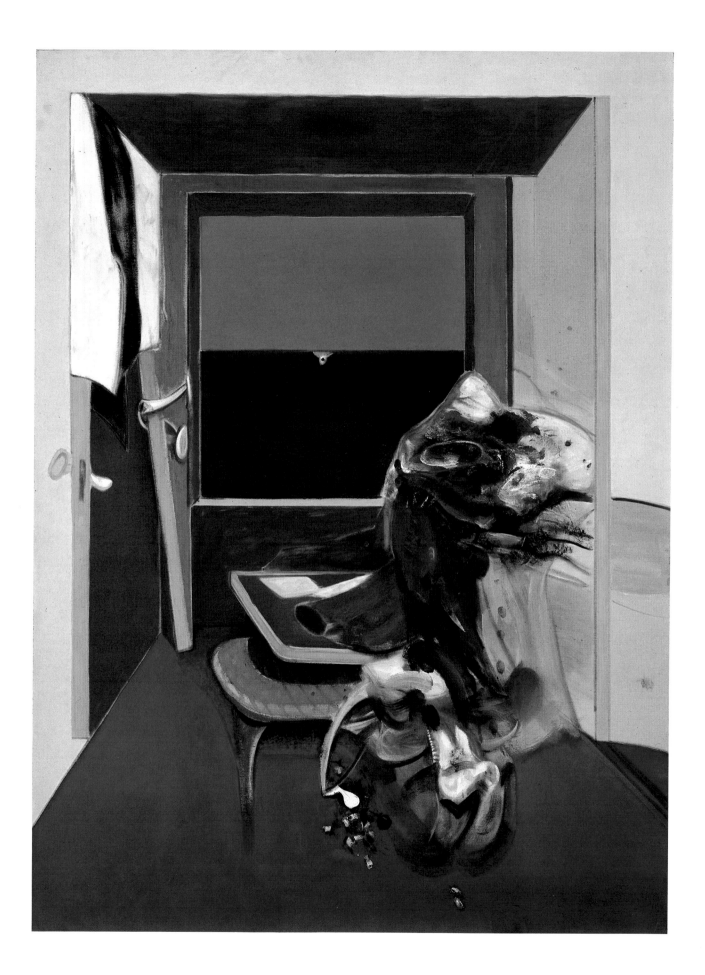

34 TWO STUDIES FOR A PORTRAIT OF GEORGE DYER, 1968
Oil on canvas; 78 x 58 (198.1 x 147.3)
Sara Hildén Foundation, Sara Hildén Art Museum, Tampere, Finland

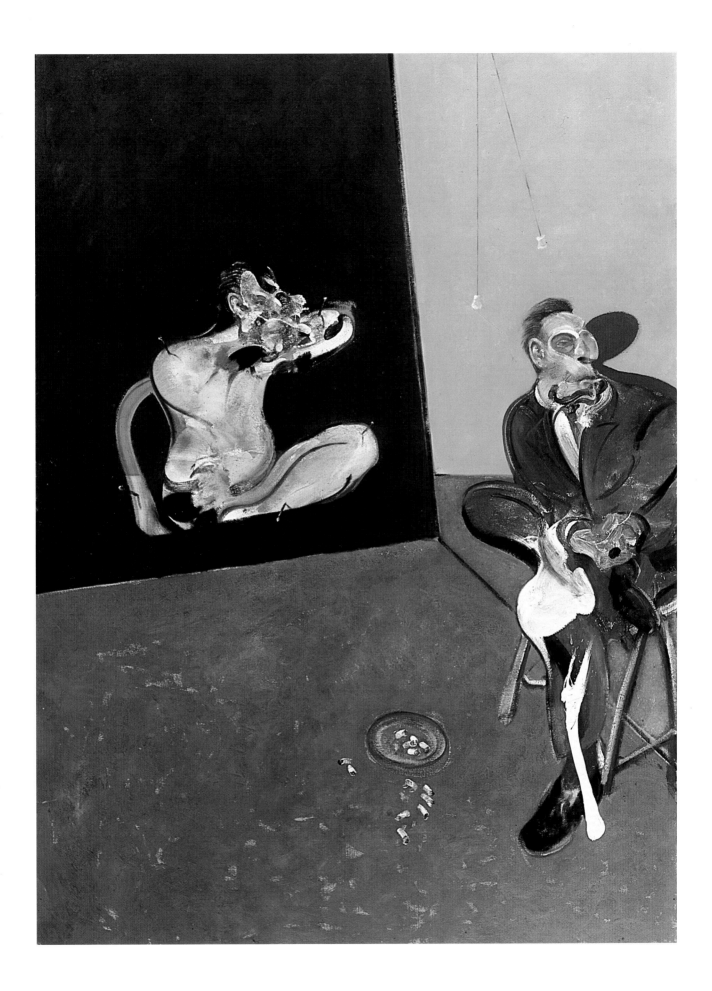

35 LYING FIGURE, 1969
Oil on canvas; 78 x 58 (198.1 x 147.3)
Galerie Beyeler, Basel

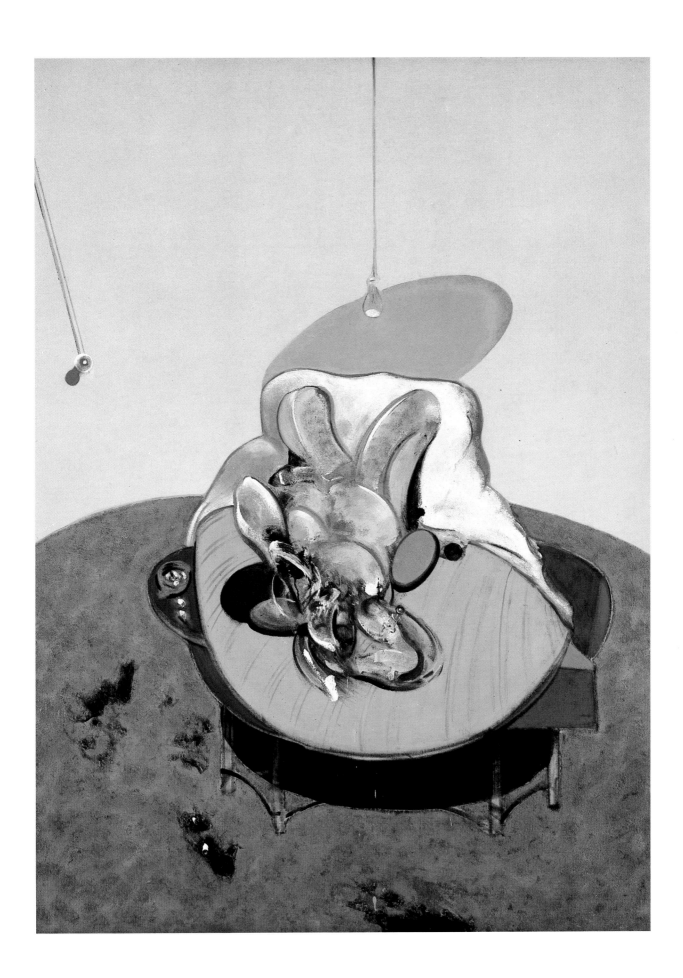

36 THREE STUDIES FOR PORTRAITS INCLUDING SELF-PORTRAIT, 1969
Oil on canvas; three panels, each 14 x 12 (35.5 x 30.5)
Private collection

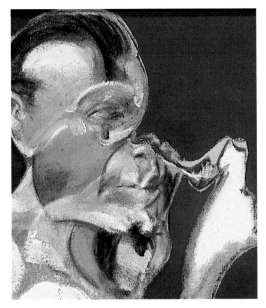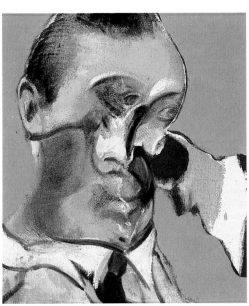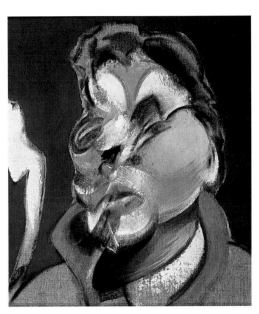

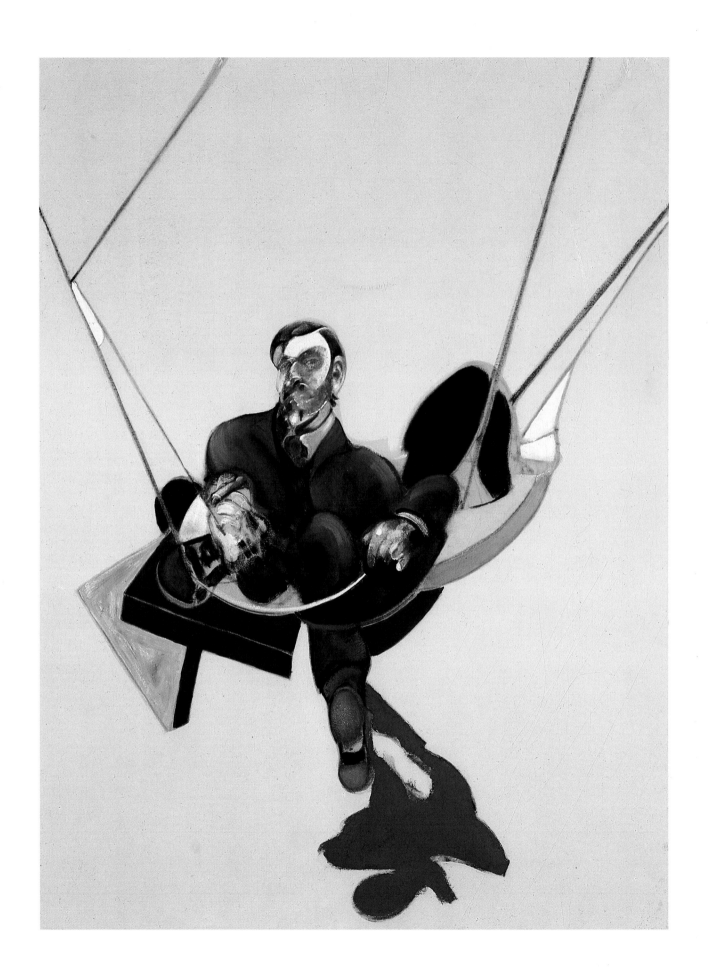

37 TRIPTYCH, 1970
Oil on canvas; three panels, each 78 x 58 (198.1 x 147.3)
Australian National Gallery, Canberra

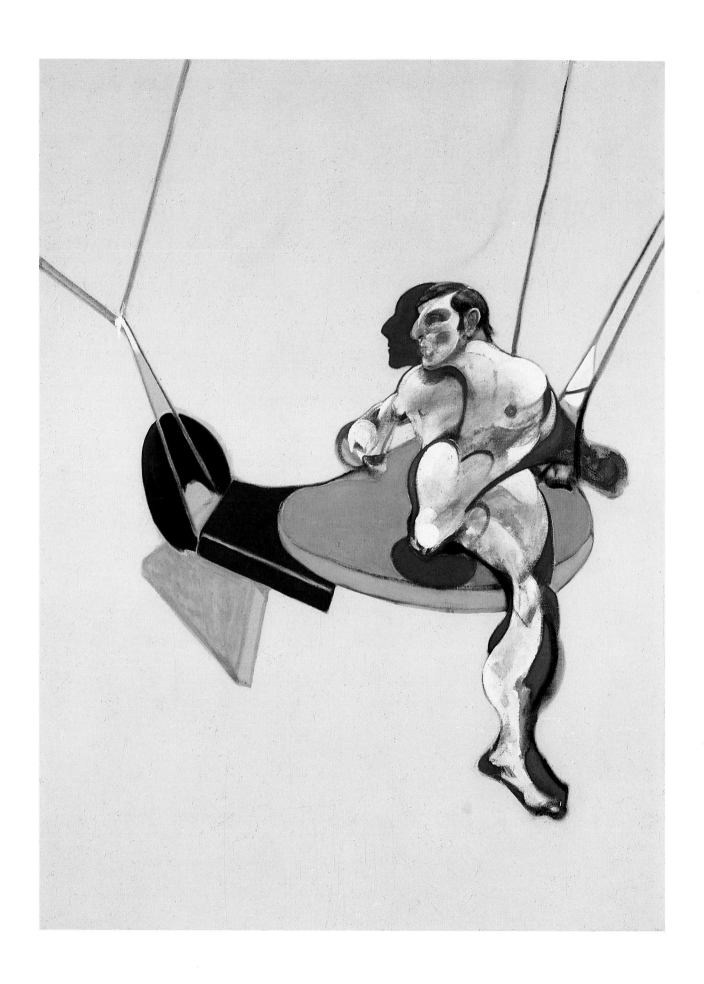

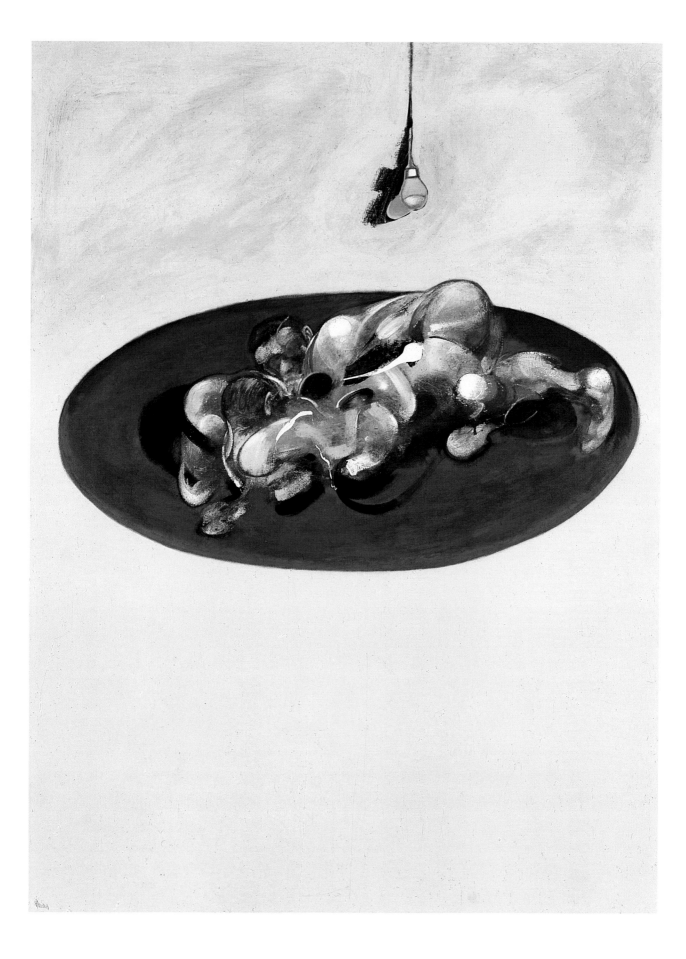

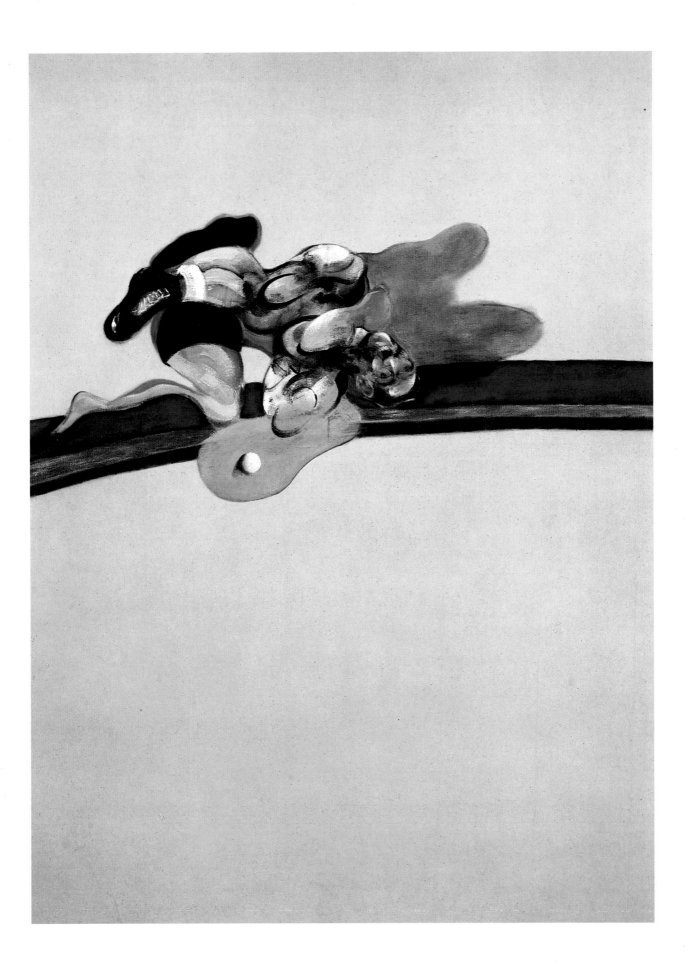

38 IN MEMORY OF GEORGE DYER, 1971
Oil on canvas; three panels, each 78 x 58 (198.1 x 147.3)
Galerie Beyeler, Basel

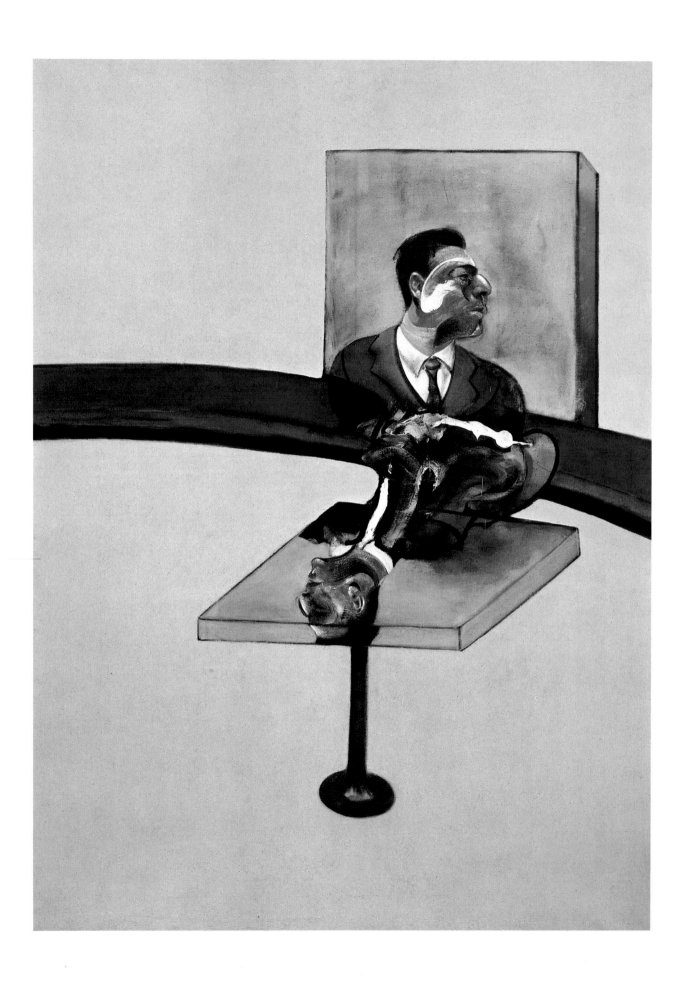

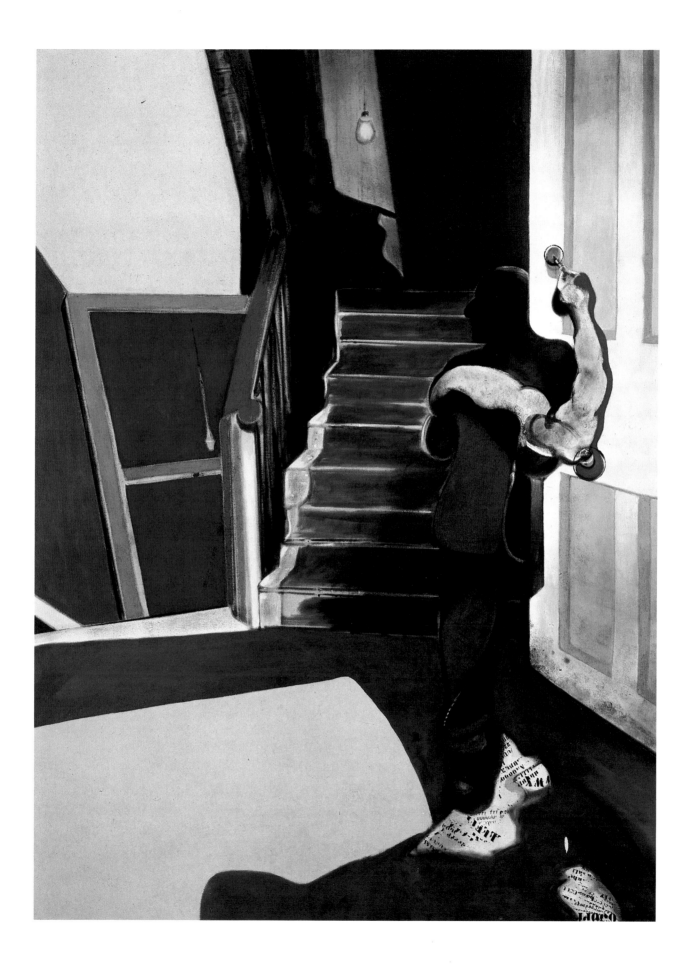

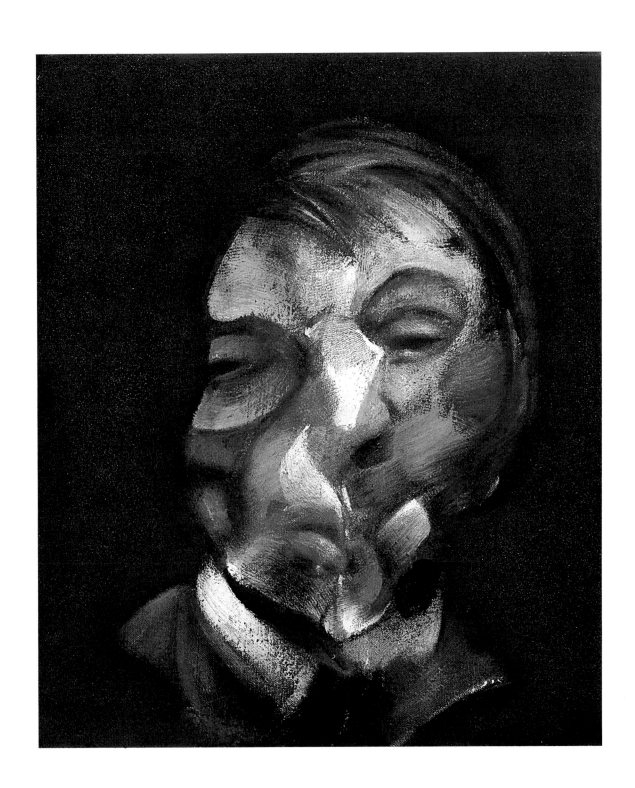

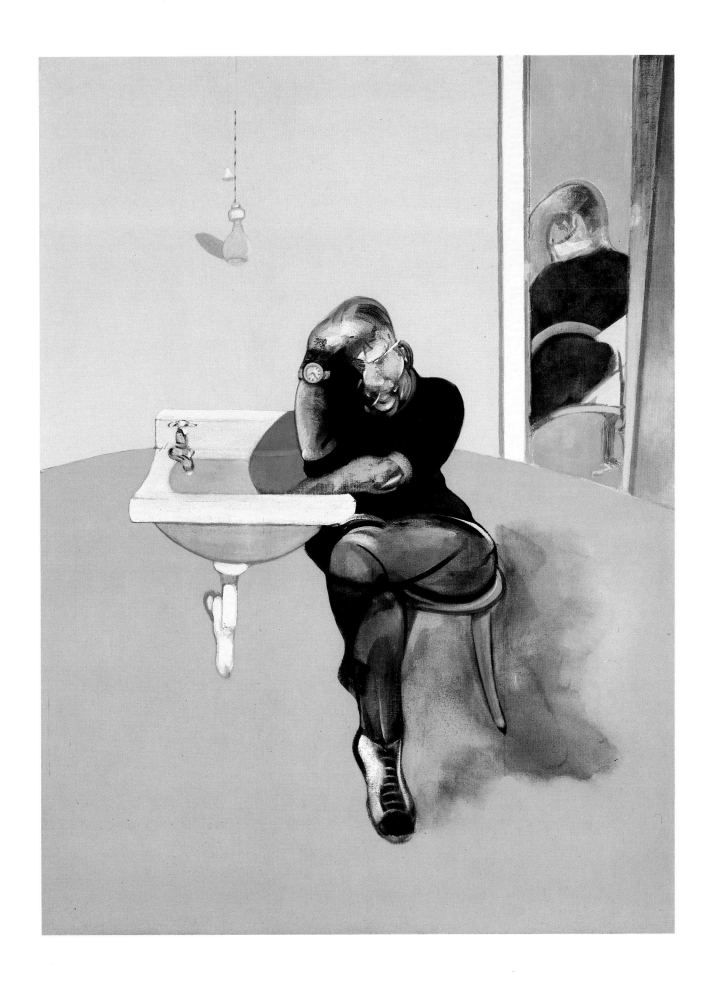

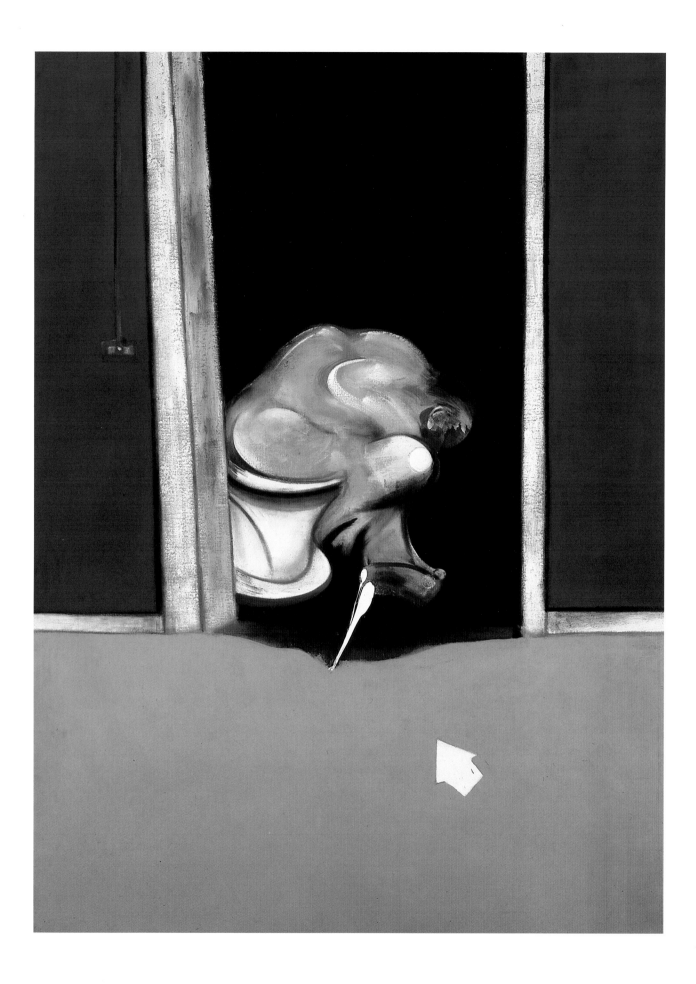

41 TRIPTYCH—MAY–JUNE 1973, 1973
Oil on canvas; three panels, each 78 x 58 (198.1 x 147.3)
Private collection, Switzerland

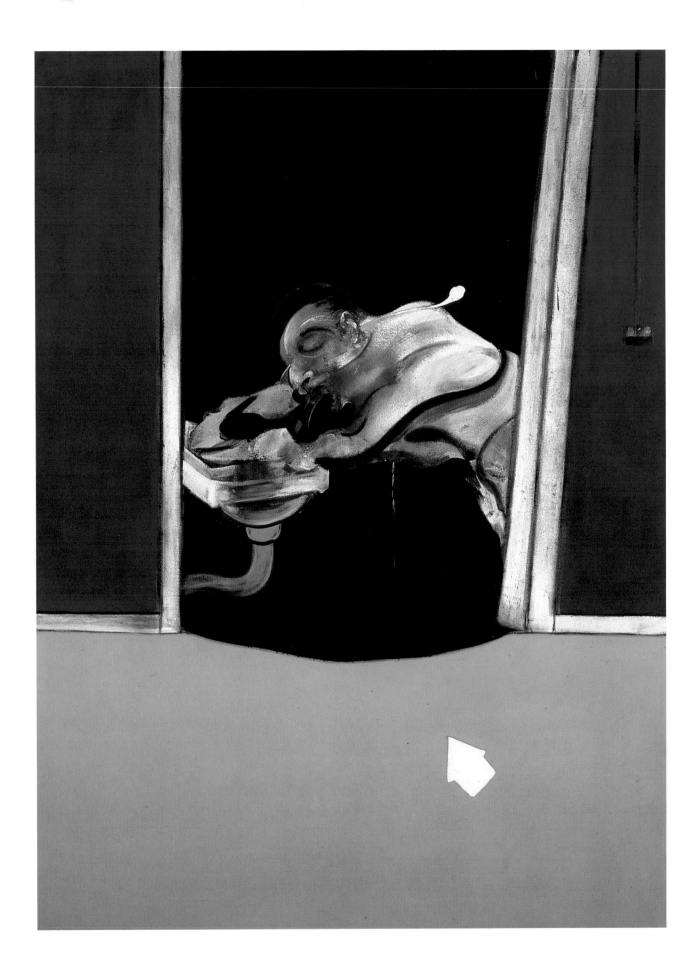

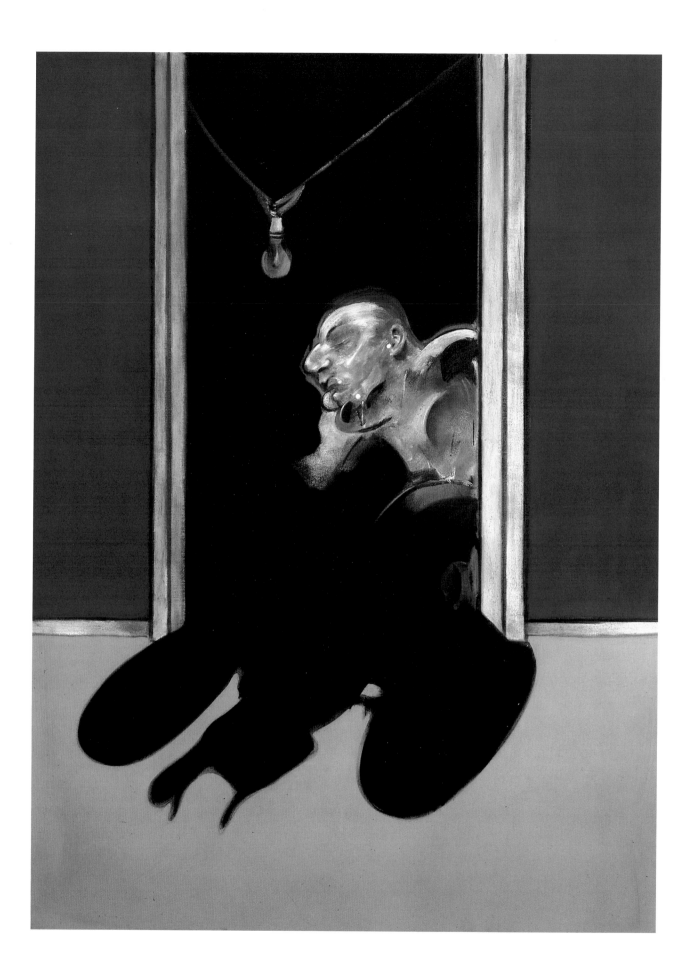

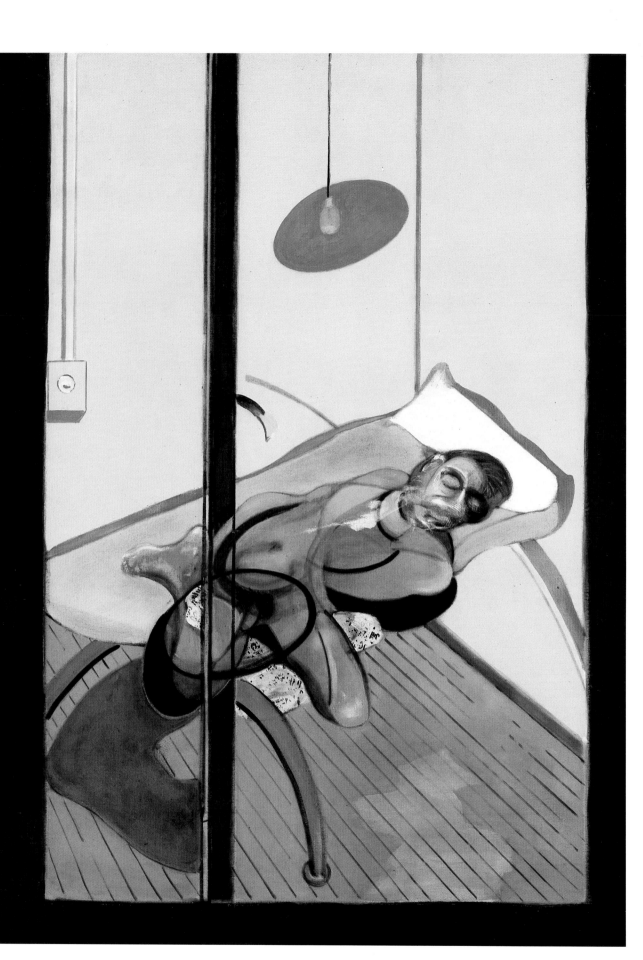

43 STUDIES FROM THE HUMAN BODY, 1975
Oil on canvas; 78 x 58 (198.1 x 147.3)
Gilbert de Botton, Switzerland

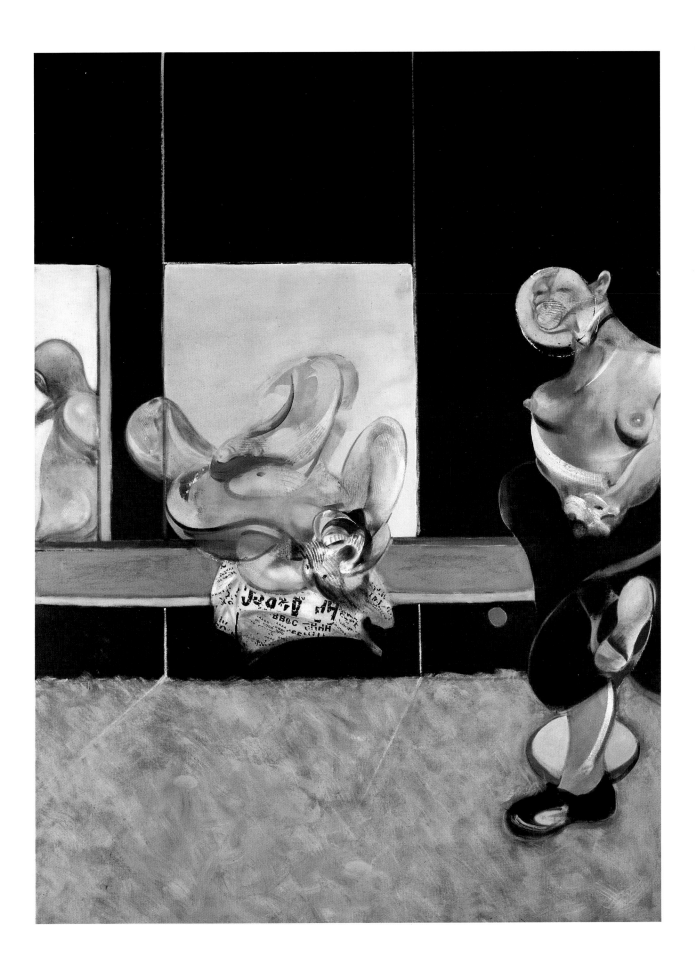

44 FIGURE AT A WASH BASIN, 1976
Oil on canvas; 78 x 58 (198.1 x 147.3)
Museo de Arte Contemporaneo de Caracas

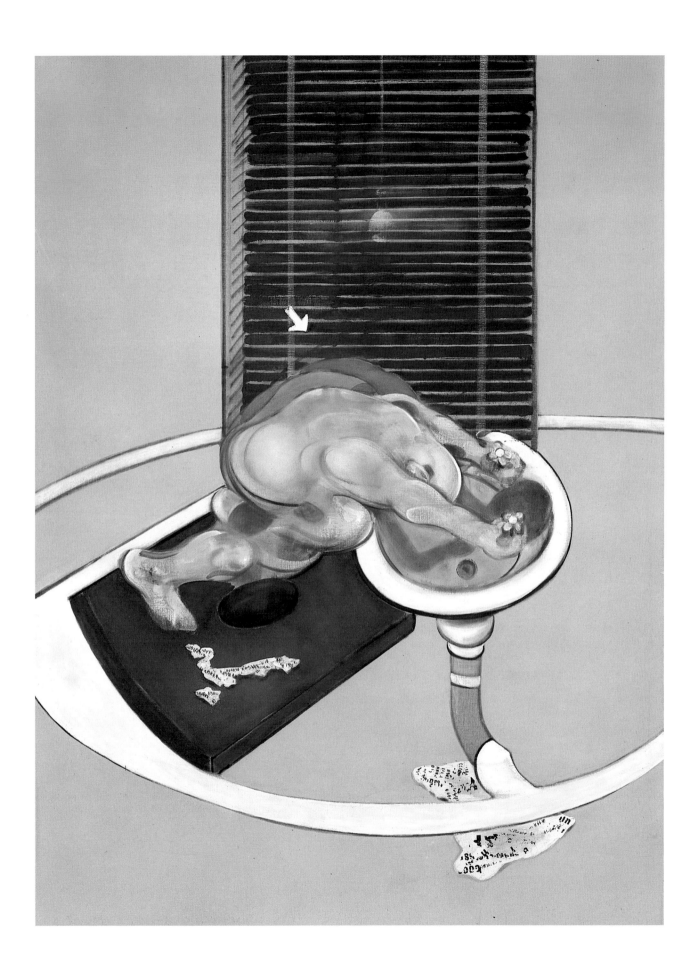

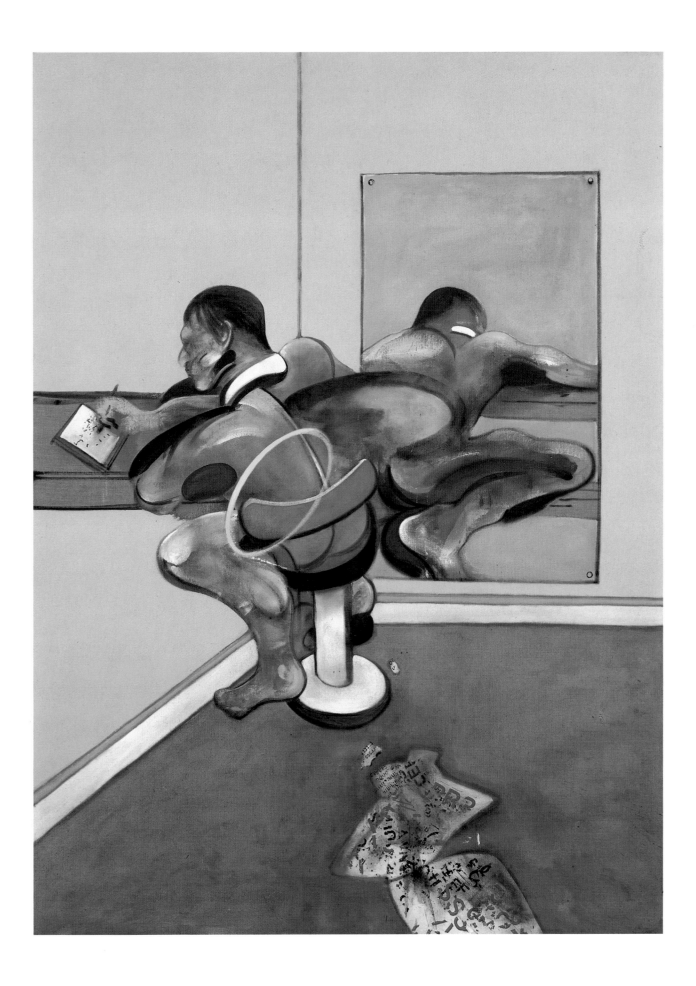

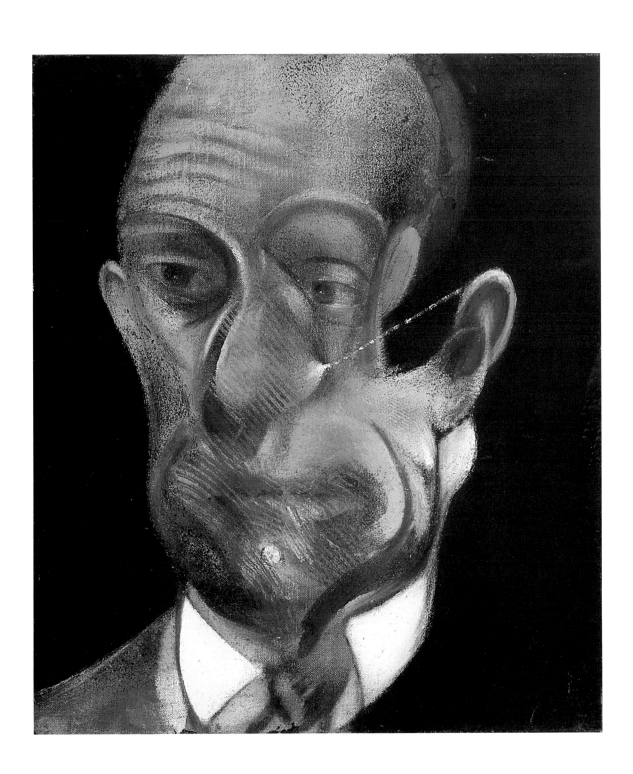

47 SPHINX—PORTRAIT OF MURIEL BELCHER, 1979
Oil on canvas; 78 x 58 (198. I x 147.3)
The National Museum of Modern Art, Tokyo

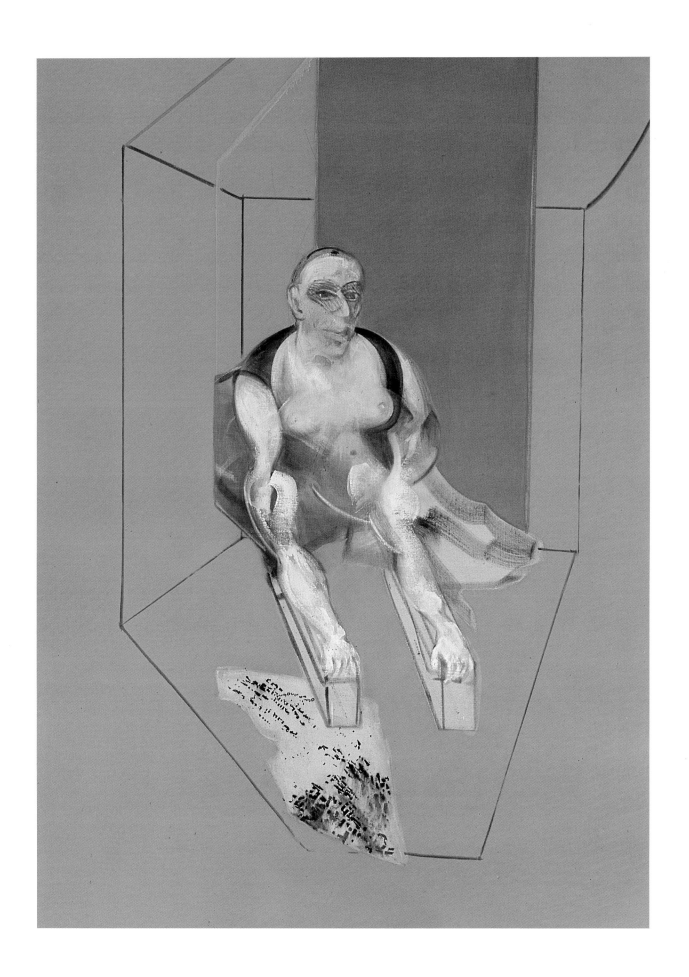

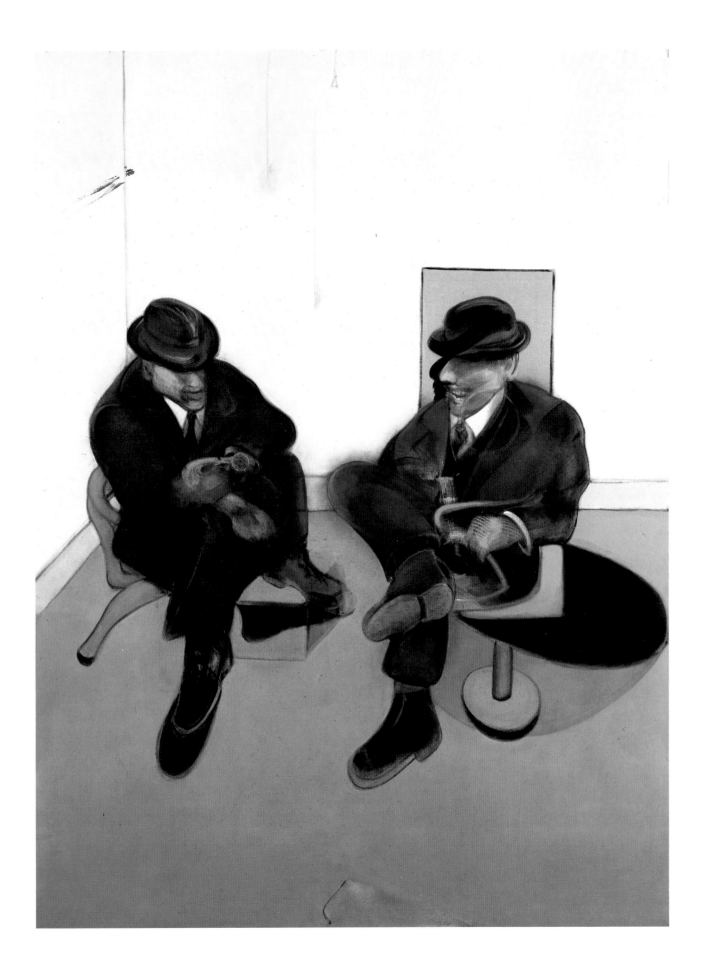

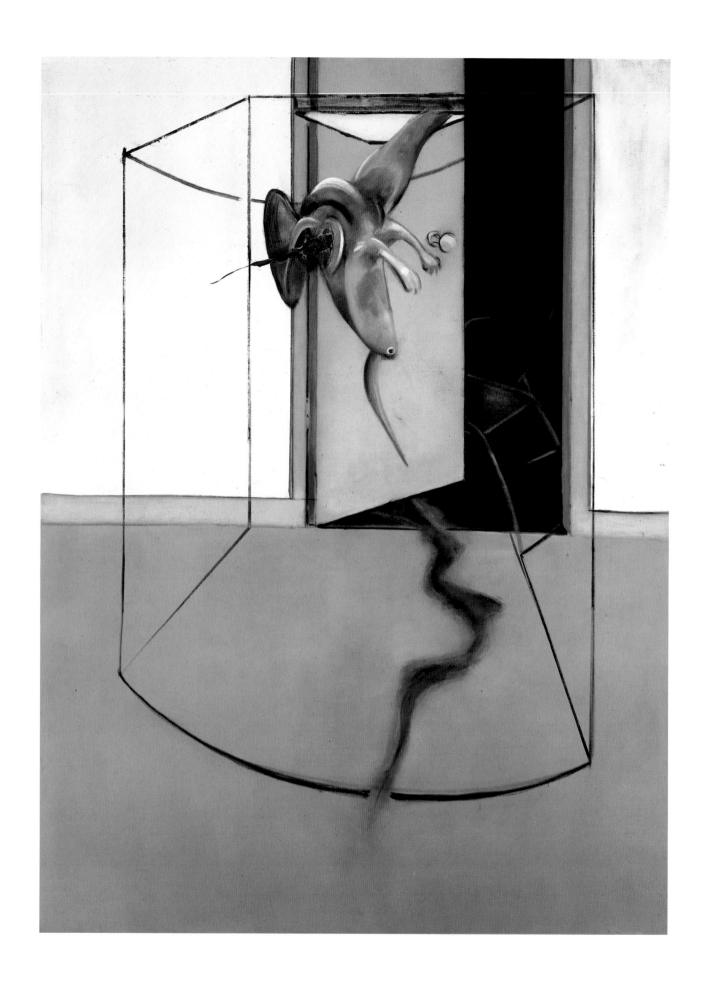

49 TRIPTYCH INSPIRED BY THE ORESTEIA OF AESCHYLUS, 1981
Oil on canvas; three panels, each 78 x 58 (198.1 x 147.3)
Private collection

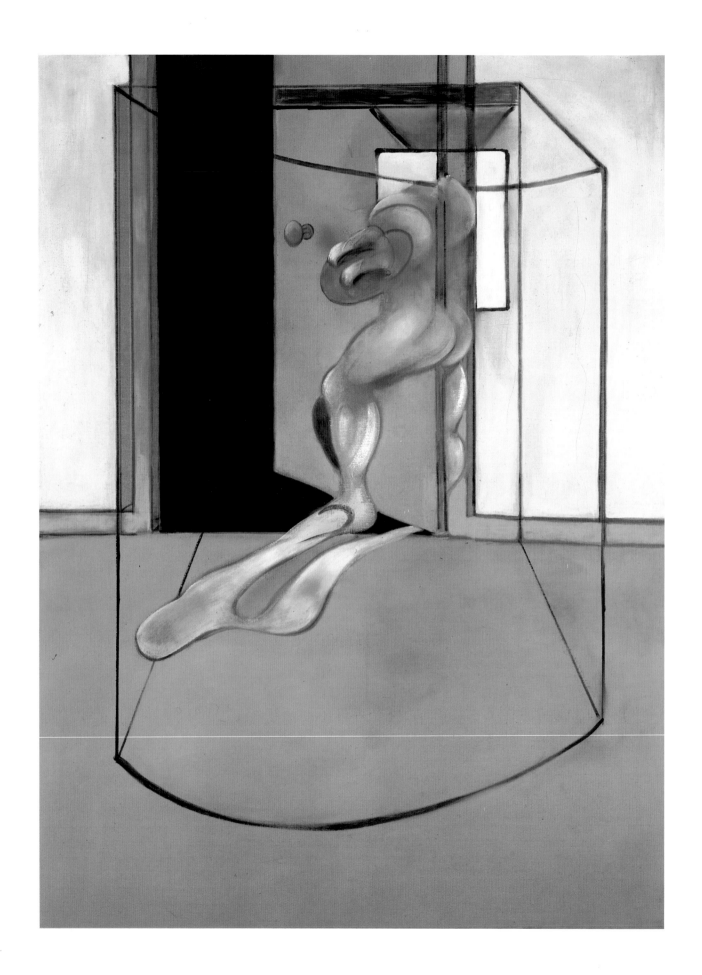

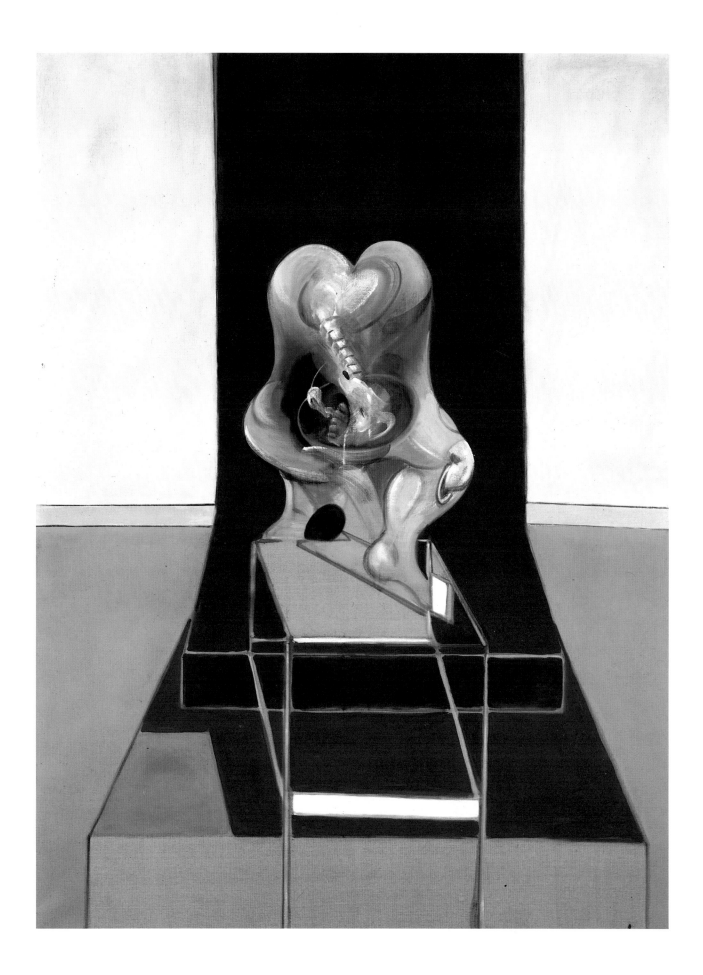

50 SAND DUNE, 1983
Oil on canvas; 78 x 58 (198.1 x 147.3)
Ernst Beyeler, Basel

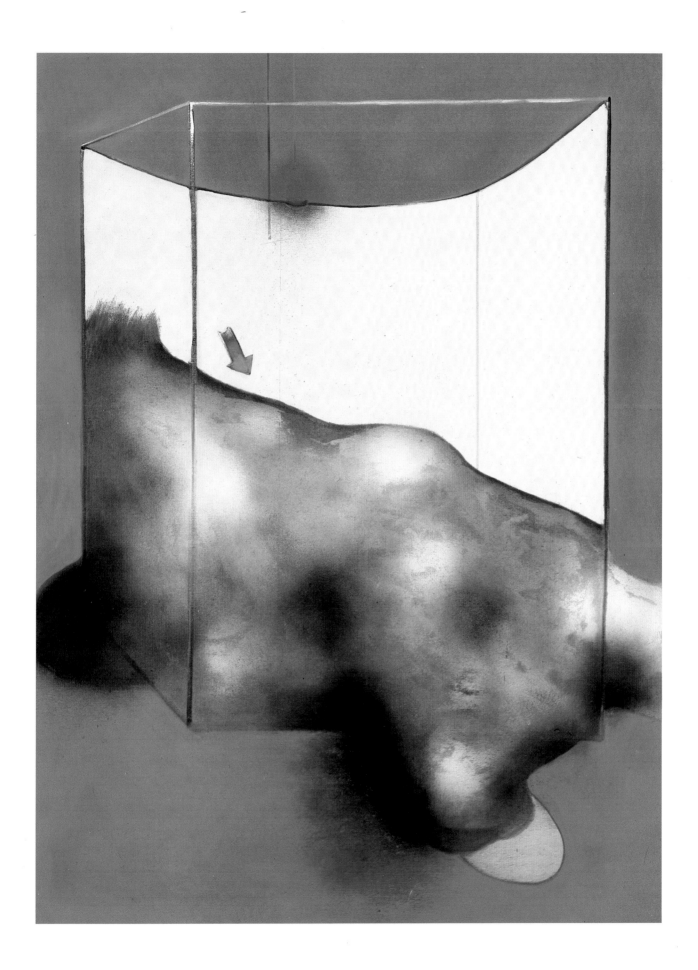

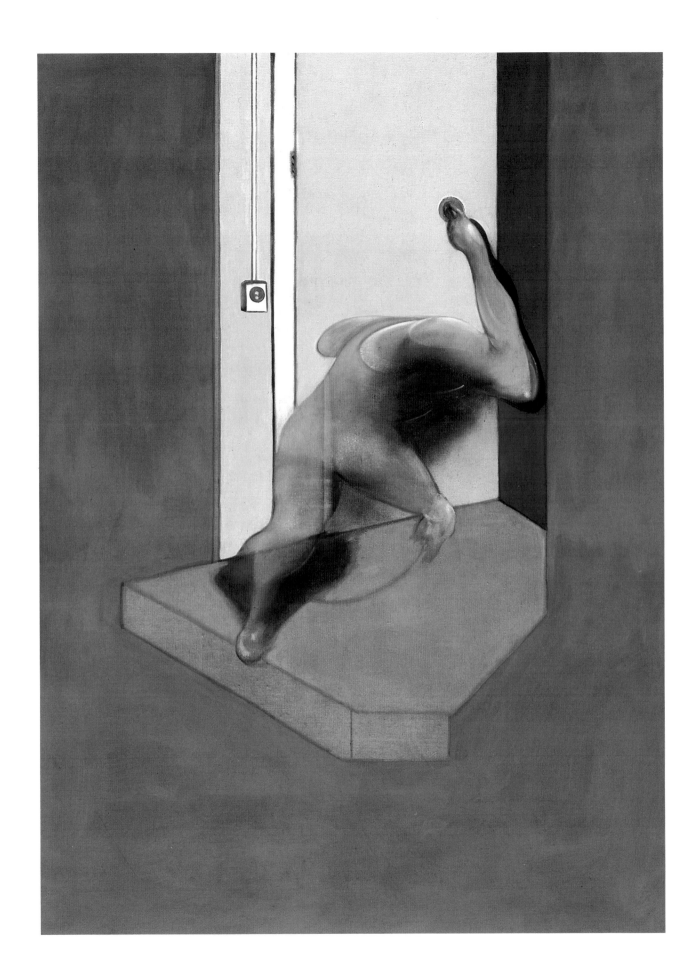

52 THREE STUDIES FOR SELF-PORTRAIT, 1983
Oil on canvas; three panels, each 13¾ x 12 (34.9 x 30.5)
Honolulu Academy of Arts, gift of Mr. and Mrs. Henry B. Clark, Jr.

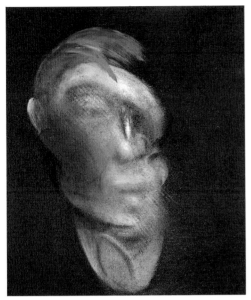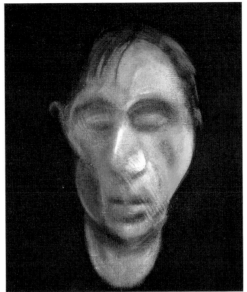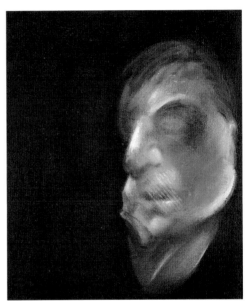

53 DIPTYCH, 1982–84
STUDY FROM THE HUMAN BODY, 1982–84
STUDY OF THE HUMAN BODY—FROM A DRAWING BY INGRES, 1982
Oil and transfer type on linen; two panels,
left: 78⅛ x 58¼ (198.2 x 147.9); right: 78⅛ x 58⅛ (198.2 x 147.5)
Hirshhorn Museum and Sculpture Garden, Smithsonian Institution, Washington, D.C.,
gift of Marlborough International Fine Art and the Joseph H. Hirshhorn Foundation, by exchange

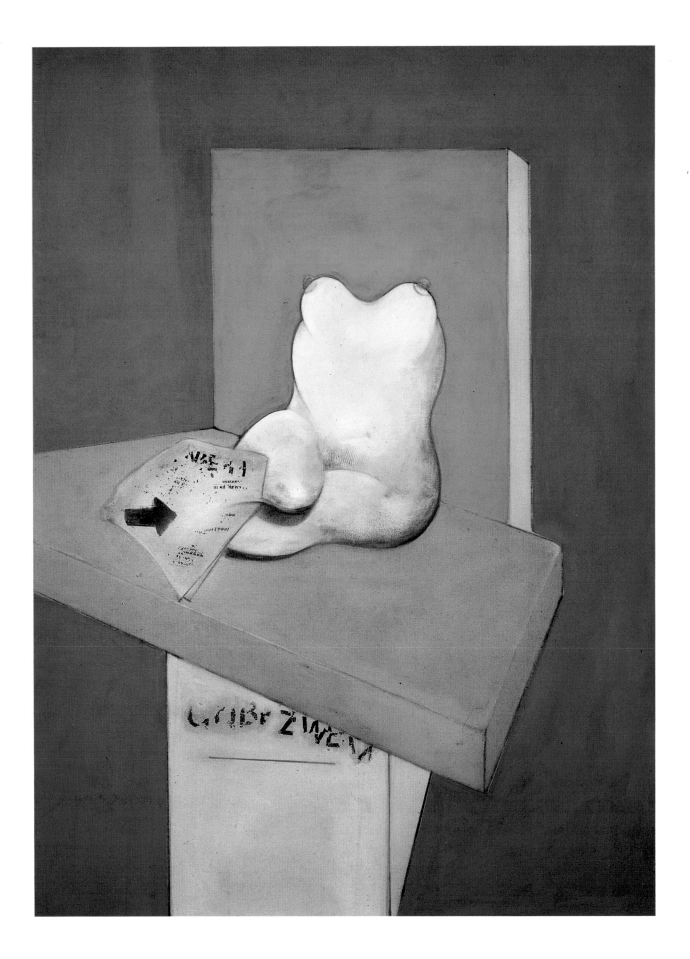

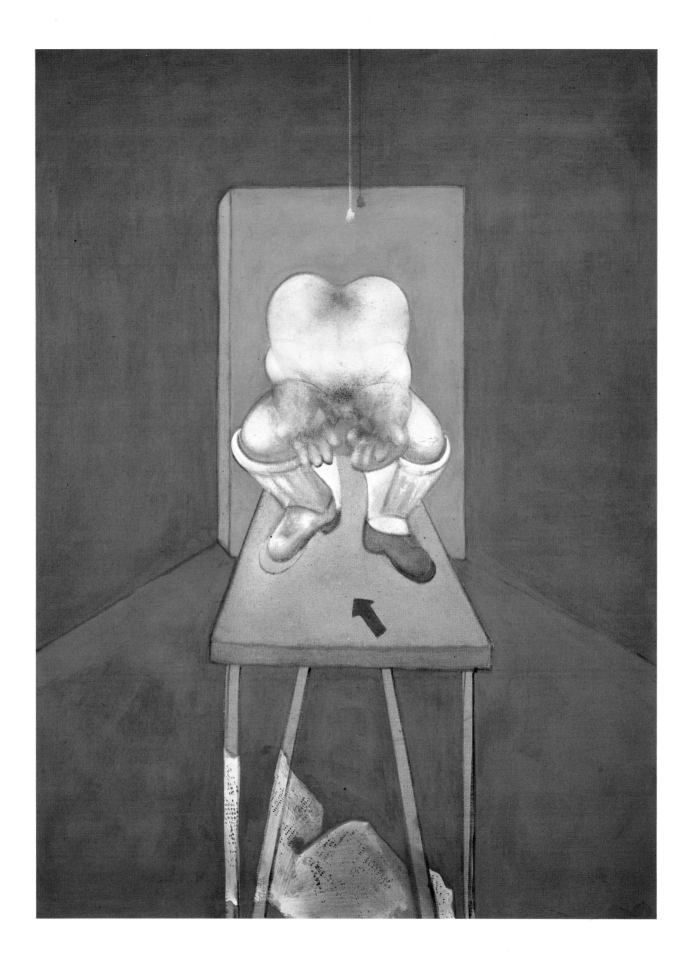

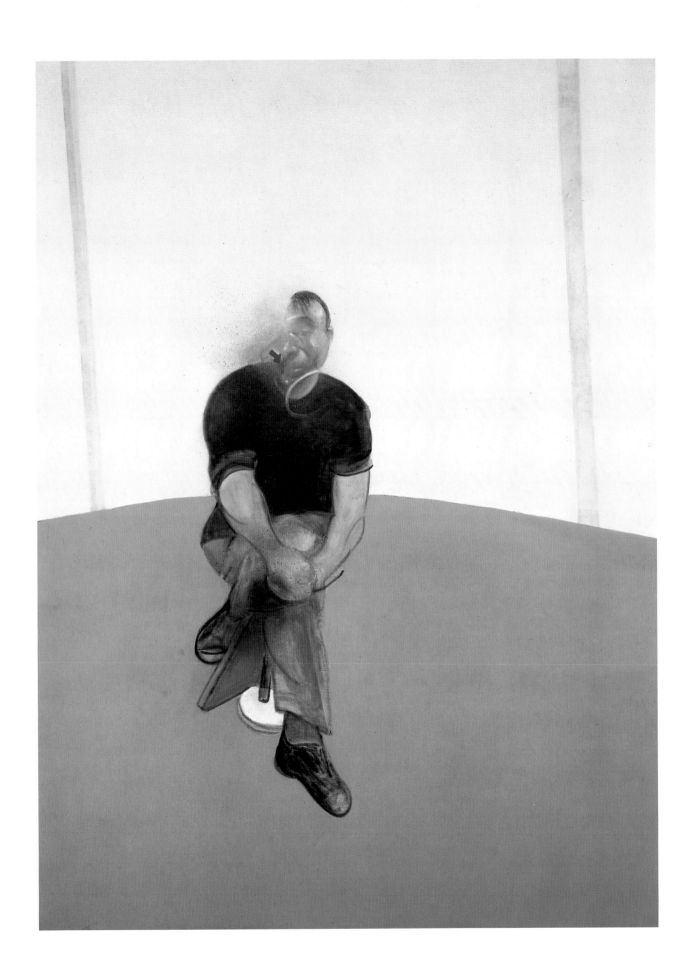

54 STUDY FOR SELF-PORTRAIT—TRIPTYCH, 1985–86
Oil on canvas; three panels, each 78 x 58 (198.1 x 147.3)
Marlborough International Fine Art

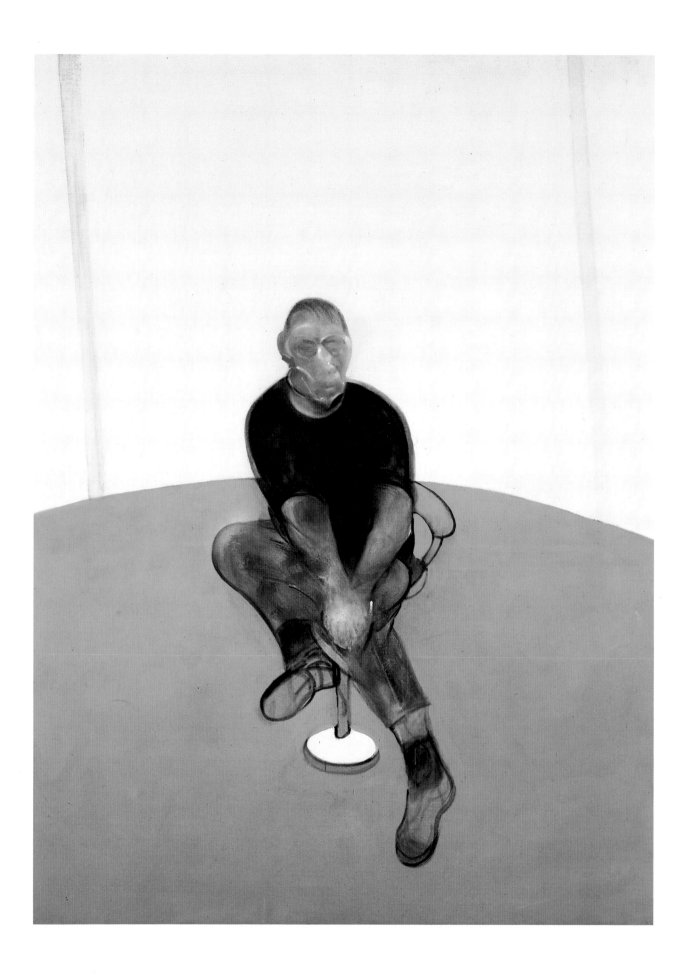

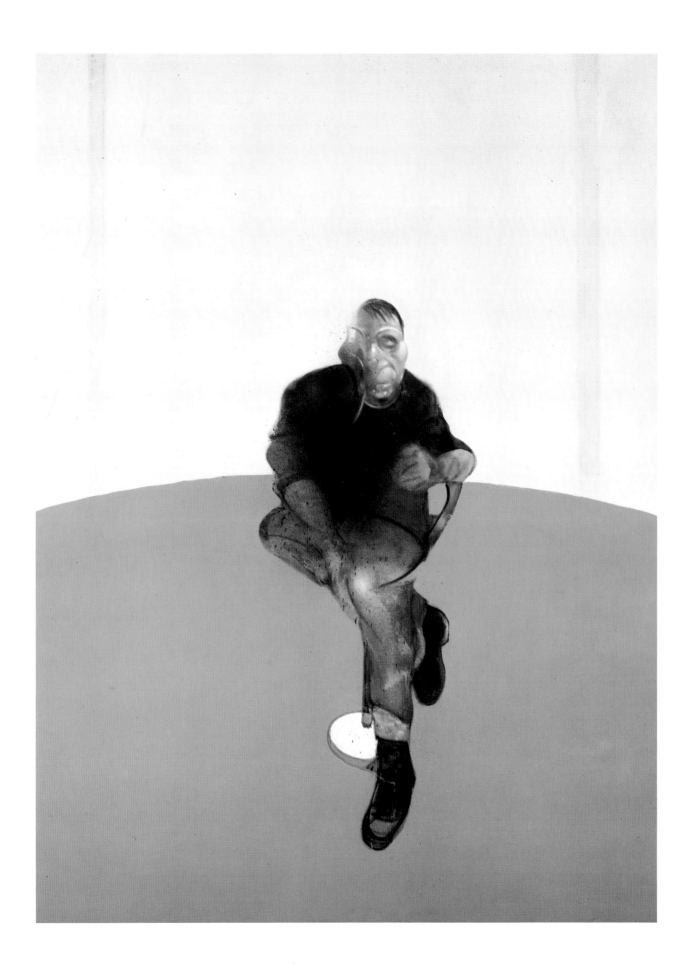

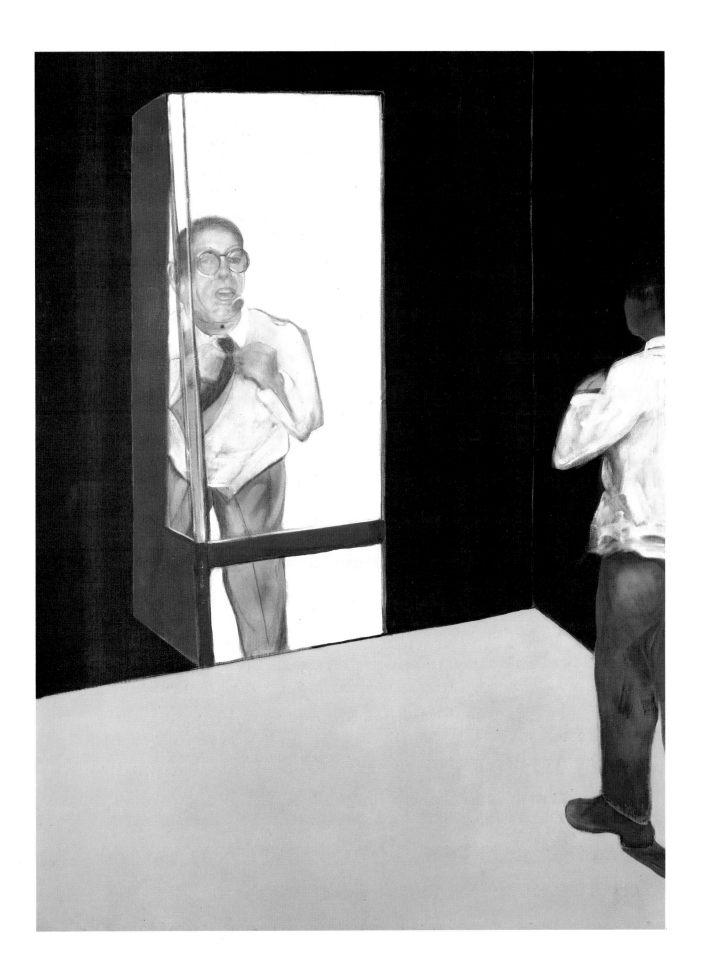

56 STUDY FOR PORTRAIT OF JOHN EDWARDS, 1986
Oil and pastel on canvas; 78 x 58 (198.1 x 147.3)
Private collection

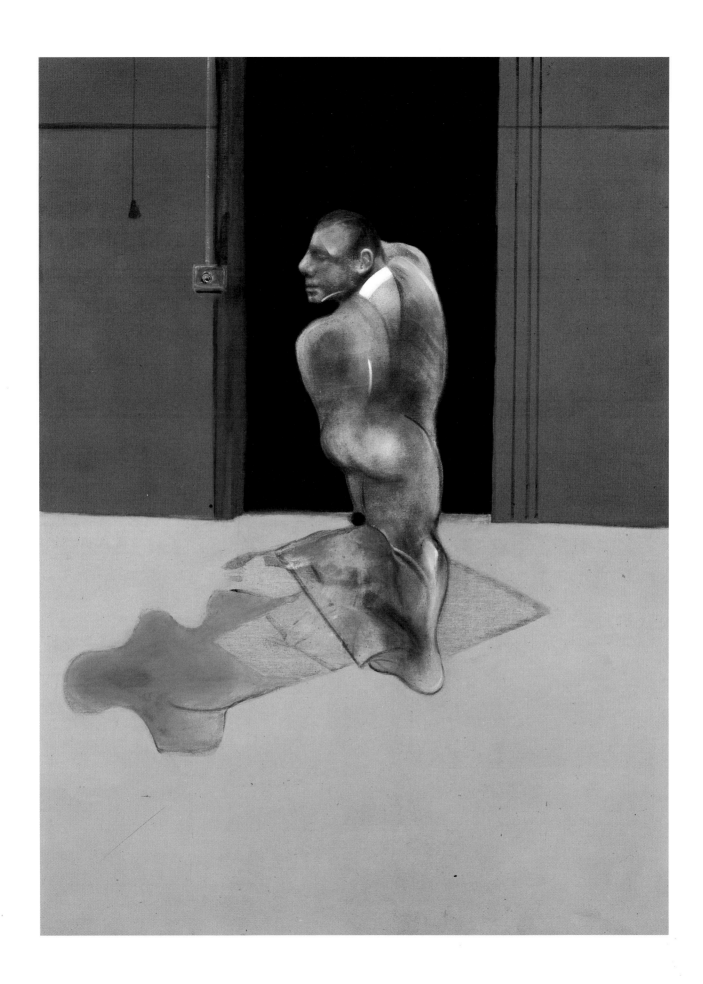

57 JET OF WATER, 1988
Oil on canvas; 78 x 58 (198. 1 x 147.3)
Marlborough International Fine Art

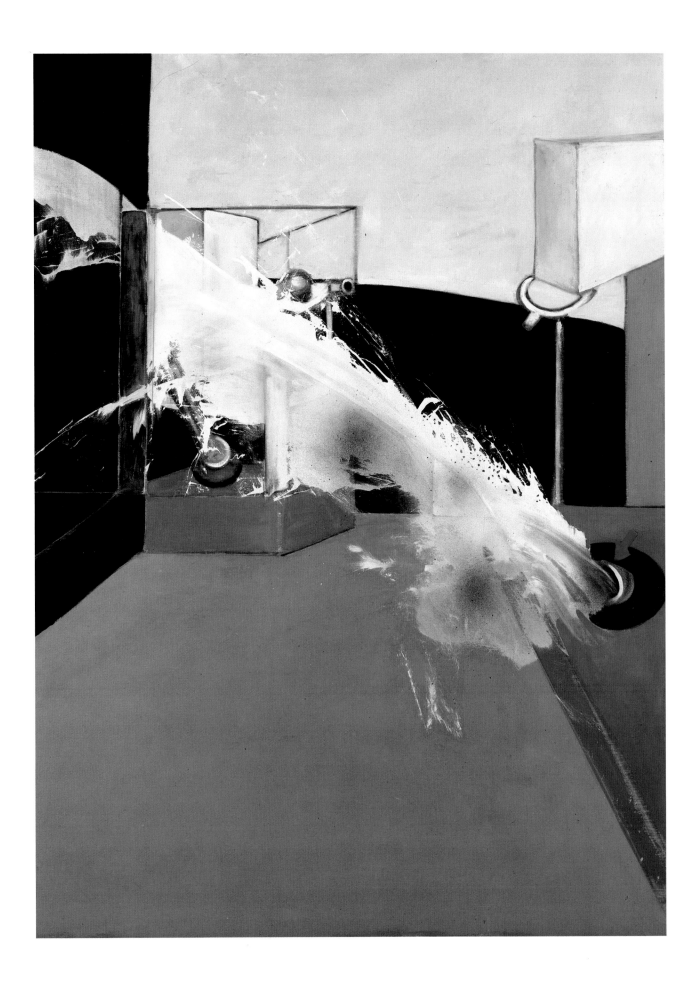

58 STUDY FOR PORTRAIT OF JOHN EDWARDS, 1988
Oil on canvas; 78 x 58 (198.1 x 147.3)
Richard Nagy

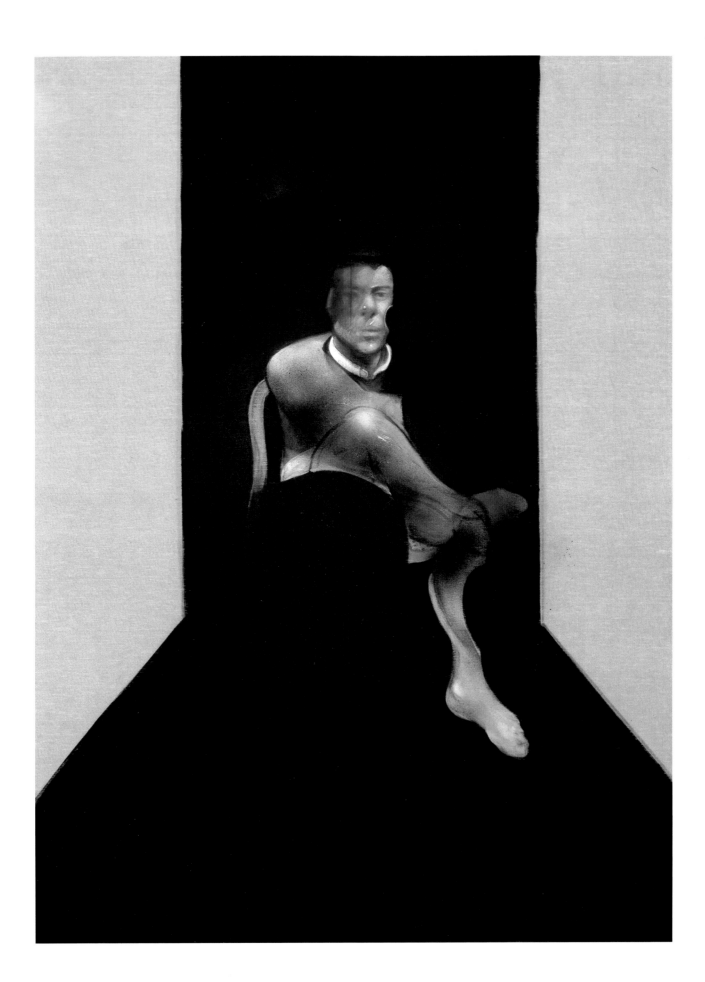

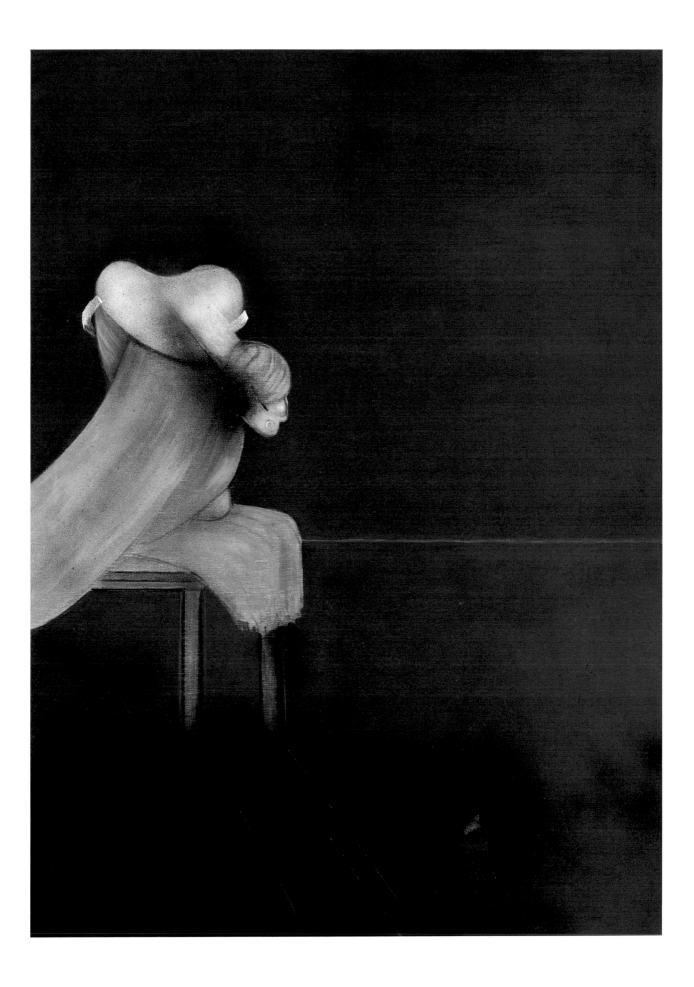

59 SECOND VERSION OF TRIPTYCH 1944, 1988
Oil on canvas; three panels, each 78 x 58 (198.1 x 147.3)
Collection of the artist

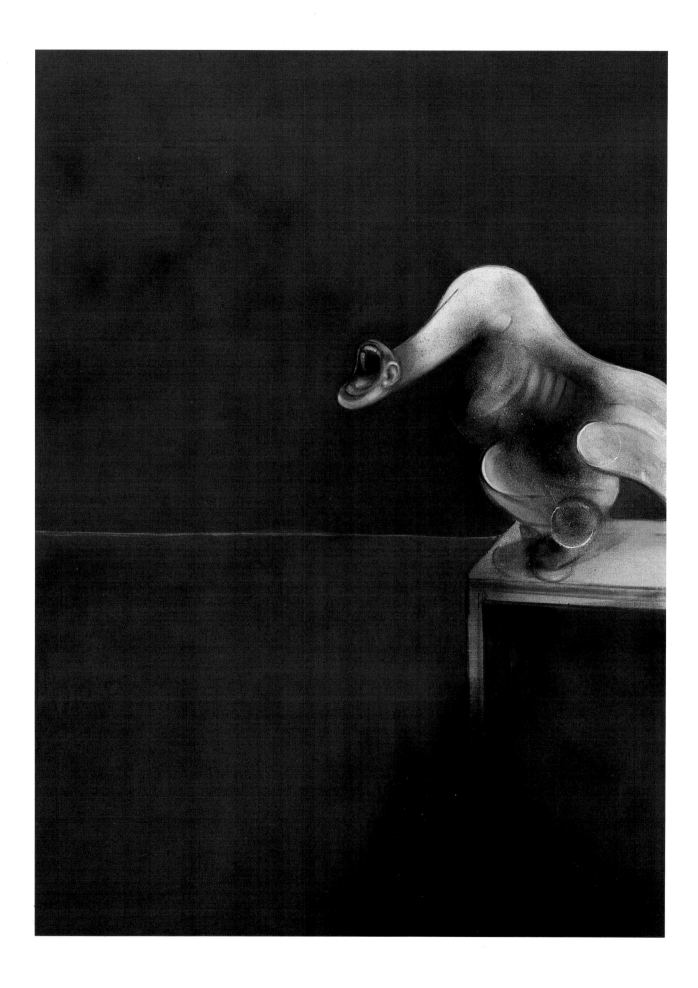

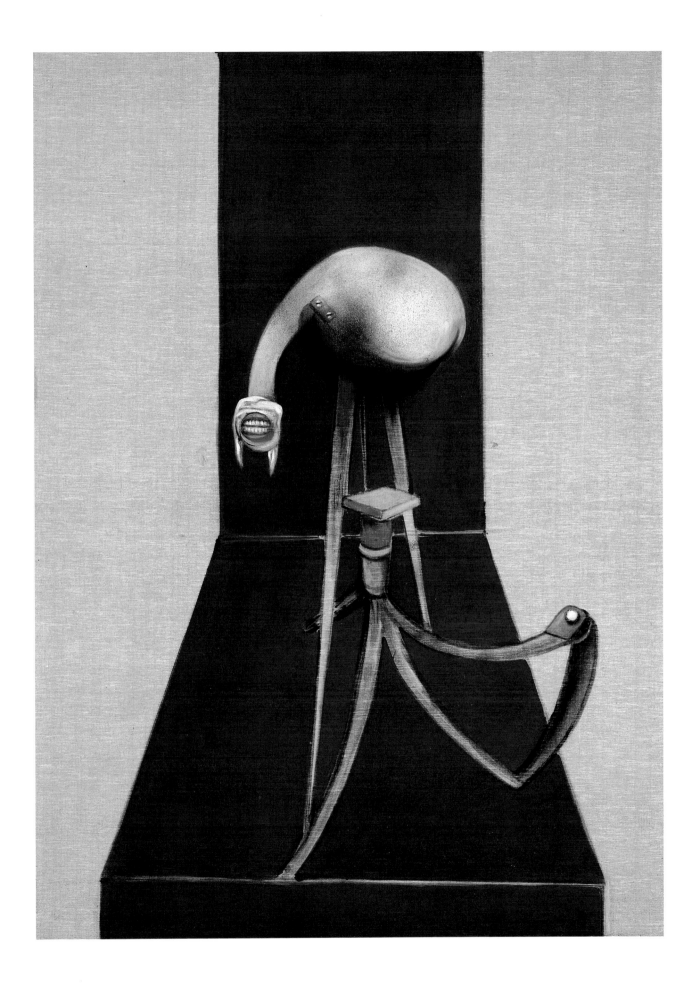

1

Figure in a Landscape, 1945
Oil on canvas; 57 x 50½ (144.8 x 128.3)
The Trustees of the Tate Gallery,
London

2

Figure Study II, 1945-46
Oil on canvas; 57¼ x 50¾ (145.4 x 128.9)
Kirklees Metropolitan Council, Huddersfield
Art Gallery, Yorkshire, England

3

Painting, 1946
Oil on canvas; 78 x 52 (198.1 x 132.1)
The Museum of Modern Art, New York, purchase
(shown at the Museum of Modern Art only)

4

Head I, 1948
Oil and tempera on cardboard; 39½ x 29½
(100.3 x 74.9)
Richard S. Zeisler Collection, New York

5

Head II, 1949
Oil on canvas; 31¾ x 25⅝ (80.6 x 65.1)
Ulster Museum, Belfast

6

Head VI, 1949
Oil on canvas; 36⅝ x 30⅛ (93.2 x 76.5)
Arts Council of Great Britain, London

7

Study for Portrait (Man in a Blue Box), 1949
Oil on canvas; 58 x 51½ (147.3 x 130.8)
Museum of Contemporary Art, Chicago, gift of
Joseph and Jory Shapiro

8

Fragment for a Crucifixion, 1950
Oil and cotton wool on canvas; 55 x 42¾
(139.7 x 108.6)
Stedelijk van Abbemuseum, Eindhoven,
The Netherlands

9

Pope I, 1951
Oil on canvas; 78¼ x 54 (198.7 x 137.2)
Aberdeen Art Gallery and Museums,
Scotland

10

Study for Crouching Nude, 1952
Oil and sand on canvas; 78 x 54 (198.1 x 137.2)
The Detroit Institute of Arts, gift of
Dr. Wilhelm R. Valentiner

11

Study of Figure in a Landscape, 1952
Oil on canvas; 78 x 54¼ (198.1 x 137.8)
The Phillips Collection, Washington, D.C.

12

Man with Dog, 1953
Oil on canvas, 59⅞ x 46 (152.1 x 116.8)
Albright-Knox Art Gallery, Buffalo,
gift of Seymour H. Knox

13

**Study after Velásquez's Portrait of Pope
Innocent X,** 1953
Oil on canvas; 60¼ x 46½ (153.0 x 118.1)
Des Moines Art Center, Coffin Fine Arts
Trust Fund

14

Study for a Portrait, 1953
Oil on canvas; 60 x 46½ (152.4 x 118.1)
Hamburger Kunsthalle, Federal Republic of
Germany

15

Study of a Baboon, 1953
Oil on canvas; 78⅛ x 54⅛ (198.4 x 137.5)
The Museum of Modern Art, New York,
James Thrall Soby Bequest

16

Sphinx II, 1953
Oil and pastel on canvas; 78¼ x 58¼ (198.8 x 147.9)
Yale University Art Gallery, New Haven,
gift of Stephen Carlton Clark, B.A. 1903,
courtesy Yale Center for British Art

17

Two Figures in the Grass, 1954
Oil on canvas; 59¾ x 46⅛ (151.8 x 117.2)
Private collection

18

**Study for Portrait II (after the Life Mask of
William Blake),** 1955
Oil on canvas; 24 x 20 (61.0 x 50.1)
The Trustees of the Tate Gallery, London

19

Study for Portrait of Van Gogh III, 1957
Oil and sand on canvas; 78⅛ x 54⅛ (198.4 x 137.5)
Hirshhorn Museum and Sculpture Garden,
Smithsonian Institution, Washington, D.C.,
gift of the Joseph H. Hirshhorn Foundation

20

Self-Portrait, 1958
Oil on canvas; 59⅞ x 47 (152.1 x 119.4)
Hirshhorn Museum and Sculpture Garden,
Smithsonian Institution, Washington, D.C.,
gift of the Joseph H. Hirshhorn Foundation

21

Sleeping Figure, 1959
Oil on canvas; 47 x 60 (119.4 x 152.4)
Private collection, England

22

Head of a Woman, 1960
Oil on canvas; 35 x 26⅞ (88.9 x 68.3)
Mrs. Lewis H. Lapham

23

**Paralytic Child Walking on All Fours
(from Muybridge),** 1961
Oil on canvas; 77¾ x 55½ (197.5 x 140.9)
Haags Gemeentemuseum, The Hague

24

Three Studies for a Crucifixion, 1962
Oil and sand on canvas; three panels,
each 78 x 57 (198.1 x 144.8)
Solomon R. Guggenheim Museum, New York

25

Landscape Near Malabata, Tangier, 1963
Oil on canvas; 78 x 57 (198.1 x 144.8)
Ivor Braka Limited, London

26

**Double Portrait of Lucian Freud and Frank
Auerbach,** 1964
Oil on canvas; two panels, each 66 x 57 (167.7 x 144.8)
Moderna Museet, Stockholm

27

Portrait of George Dyer Crouching, 1966
Oil on canvas; 78 x 58 (198.1 x 147.3)
Private collection, Caracas

28

Portrait of George Dyer Riding a Bicycle, 1966
Oil on canvas; 78 x 58 (198.1 x 147.3)
Ernst Beyeler, Basel

29

Portrait of Isabel Rawsthorne, 1966
Oil on canvas; 32 x 27 (81.3 x 68.6)
The Trustees of the Tate Gallery, London

30

**Three Studies for Portraits: Isabel
Rawsthorne, Lucian Freud, and J. H.,** 1966
Oil on canvas; three panels, each 14 x 12 (35.5 x 30.5)
Private collection

31

**Portrait of Isabel Rawsthorne Standing in a
Street in Soho,** 1967
Oil on canvas; 78 x 58 (198.1 x 147.3)
Staatliche Museen Preussischer Kulturbesitz,
Nationalgalerie, Berlin

32

Study for a Portrait, 1967
Oil on canvas; 61 x 55 (154.9 x 139.7)
Richard E. Lang and Jane M. Davis Collection,
Medina, Washington

33

**Triptych Inspired by T. S. Eliot's Poem
Sweeney Agonistes,** 1967
Oil on canvas; three panels, left: 78¼ x 58⅜
(198.8 x 148.3); center: 78¼ x 58¼ (198.8 x 147.9);
right: 78⅛ x 58¼ (198.4 x 147.9)
Hirshhorn Museum and Sculpture Garden,
Smithsonian Institution, Washington, D.C.,
gift of the Joseph H. Hirshhorn Foundation

34

Two Studies for a Portrait of George Dyer,
1968
Oil on canvas; 78 x 58 (198.1 x 147.3)
Sara Hildén Foundation, Sara Hildén Art Museum,
Tampere, Finland

35

Lying Figure, 1969
Oil on canvas; 78 x 58 (198.1 x 147.3)
Galerie Beyeler, Basel

36

**Three Studies for Portraits Including
Self-Portrait,** 1969
Oil on canvas; three panels, each 14 x 12
(35.5 x 30.5)
Private collection

37

Triptych, 1970
Oil on canvas; three panels, each 78 x 58
(198.1 x 147.3)
Australian National Gallery, Canberra

38

In Memory of George Dyer, 1971
Oil on canvas; three panels, each 78 x 58
(198.1 x 147.3)
Galerie Beyeler, Basel

39

Self-Portrait, 1971
Oil on canvas; 14 x 12 (35.5 x 30.5)
Musée National d'Art Moderne, Centre Georges
Pompidou, Paris, gift of Louise and Michel Leiris,
with the donors retaining a life interest

40

Self-Portrait, 1973
Oil on canvas; 78 x 58 (198.1 x 147.3)
Private collection

41

Triptych—May–June 1973, 1973
Oil on canvas; three panels, each 78 x 58
(198.1 x 147.3)
Private collection, Switzerland

42

Sleeping Figure, 1974
Oil on canvas; 78 x 58 (198.1 x 147.3)
Private collection, New York

43

Studies from the Human Body, 1975
Oil on canvas; 78 x 58 (198.1 x 147.3)
Gilbert de Botton, Switzerland

44

Figure at a Wash Basin, 1976
Oil on canvas; 78 x 58 (198.1 x 147.3)
Museo de Arte Contemporaneo
de Caracas

45

Figure Writing Reflected in a Mirror, 1976
Oil on canvas; 78 x 58 (198.1 x 147.3)
Private collection

46

Study for Portrait (Michel Leiris), 1978
Oil on canvas; 14 x 12 (35.5 x 30.5)
Musée National d'Art Moderne,
Centre Georges Pompidou,
Paris, gift of Louise and Michel Leiris,
with the donors retaining a life interest

47

Sphinx—Portrait of Muriel Belcher, 1979
Oil on canvas; 78 x 58 (198.1 x 147.3)
The National Museum of Modern Art,
Tokyo

48

Two Seated Figures, 1979
Oil on canvas; 78 x 58 (198.1 x 147.3)
Galerie Beyeler, Basel

49

**Triptych Inspired by the Oresteia of
Aeschylus,** 1981
Oil on canvas; three panels, each 78 x 58
(198.1 x 147.3)
Private collection

50

Sand Dune, 1983
Oil on canvas; 78 x 58 (198.1 x 147.3)
Ernst Beyeler, Basel

51

Study from the Human Body, 1983
Oil and pastel on canvas; 78 x 58⅛
(198.1 x 147.6)
The Menil Collection, Houston

52

Three Studies for Self-Portrait, 1983
Oil on canvas; three panels, each 13¾ x 12
(34.9 x 30.5)
Honolulu Academy of Arts, gift of
Mr. and Mrs. Henry B. Clark, Jr.

53

Diptych, 1982–84
Study from the Human Body, 1982–1984
**Study of the Human Body—
From a Drawing by Ingres,** 1982
Oil and transfer type on linen; two panels,
left: 78⅛ x 58¼ (198.2 x 147.9);
right: 78⅛ x 58⅛ (198.2 x 147.5)
Hirshhorn Museum and Sculpture Garden,
Smithsonian Institution, Washington, D.C.,
gift of Marlborough International Fine Art
and the Joseph H. Hirshhorn Foundation,
by exchange

54

Study for Self-Portrait—Triptych, 1985–86
Oil on canvas; three panels, each 78 x 58
(198.1 x 147.3)
Marlborough International Fine Art

55

**Study for Portrait of Gilbert de Botton
Speaking,** 1986
Oil on canvas; 78 x 58 (198.1 x 147.3)
Gilbert de Botton, Switzerland

56

Study for Portrait of John Edwards, 1986
Oil and pastel on canvas; 78 x 58
(198.1 x 147.3)
Private collection

57

Jet of Water, 1988
Oil on canvas; 78 x 58 (198.1 x 147.3)
Marlborough International Fine Art

58

Study for Portrait of John Edwards, 1988
Oil on canvas; 78 x 58 (198.1 x 147.3)
Richard Nagy

59

Second Version of Triptych 1944, 1988
Oil on canvas; three panels, each 78 x 58
(198.1 x 147.3)
Collection of the artist

Chronology
Public Collections
Exhibitions
Select Bibliography

1909

October 28, in Dublin—born Francis Bacon, second of five children, of English parents, Edward Anthony Mortimer Bacon and Christine Winifred Firth. Family lives at 63 Lower Baggot Street. Suffers from asthma as a child. Receives little formal schooling; tutored by the local clergyman and briefly attends Dean Close School, a boarding school in Cheltenham.

1914

Early fall—father goes to work in the War Office and family moves to Westbourne Terrace in London, subsequently moving frequently between England and Ireland.

1925

Leaves home to go to London. Works at various jobs.

1926

Travels to Berlin and Munich where he spends two months, then to Paris where he lives for more than a year, occasionally securing commissions for interior decoration and furniture design.

1927

Visits an exhibition of Picasso drawings at Paul Rosenberg, which greatly impresses him and inspires him to make drawings and watercolors.

1929

Returns to London. Begins to paint in oil. Takes a studio at 7 Queensberry Mews West, South Kensington, where he exhibits rugs, furniture, watercolors. Meets Australian artist Roy de Maistre. Receives occasional commissions. Meets Douglas Cooper, collector and critic, about this time.

1930

August—article, with photographs, is published in *Studio*, drawing attention to his work as a designer. November—holds joint exhibition in his studio of own furniture, paintings, gouaches and work by Roy de Maistre.

1931

Moves to Fulham Road in Chelsea. Gradually gives up commissions for decoration and devotes himself to painting.

1933

April—first commercial gallery group exhibition at Mayor Gallery includes one of his works. Moves to 71 Royal Hospital Road, Chelsea. October—

Crucifixion, 1933, included in Herbert Read's exhibition and book *Art Now*. Sir Michael Sadler, collector of contemporary art, purchases the painting and commissions a portrait.

1934

February—organizes first solo exhibition, held at "Transition Gallery" in the basement of Sunderland House, Curzon Street, London, owned by friend Arundell Clarke.

1936

Moves to 1 Glebe Street, Chelsea. Submits one painting (it was rejected) to the "International Surrealist Exhibition" at New Burlington Galleries, one of the first exhibitions of Surrealist art held in Great Britain.

1937

January—group exhibition, which includes four of his works, is organized by collector Eric Hall at Thomas Agnew and Sons.

1941–42

Lives one year in a cottage in Petersfield, Hampshire.

1943

Is declared unfit for military service because of asthma; briefly works in the reserve service of the ARP, Civil Defense Corps rescue service, but is discharged because of his health. Destroys most of his earlier work. Returns to London late in the year. Moves to John Everett Millais's former studio at 7 Cromwell Place, South Kensington. Renews friendship with artist Graham Sutherland. Meets artist Lucian Freud.

1944

Resumes painting. Completes *Three Studies for Figures at the Base of a Crucifixion*, which is acquired by the Tate Gallery in 1953. Kenneth Clark, director of the National Gallery, London, at the time, visits his studio.

1945

April—receives recognition for two works, *Figure in a Landscape*, 1945, and *Three Studies for Figures at the Base of a Crucifixion*, 1944, included in group exhibition at Lefevre Gallery in London.

1946

Art dealer Erica Brausen visits his studio and buys *Painting, 1946*. Contemporary Art Society purchases *Figure Study II*, 1945–46. June—lives at Hôtel de Ré, Monte Carlo, with infrequent visits to

London; paints very little; gambles. November—visits "Exposition internationale d'art moderne, UNESCO," which includes *Painting, 1946*, at Musée National d'Art Moderne in Paris.

1947–50

Rents a flat in Monte Carlo. Graham Sutherland and his wife spend the winters nearby. Travels between Monte Carlo and London until 1950.

1948

Alfred Barr buys *Painting, 1946*, for the Museum of Modern Art in New York, the first museum to purchase a work. Meets John Minton, painter and teacher at the Royal College of Art. Begins "Heads" series.

1949

November 7—first commercial gallery solo exhibition opens at Erica Brausen's Hanover Gallery in London, an association that continued until 1958. Begins painting "Pope" series.

1950

Teaches for several months as visiting artist at Royal College of Art, London, replacing John Minton. October 19—"Pittsburgh International Exhibition of Paintings," which includes *Head VI*, 1949, opens at the Carnegie Institute (has work in 1958 and 1967 exhibitions also). Late in the year, visits mother who lives in South Africa, stopping in Cairo for two days en route.

1951

Paints portrait of Lucian Freud, Bacon's first of an identified person. Paints in artist Rodrigo Moynihan's studio at the Royal College of Art for the next two years. Sells studio at 7 Cromwell Place; lives for a period in Carlyle Studios; moves studio several times (until 1955).

1952

Spring—returns to South Africa and Kenya. December—exhibition of landscapes inspired by Africa and the south of France is held at Hanover Gallery.

1953

Lives at 6 Beaufort Gardens. Summer—rents a cottage at Hurst near Henley-on-Thames. September—writes tribute to Matthew Smith for the catalog of the Tate Gallery's exhibition of Smith's work. October 20—first solo exhibition outside London opens at Durlacher Brothers in New York. Shares house with David Sylvester for a few weeks at 9 Apollo Place.

1954

February—lives in a furnished room at 19 Cromwell Road, S.W., in the same house as David Sylvester. March—lives at the Imperial Hotel at Henley-on-Thames and later moves to a flat at 9 Market Place. June 19—exhibition opens in British Pavilion at Venice Biennale (also has work in 1978 Biennale). Visits Rome and Ostia. December—returns to the Imperial Hotel.

1955

January 20—first major exhibition, which includes thirteen works, opens at Institute of Contemporary Arts in London. Moves to a flat off Sloane Street and paints in a borrowed studio at 28 Mallord Street. March—paints portrait of Sir Robert Sainsbury, patron and collector. Fall—shares flat at 9 Overstrand Mansions, Prince of Wales Drive, Battersea.

1956

Spring—begins "Van Gogh" series. Summer—visits friend Peter Lacey in Tangier and rents a flat there. Makes many visits to Tangier in the next three years.

1957

January 20—friend John Minton dies. February 12—first solo exhibition in Paris opens at Rive Droite. March 21—exhibition including "Van Gogh" series opens at Hanover Gallery.

1958

January 23—first solo exhibition in Italy opens at Galleria Galatea in Turin. Leaves Hanover Gallery; October 16—signs contract with Marlborough Fine Art.

1959

July 11—"Documenta II," which includes three of his works, opens in Kassel, West Germany. September 21—"V São Paulo Bienal," which includes three of his works, opens. September to January 1960—stays in St. Ives, Cornwall, painting in No. 3 Porthmeor Studios. Paints portrait of friend Muriel Belcher, manager of the Colony Club in Soho, a meeting place for artists.

1960

March 23—first exhibition at Marlborough Fine Art opens. May 8—"XVI Salon de Mai," which includes one of his works, opens at Musée d'Art Moderne de la Ville de Paris (also has work in 1961, 1962, and 1964 exhibitions).

1961

Fall—moves to apartment above a garage in South Kensington.

1962

May 24—major retrospective exhibition opens at the Tate Gallery; exhibition tours to Mannheim, Turin, Zurich, and Amsterdam. Peter Lacey dies in Tangier. Meets artist R. B. Kitaj.

1963

October 18—major retrospective exhibition opens at the Solomon R. Guggenheim Museum in New York; exhibition tours to the Art Institute of Chicago.

1964

George Dyer becomes friend and model. Begins portrait series of friend Isabel Rawsthorne (to 1966).

1965

January 23—major exhibition opens at Hamburger Kunsthalle; exhibition tours to Stockholm and Dublin.

1966

November 15—exhibition opens at Galerie Maeght in Paris.

1967

Receives Carnegie Institute Award in Painting from the Pittsburgh international exhibition. Receives Rubens prize from the City of Siegen, West Germany. Artist in residence at Royal College of Art about this time.

1971

October 24—George Dyer dies in Paris. October 26—attends preview of retrospective exhibition at Galeries Nationales du Grand Palais in Paris; exhibition tours to Düsseldorf.

1972–74

Paints series of three triptychs based on the death of George Dyer.

1975

March 19—attends preview of his exhibition at the Metropolitan Museum of Art in New York, which was selected by curator Henry Geldzahler.

1976

July 8—attends opening of his exhibition at Musée Cantini in Marseilles.

1977

January 19—attends opening of his exhibition at Galerie Claude Bernard in Paris. October 2—solo exhibition opens at the Museo de Arte Moderno in Mexico City. Briefly visits Rome to meet artist Balthus at Villa Medici.

1978

April 14—solo exhibition opens at Fundación Juan March in Madrid; exhibition tours to Barcelona.

1979

Muriel Belcher dies; paints *Sphinx—Portrait of Muriel Belcher*.

1980

April 26—exhibition opens at Marlborough Gallery in New York.

1981

Paints Oresteia triptych.

1983

June 30—retrospective exhibition opens at the National Museum of Modern Art in Tokyo; exhibition tours to Kyoto and Nagoya.

1984

January—briefly visits Paris with friend John Edwards for exhibition at Galerie Maeght Lelong. May 4—attends opening of his exhibition at Marlborough Gallery in New York. Paints triptych portrait of John Edwards.

1985

May 22—second major retrospective exhibition opens at the Tate Gallery; exhibition tours to Staatsgalerie Stuttgart and Nationalgalerie, Berlin.

1986

March—spends a few days in West Berlin to see solo exhibition at Nationalgalerie; visits the Pergamon Museum in East Berlin.

1987

September 30—attends opening of his exhibition of eleven works at Galerie Lelong in Paris.

1988

September 23—exhibition of twenty-two works opens at the Central House of Artists at the New Tretyakov Gallery in Moscow, the first retrospective exhibition of a living Western artist to be held in the Soviet Union; is unable to attend the opening in Moscow because of illness.

1989

January 6—"Auerbach, Bacon, Kitaj" exhibition, which includes *Second Version of Triptych 1944*, 1988, opens at Marlborough Fine Art in London. Lives and works in London.

Australia
Adelaide, Art Gallery of South Australia
Canberra, Australian National Gallery
Melbourne, National Gallery of Victoria
Sydney, Art Gallery of New South Wales

Austria
Vienna, Museum Moderner Kunst

Belgium
Brussels, Musée d'Art Moderne, Musées Royaux
 des Beaux-Arts de Belgique
Ghent, Museum van Hedendaagse Kunst

Canada
Ottawa, National Gallery of Canada

Denmark
Humlebaek, Louisiana Museum

Federal Republic of Germany
Berlin, Nationalgalerie, Staatliche Museen
 Preussischer Kulturbesitz
Bochum, Kunstsammlung Museum Bochum
Cologne, Museum Ludwig
Düsseldorf, Kunstsammlung Nordrhein-
 Westfalen
Frankfurt am Main, Städelsches Kunstinstitut und
 Städtische Galerie
Hamburg, Hamburger Kunsthalle
Hannover, Sprengel Museum Hannover
Mannheim, Städtische Kunsthalle
Munich, Bayerische Staatsgemäldesammlungen,
 Staatsgalerie Moderner Kunst
Stuttgart, Staatsgalerie Stuttgart
Wuppertal, Von der Heydt-Museum

Finland
Tampere, Sara Hildén Foundation, Sara Hildén
 Art Museum

France
Marseilles, Musée Cantini Art Contemporain et
 Galerie de la Faience
Paris, Musée National d'Art Moderne, Centre
 Georges Pompidou

Israel
Jerusalem, The Israel Museum

Italy
Milan, Pinacoteca di Brera (on loan from the Italian
 government)

Japan
Ito, Ikedo Museum of Twentieth-Century Art
Tokyo, National Museum of Modern Art
Toyama, The Museum of Modern Art
Yokohama, Yokohama Museum of Art

Mexico
Mexico City, Museo Rufino Tamayo

The Netherlands
Amsterdam, Stedelijk Museum
Eindhoven, Stedelijk van Abbemuseum
The Hague, Haags Gemeentemuseum
Rotterdam, Museum Boymans-van Beuningen

South Africa
Johannesburg, Johannesburg Art Gallery

Spain
Bilbao, Museo de Bellas Artes
Madrid, Museo Español de Arte Contemporaneo

Sweden
Göteborg, Göteborgs Konstmuseum
Stockholm, Moderna Museet

Switzerland
Zurich, Kunsthaus

United Kingdom
Aberdeen, Aberdeen Art Gallery and Museums
Belfast, Ulster Museum
Birmingham, Birmingham Museum and Art
 Gallery
Cardiff, National Museum of Wales
Huddersfield, Huddersfield Art Gallery, Kirklees
 Metropolitan Council
Leeds, Leeds City Art Galleries, Temple Newsam
 House
Leicester, Leicester Museum and Art Gallery

London, Arts Council of Great Britain
 Royal College of Art
 Tate Gallery
Manchester, City Art Gallery
 Whitworth Art Gallery, University of
 Manchester
Newcastle upon Tyne, Hatton Gallery, The
 University of Newcastle upon Tyne
Norwich, Robert and Lisa Sainsbury Collection,
 University of East Anglia
Oxford, Pembroke College

United States
Berkeley (California), University Art Museum,
 Berkeley
Buffalo, Albright-Knox Art Gallery
Chicago, The Art Institute of Chicago
 Museum of Contemporary Art
Cleveland, The Cleveland Museum of Art
Dallas, Dallas Museum of Art
Des Moines, Des Moines Art Center
Detroit, The Detroit Institute of Arts
Honolulu, Honolulu Academy of Arts
Houston, The Menil Collection
Minneapolis, Minneapolis Institute of Arts
New Haven, Yale University Art Gallery
New York, The Museum of Modern Art
 Solomon R. Guggenheim Museum
Pittsburgh, The Carnegie Museum of Art
Poughkeepsie (New York), Vassar College Art
 Gallery
Washington (D.C.), Hirshhorn Museum and
 Sculpture Garden, Smithsonian Institution
 National Gallery of Art
 The Phillips Collection

Vatican City
Collezione d'Arte Religiosa Moderna, Musei
 Vaticani

Venezuela
Caracas, Museo de Arte Contemporaneo de
 Caracas

This listing is selected from solo and group exhibitions after 1984. The bibliography compiled by Krzysztof Cieszkowski that appears in *Francis Bacon* by Dawn Ades and Andrew Forge, the catalog of an exhibition held at the Tate Gallery, London, in 1985, lists solo and group exhibition catalogs through 1984.

Solo Exhibitions

1985
Tate Gallery, London, "Francis Bacon," May 22–August 18, and tour to Staatsgalerie, Stuttgart, October 18–January 5, 1986; Nationalgalerie, Berlin, February 7–March 31.

Marlborough Fine Art, London, "Francis Bacon," May 29–July 31.

1987
Marlborough Gallery, New York, "Francis Bacon: Paintings of the Eighties," May 7–July 31.

Galerie Beyeler, Basel, "Francis Bacon Retrospektive," June 12–September 12.

Galerie Lelong, Paris, "Francis Bacon: Peintures récentes," September 30–November 14.

1988
Central House of Artists, New Tretyakov Gallery, Moscow, "Fréncis Békon zhivopis'," September 23–November 6.

Marlborough Fine Art, Tokyo, "Francis Bacon: Paintings," October 18–January 21, 1989.

Group Exhibitions

1985
Musée Cantonal des Beaux-Arts, Lausanne, "L'Autoportrait à l'Age de la photographie: Peintures et photographes en dialogue avec leur propre image," January 18–March 24, and tour to Württembergischer Kunstverein Stuttgart, April 19–June 9; Akademie der Künste, Berlin, September 1–October 6.

Hayward Gallery, London, "Hayward Annual 1985," May 15–July 7.

1986
Tate Gallery, London, "Forty Years of Modern Art 1945–1985," February 19–April 27.

Marlborough Fine Art, London, "Studies of the Nude," March 19–May 2.

Mathildenhöhe, Darmstadt, "Symmetrie in Kunst: Natur und Wissenschaft," June 1–August 24.

Museum Ludwig, Cologne, "Europa/Amerika: Die Geschichte einer künstlerischen Faszination seit 1940," September 6–November 30.

1987
Royal Academy of Arts, London, "British Art in the Twentieth Century," January 15–April 5, and tour to Staatsgalerie, Stuttgart, May 9–August 9.

Kunstnernes Hus, Oslo, "A School of London: Six Figurative Painters," May 9–June 14, and British Council tour to Louisiana Museum, Humlebaek, Denmark, June 27–August 16; Museo d'Arte Moderna Ca' Pesaro, Venice, September 5–October 18; Kunstmuseum, Düsseldorf, November 6–January 10, 1988.

Barbican Art Gallery, London, "A Paradise Lost," May 21–July 19.

1988
Royal College of Art, London, "Exhibition Road: Painters at the Royal College of Art," March 17–April 24.

Art Gallery of New South Wales and Pier 2/3, Sydney, "1988 Australian Biennale," May 18–July 3, and tour to National Gallery of Victoria, Melbourne, August 4–September 18.

Centre Georges Pompidou, Paris, "Les Années 50," June 30–October 17.

National Museum of Modern Art, Tokyo, "The Image of Man in Modern Japanese Art from the Museum Collection," July 22–September 11.

1989
Marlborough Fine Art, London, "Auerbach, Bacon, Kitaj," January 6–February 10.

Serpentine Gallery, London, "Blasphemies, Ecstasies, Cries," January 18–February 26.

This bibliography is selected from material published after September 1984. A more complete bibliography by Krzysztof Cieszkowski appears in *Francis Bacon* by Dawn Ades and Andrew Forge, the catalog of an exhibition held at the Tate Gallery, London, in 1985.

Books and Solo Exhibition Catalogs

Ades, Dawn, and Andrew Forge. *Francis Bacon.* Exhibition catalog. London: Tate Gallery and Thames and Hudson, and New York: Abrams, 1985.

Davies, Hugh, and Sally Yard. *Francis Bacon.* New York: Abbeville, 1986.

Dupin, Jacques, preface, and David Sylvester, interview. *Francis Bacon: Peintures récentes.* Exhibition catalog. Paris: Galerie Lelong, 1987.

Francis Bacon: Paintings. Exhibition catalog. Tokyo: Marlborough Fine Art, 1988. Text by John McEwen.

Francis Bacon: Paintings of the Eighties. Exhibition catalog. New York: Marlborough Gallery, 1987. Interview with David Sylvester.

Francis Bacon Retrospektive. Basel: Galerie Beyeler, 1987.

Fréncis Békon zhivopis'. Exhibition catalog (New Tretyakov Gallery, Moscow). London: British Council and Marlborough Fine Art, 1988. Text by Grey Gowrie and Sergei Klokov.

Leiris, Michel. *Francis Bacon: Full Face and in Profile.* rev. ed. New York: Rizzoli, 1988.

Nixon, John William. "Francis Bacon Paintings 1959–1979, Opposites and Structural Rationalism." 2 vol. Ph.D. diss., University of Ulster, 1986.

Schmied, Wieland. *Francis Bacon. Vier Studien zu einem Porträt.* Berlin: Frölich & Kaufmann, 1985.

Zimmermann, Jörg. *Francis Bacon: Kreuzigung.* Frankfurt am Main: Fischer Taschenbuch, 1986.

Interviews and Statements

Bacon, Francis. Statement in *The Artist's Eye: Francis Bacon: An Exhibition of National Gallery Paintings Selected by the Artist.* Exhibition brochure. London: National Gallery, 1985, unpaginated.

Beard, Peter. "Bacon." *Paris Match* (December 1988): 44–53.

Dagen, Philippe. "Un entretein avec Francis Bacon: 'Je suis un peintre réaliste.'" *Le Monde,* September 24, 1987, p. 23.

Greig, Geordie. "Bacon's Art Gets the Red-Carpet Treatment." *The Sunday Times,* September 25, 1988, sec. C, p. 8. Interview.

Peppiatt, Michael. "Francis Bacon: Reality Conveyed by a Lie." *Art International* (Paris) 1 (Autumn 1987): 30–33. Interview.

Stourton, Henry. "Aloof, Alone, Anonymous." *Airport* (December 1988): 36–37. Includes statement.

Sylvester, David. *The Brutality of Fact: Interviews with Francis Bacon.* 3rd ed. London and New York: Thames and Hudson, 1987.

Vaughan, Paul. *Interview with Sergei Klokov, Nikolai Gorshkov, Elena Disparova, Brandon Taylor, Elena Bespalova.* "Kaleidoscope," BBC Radio Four, September 29 and 30, 1988. Transcript.

Periodicals

Alvarez Diez, Ildefonso. "Francis Bacon: Contradicciones sublimadas." *Goya* 189 (November–December 1985): 156–58.

"Approaching Bacon." *Economist* 309 (October 1, 1988): 102–3.

Auty, Giles. "Formal Fallacy." *Spectator,* October 1, 1988, p. 38.

"Bacon, Francis." *Current Biography Yearbook 1985,* pp. 13–17.

Batache, Eddy. "Francis Bacon and the Last Convulsions of Humanism." *Art and Australia* 23 (Summer 1985): 222–25.

Beek, Marius van. "Dat weergaloze rood van Francis Bacon." *Kunst Beeld* (Brussels) 1 (July–August 1985): 4–7.

Bespalova, Elena. "This History of Mankind's Illness." *Soviet Culture,* October 4, 1988, p. 5.

Birch, James. "Bacon Goes to Moscow." *Modern Painters* 1 (Autumn 1988): 22–23.

Brighton, Andrew. "Why Bacon Is a Great Artist." *Art Monthly* 88 (July–August 1985): 3–6.

Burr, James. "Crisis under the Skin." *Apollo* 121 (June 1985): 431.

Cork, Richard. "Virtuoso Manipulator of Paint." *The Listener,* November 15, 1984, pp. 12–13.

Darwent, Charles. "Surreal Encounter." *The Guardian,* September 26, 1988, p. 20.

Denvir, B. "Editorial: In the Eye of the Beholder." *Art and Artists* 225 (June 1985): 2.

Esteban, Claude. "Francis Bacon o la pintura en carne viva." *Goya* 179 (March–April 1984): 284–87.

Farrell, B. A. "Psychoanalysis and Francis Bacon." *The New Society,* August 2, 1985, pp. 156–58.

Farson, Daniel. "A Cause for Celebration." *The Spectator,* May 11, 1985, pp. 32–33.

Feaver, William. "The Greatest Living Painter?" *Art News* 84 (September 1985): 123–25.

Frigerio, Simone. "Balthus/Bacon." *D'Ars* (Milan) 25 (April 1984): 52–55.

Fuller, Peter. "Francis Bacon." *Burlington Magazine* 127 (August 1985): 553–54.

———. "Sutherland & Bacon: Nature and Raw Flesh." *Modern Painters* 1 (Spring 1988): 21–27.

Gowing, Lawrence. "La position dans la représentation: Réflexions sur Bacon et la figuration du passé et du futur." *Cahiers du Musée National d'Art Moderne* 21 (September 1987): 79–102.

Gowrie, Grey. "Bacon in Moscow: A Small Gloss on Glasnost." *Modern Painters* 1 (Winter 1988–89): 33.

———. "Francis Bacon: Artist of the Endgame." *The Sunday Times,* May 19, 1985, pp. 48–54. Reprinted as "Francis Bacon" in *Fréncis Békon zhivopis',* exhibition catalog, and in *Modern Painters* 1 (Winter 1988–89): 34–39.

Graham-Dixon, Andrew. "Francis Bacon in Moscow." *Za Rubezhom* 44 (1988): 22. Reprinted in *The Independent,* September 24, 1988, p. 14.

Grimes, Nancy. "New York, Francis Bacon, Marlborough." *Art News* 86 (October 1987): 167.

Hale, Jane Alison. "The Impossibe Art of Francis Bacon and Samuel Beckett." *Gazette des Beaux Arts* 111 (April 1988): 268–74.

Hicks, Alistair. "Talking to Francis." *The Spectator,* May 25, 1985, pp. 36–37.

High, Graham, and Henry Meyric Hughes. "Letters to the Editor." *Modern Painters* 1 (Winter 1988–89): 58.

Hubbard, Sue. "Francis Bacon at the Tate." *The Green Book* (Bath, England) 2 (Autumn 1985): 31–36.

Hughes, Robert. "Singing within the Bloody Wood." *Time,* July 1, 1985, pp. 54–55.

Klokov, Sergei. "Letter from Moscow: Francis Bacon." *Apollo* 128 (December 1988): 428–29.

Kuspit, Donald. "Hysterical Painting." *Artforum* 24 (January 1986): 55–60.

Laessøe, Rolf. "Francis Bacon 'Man and Child'— selvprojektion of katharsis." *Tidsbilleder* (Copenhagen) 5 (1986): 8–18. Reprinted in *The Evolution of a Collection /En Samling under Edvikling,* Kjeld Kjeldsen and Charlotte Sabroe, eds. Humlebaek: Louisiana Museum, 1988, pp. 35–39.

———. "Francis Bacon's Crucifixions and Related Themes." *Hafnia. Copenhagen Papers in the History of Art* 11 (1987): 7–38.

Larson, Kay. "Tedious Torture." *New York* 18 (August 12, 1985): 54–55.

LeBot, Marc. "Francis Bacon: Personnage écrivant, reflété dans le miroir." *Art Press* 110 (January 1987): 84–85.

Levaillant, Françoise. "Materiaux, formes et transformations dans l'art du XXᵉ siècle." *Revue de l'Art* 72 (1986): 26–31.

McEvilley, Thomas. "Francis Bacon." *Artforum* 23 (October 1984): 85.

McEwen, John. "Francis Bacon: New Transmutations of an Autumn Rose." *Studio International* 198, no. 1010 (1985): 3–13.

———. "Report from London." *Art in America* 74 (January 1986): 27–29.

Meuli, Andrea. "Der gemalte Schrei." *Du* 9 (1987): 74–79.

Meyer, Laure. "Francis Bacon." *L'Oeil* 359 (June 1985): 83.

Ottmann, Klaus. "Francis Bacon, Marlborough." *Flash Art* 119 (November 1984): 40–41.

Packer, William. "Russian Taste of Bacon." *Financial Times,* October 1, 1988, p. 26.

Peppiatt, Michael. "Could There Be a School of London?" *Art International* (Paris) 1 (Autumn 1987): 7–21.

———. "Six New Masters." *Connoisseur* 217 (September 1987): 79–85.

———. "Sono come un tritatutto." *Arte* 153 (June 1985): 36–43.

Pierre, José. "Francis Bacon." *Cimaise* 34 (September–October 1987): 81–84.

Piguet, Philippe. "Paris: Francis Bacon." *L'Oeil* 387 (October 1987): 82.

Platschek, Hans. "Francis Bacon: alle Kunst ist Instinkt." *Art: das Kunstmagazin* 10 (October 1984): 20–36, 38.

"Prints and Photographs Published: Francis Bacon." *Print Collectors Newsletter* 15 (January–February 1985): 215.

"Profile: Francis Bacon, Confounder of Art Critics." *The Independent,* September 24, 1988, p. 14.

Reif, Rita. " '78 Work by Bacon Sold." *New York Times,* November 13, 1986, sec. C, p. 32.

———. "Work by Bacon Brings $1.76 Million." *New York Times,* May 6, 1987, sec. C, p. 19.

Russell, John. "Time Vindicates Francis Bacon's Searing Vision." *New York Times,* June 9, 1985, sec. H, p. 31.

Schwabsky, Barry. "Francis Bacon: Marlborough." *Flash Art* 136 (October 1987): 104.

Shepherd, Michael, and Alexander Rozhin. "Francis Bacon in Russia." *Arts Review* 40 (September 23, 1988): 646–47.

Smiley, Xan. "An Alien Culture Comes to Moscow." *Daily Telegraph,* September 24, 1988, Weekend sec., p. ix.

Smith, Roberta. "Art: Francis Bacon Show Centers on 80's Triptychs." *New York Times,* May 22, 1987, sec. C, p. 19.

Sokolov, Mikhail N. "Tragedies without a Hero: The Art of Francis Bacon." *Australian and International Art Monthly* 16 (November 1988): 1–3.

Solomon, Andrew. "Francis Bacon." *Contemporanea* 1 (November–December 1988): 107–9.

Spurling, John. "Gilt-framed: Francis Bacon, Tate." *New Statesman* 109 (May 31, 1985): 31–32.

Stevenson, Sylvia. "Letter from the Soviet Union." *Arts Review,* November 18, 1988, p. 83.

Stringham, Robin. "Francis Bacon: The Fifties." *Arts Magazine* 60 (October 1985): 84–87.

Taylor, Brandon. "Master of Isolation." *The Times,* October 12, 1988, p. 18.

———. "The Taste for Bacon." *Art News* 88 (January 1989): 57.

Villier, Dirk de. "Moscow Is Intrigued by Bacon's Art." *The Star* (Johannesburg), October 11, 1988, p. 8.

Welchman, John. "Summer Ghosts." *Art International* 1 (Autumn 1987): 89–95.

Zellweger, Harry. "Ausstellungs-Ruckschau: Kunstbrief aus London." *Kunstwerk* 38 (September 1985): 154–56.

Anna Brooke